IBERIAN AND LATIN AMERICAN STUDIES

The Films of Elías Qu

IBERIAN AND LATIN AMERICAN STUDIES

The Films of Elías Querejeta

A Producer of Landscapes

TOM WHITTAKER

UNIVERSITY OF WALES PRESS
CARDIFF
2011

www.uwp.co.uk

British Library CIP
A catalogue record for this book is available from the British Library.

ISBN 978–0–7083–2438–7 (paperback)
 978–0–7083–2437–0 (hardback)
e-ISBN 978–0–7083–2439–4

Typeset by Columns Design XML Limited, Reading
Printed by CPI Antony Rowe, Chippenham, Wiltshire

Contents

Series Editors' Foreword

Over recent decades the traditional 'languages and literatures' model in Spanish departments in universities in the United Kingdom has been superseded by a contextual, interdisciplinary and 'area studies' approach to the study of the culture, history, society and politics of the Hispanic and Lusophone worlds – categories that extend far beyond the confines of the Iberian Peninsula, not only in Latin America but also to Spanish-speaking and Lusophone Africa.

In response to these dynamic trends in research priorities and curriculum development, this series is designed to present both disciplinary and interdisciplinary research within the general field of Iberian and Latin American Studies, particularly studies that explore all aspects of cultural production (inter alia literature, film, music, dance, sport) in Spanish, Portuguese, Basque, Catalan, Galician and indigenous languages of Latin America. The series also aims to publish research in the History and Politics of the Hispanic and Lusophone worlds, at the level of both the region and the nation-state, as well as on Cultural Studies that explore the shifting terrains of gender, sexual, racial and postcolonial identities in those same regions.

Acknowledgements

This book would not have been possible without Peter Evans and Parvati Nair, who, as first and second supervisor of my doctoral thesis, gave me expert guidance and unswerving encouragement. I would like to thank Peter Evans for his inspiration: it was through his absorbing lectures at Queen Mary, University of London, that as an undergraduate I first became fascinated with Spanish cinema. Parvati Nair's intellectual generosity and thorough readings of my work were also invaluable. I wish to thank Rob Stone and Federico Bonaddio, who were the examiners of my thesis, for their thoughtful suggestions, and Rob, in particular, for encouraging me to publish it as a book. Thanks are due also to Trinidad del Río at the Filmoteca Española in Madrid, who assisted me with the essential task of viewing the films, and to the staff at the Biblioteca Nacional, who helped me with the historical and sociological sources. I would especially like to thank Elías Querejeta, and his colleagues at Elías Querejeta Producciones Cinematográficas (Elías Querejeta PC), for giving me access to films and scripts. The team at University of Wales Press, especially Sarah Lewis and Elin Lewis, have also provided excellent support and patience during the production of this book.

A special thanks to my past friends and colleagues at Queen Mary, and my present colleagues at Kingston University, who have all offered their support and kindness over the years. Finally, I would like to thank my Dad, for instilling in me a sense of wonder of the world as a child. And, of course, to Michael for his patience, humour and kindness. Without his emotional support, I am sure this book would not have been possible.

Earlier drafts of some of the material in this book have been published elsewhere in journals: Tom Whittaker (2007).'Infinite Landscapes in Gutiérrez Aragón's *Habla, mudita*'. *Studies in Hispanic Cinemas* 3.2: 89–90; Tom Whittaker (2008).'No-man's Land: Transitional Time and Space in Carlos Saura's *Deprisa, deprisa*'. *Bulletin of Hispanic Studies* 85.5: 679–94; Tom Whittaker (2009). 'Geographies of Anxiety: Space, Modernization and Sexuality in Antxón Eceiza's *El próximo otoño* and *De cuerpo presente*'. *Studies in European Cinema* 6.1: 7–16; Tom Whittaker (2010). 'Producing Resistance: Elías Querejeta's Political Landscapes'. *Jump Cut: A Review of Contemporary Media* 53.

Introduction

Producing Resistance: Elías Querejeta's Political Landscapes

The producer as auteur

To speak of the producer Elías Querejeta, who was born in Hernani in 1934, is to speak of the history of modern Spanish film. From the early 1960s to the present day, he has overseen the production of fifty-nine feature-length films. Many of these have been among the most important in the history of Spanish cinema: *El espíritu de la colmena* (*Spirit of the Beehive*) (Víctor Erice, 1973), *Cría cuervos* (*Raise Ravens*) (Carlos Saura, 1975) and *Barrio* (Fernando León, 1998), for instance, have earned critical acclaim with domestic critics and film festivals alike, while catapulting their respective directors to international fame.

His method of production is unique. Unlike most producers, his role stretches far beyond the usual industrial concerns such as fundraising, distribution and coordination. More a creator than a producer, he most regularly has a hand in every artistic aspect of the film-making process. His intervention is most evidently felt in the development stages of the film: Querejeta has co-written no fewer than twenty-two screenplays of his forty-seven Spanish productions, which include the critically acclaimed films *El desencanto* (*The Disenchantment*) (Jaime Chávarri, 1976) and *Deprisa, deprisa* (*Hurry, Hurry!*) (Carlos Saura, 1980).[1] Elsewhere, where he has not been credited as co-writer, Querejeta has offered financial backing to screenplays which are presented in their earliest stages of conception, thus enabling him to oversee their development. The director Fernando León's proposal for *Barrio* was a case in point: the producer gave the film the provisional go-ahead on the basis of a brief synopsis which León had scribbled on a letter (Ponga et al., 2002, p. 39). For Querejeta, the scriptwriting stage is

largely an organic and open-ended process: it usually entails lengthy discussions between the producer and the director, and is then subject to any number of revisions during the shooting of the film. The development stages of *El espíritu de la colmena,* for instance, took several months of discussions between Erice and Querejeta before even a final treatment was formed. This holistic approach to screenwriting is quite unlike that of many larger and more commercial production houses, who treat the development of the script and the production of the film as two progressively discrete stages.

His creative presence also permeates all other artistic and formal aspects of the film-making process, which are usually placed under the guidance of the director. According to the director Manuel Gutiérrez Aragón, who collaborated with Querejeta on *Habla, mudita* (*Speak Little Mute*) (1973) and *Feroz* ('Fierce') (1984), the producer 'se mete en las películas, en el trabajo del director y del guionista, y creo que hace bien' (Chamorro, 1985, p. 118).[2] Similarly, Jaime Chávarri, who worked with the producer on *El desencanto* (*The Disenchantment*) (1976), *A un diós desconocido* (*To an Unknown God*) (1977) and *Dedicatoria* (*Dedication*) (1980), says that 'para un director que trabaje con él es muy difícil no comunicar lo que Elías comunica sin ser consciente de ello' (Baza, 2000, p. 56).[3] These observations are largely in tune with the way in which Querejeta perceives his own role, which he outlines as follows:

> El productor debe estar al tanto de todos los medios que suponen la realización de una película. Y si trabaja de una manera rigurosa debe tener en cuenta que la película le llega no solamente al lado del guión, del pretendido proyecto literario, sino desde otros muchos elementos: la luz, los escenarios, el vestuario. (1994, p. 38)[4]

If the directors above have absorbed the influence of the producer, then so too has Querejeta's artistic vision been moulded by the directors. Indeed, the producer has commented that Erice, Saura and, in particular, Antxón Eceiza have each had a significant impact on his production method (Heredero, 1987, p. 8).

While his 'hands-on' approach has contributed towards consistently high production values, it has also triggered collisions of interest with some directors and members of the crew. Over the years, this has undoubtedly contributed towards his highly controversial persona, and there is evidence to suggest that at his worst he can be both an unpredictable and autocratic manager, or 'un brujo' [a witch], as Luis Cuadrado, his former director of photography, allegedly shouted as he pinned the producer against the wall after the premiere of *El espíritu de la colmena* (Garcia, 2006). For instance, Wim Wenders, the German director who worked with him on *La letra escarlata* (*The Scarlet Letter*) (1973), famously accused him of cutting ten

minutes of negatives without notifying him, leading him to retort that he would rather work with a fascist who left his negatives alone (Angulo et al., 1996, p. 36). Other conflicts arose in the 1970s with the directors Jaime Chávarri and Francisco Regueiro. According to Chávarri, he and the producer parted ways after *Dedicatoria* (1980) because the latter lost interest in the script (Baza, 2000, p. 57). The relationship between Querejeta and Regueiro was even more strained. The producer refused to give cinematic release to his film *Carta de amor de un asesino* ('Love Letter from a Murderer'), which he did not deem a high enough standard (Barbachano, 1989, p. 107). Regueiro has since spoken candidly about the relationship between Querejeta and the directors he works with, claiming that 'Elías busca enriquecerse en su relación con del director, y si no le enriquece, lo mata' (Chamorro, 1985, p. 118).[5] But most notorious of all has been the rift between Querejeta and Víctor Erice, which occurred towards the end of the making of *El sur* (*The South*) (1982), and subsequently led the two to go their separate ways. The producer decided to pull out four weeks before they were due to finish shooting, thereby creating in the words of the director, 'una obra inacabada' [an unfinished work] (Angulo et al., 1996, p. 132; Baza, 2000, p. 47). In spite of the producer's defence that the film was edited in a coherent way, the final cut of *El sur* entirely failed to coincide with the artistic vision of the director: the title, for Erice, was originally meant to refer to the young protagonist Estrella's (Icíar Bollaín) journey to the south of Spain, a section of the film Querejeta did not allow him to make. As a result, therefore, the meaning of the film was radically altered. Anecdotes such as these are perhaps not that surprising: after all, producers, who are ever intent on saving money, are renowned for shortening the length of their productions, much to the chagrin of the director. But Querejeta has since repeatedly stressed that his intervention in this case was motivated by creative rather than an economic reasons. Indeed, his inter-positions elsewhere have demanded the very opposite: during the post-production of Saura's *Elisa, vida mía* (*Elisa, My Life*) (1977), for instance, the producer wanted to keep the final cut ten minutes longer than the director himself had originally wished (Cueto, 2003, p. 98).

Stories such as these arguably throw into question the authorship of his collaborations: the allocation of the true creative voice within his films is, time and time again, both a contested and an ambiguously blurred issue. Hernández Les, for instance, maintains that his official title as producer is often misleading (1988, p. 39), Angulo et al. consider him to be a 'producer-auteur' (1996, p. 18), while Marsha Kinder claims that he is often consid-ered an auteur in his own right (1993, p. 474). Indeed, '¿Quién es el autor?' [Who is the auteur?] is the promotional tagline of *El productor* (Fernando Méndez Leite, 2006), a recent documentary film which discusses the life and work of Querejeta. Correspondingly, it would appear that the perceived

visibility of his creative influence has been carefully managed over the years. As Rob Stone has pointed out, Elías Querejeta appears as the first credit on his productions (2002, p. 1). His name provides films with a certain 'seal of quality', which has been nurtured by his enduring presence at international film festivals and the countless homages and seasons devoted to his work: there have, among others, been retrospectives of his films at the BFI London (1985) – where Saura was interviewed about his working relationship with Querejeta, Warsaw (1995) and San Sebastián (2002). In 1988, moreover, Televisión Española broadcast a season of fifteen of his productions. The distribution and subsequent curation of his films, as well as the publicity which has surrounded them, have served to showcase Querejeta as a *creative* producer, as opposed to the producer as a faceless money man. He is a self-professed 'hombre de cine más que empresa' [cineaste rather than businessman] (Del Corral, 1973), or as *El País* has put it, the consummate 'productor sin puro' [producer without the cigar] (García, 2006).[6] If, in common with most auteurs, Querejeta's name anticipates a level of critical expectation, it also serves as a commercial endorsement which seeks to unify a large, sometimes irregular, body of work. This was especially borne out by two video releases of his entire back catalogue, *Filmografía de Elías Querejeta* (Coleccionista de Cine, 1987) and *La colección Elías Querejeta* (Manga Films, 1997), which saw the resurrection of box-office and critical flops such as *El próximo otoño* ('Next Autumn') (Antxón Eceiza, 1963) and *Feroz* (Manuel Gutiérrez Aragón, 1984) along with two films which failed to even make cinematic release, *Carta de amor de un asesino* and *Los primeros metros* ('The First Metres') (Javier Anastasio et al., 1980). This commercial approach would appear to resonate with the auteurist tradition of criticism: as Andrew Sarris has written, there is always something worthwhile to be found even in the worst of an auteur's films (1968, p. 17). Released alongside two further collections of the films of heavyweight directors Ingmar Bergman and Luis Buñuel, *Filmografía de Elías Querejeta* positions the producer as an auteur in his own right: his name is promoted as an overarching source of meaning.

While Querejeta's creative hand in his productions is clearly evident, he has been quick to stress that the overall vision of the films belongs to the director, not to the producer. When asked if his films shared a common thread, he responded that they all have the 'sello del director' [stamp of the director] (Rodríguez, 1990). This paradox strikes at the very heart of Elías Querejeta's approach to production: while on the one hand, as we have seen, he has gained the unique status of a 'producer-auteur', his production company has also been pivotal to the discovery and promotion of Spain's most important and visually distinctive directors. As we will see in the chapter 1, his production company came into being in 1963 largely because of José María García Escudero, whose progressive vision for a revitalized

Spanish cinema found its expression in the promotion of young and innovative auteurs. Thus, collaborators such as Saura, Erice and Eceiza were given the relative aesthetic and industrial freedom to create a 'cinema of the self' – a looser, more modernist mode of film-making, which in explicitly foregrounding the individualized worldview of the director, bore the influence of Truffaut's 'politique des auteurs', and the subsequent *nouvelle vague* of the late 1950s. Indeed, this elevation of the director to the role of artist, rather than a merely proficient *metteur en scene,* would be one of the underlying tenets of the *nuevo cine español* (new Spanish cinema) (1963–7) – a movement in which Querejeta and his collaborators played a central role. Since then, his production company has gone on to provide a creative platform for several budding young auteurs – chief among whom have been Ricardo Franco, Manuel Gutiérrez Aragón and Jaime Chávarri in the 1970s, Montxo Armendáriz in the 1980s and Fernando León in the 1990s and 2000s. Moreover, three of his productions – *Los desafíos* (*The Challenges*) (José Luis Egea, Claudio Guerín, Víctor Erice, 1969), *Los primeros metros* and *Siete huellas* ('Seven Fingerprints') (Julio Medem et al., 1988) – have been portmanteau collaborations, each composed of short films by different directors fresh out of film school. These collaborations enabled Querejeta to both nurture and mentor budding young talent, providing an important apprenticeship for directors such as Erice and Medem.

A collaborative approach

While Querejeta has repeatedly asserted the importance of directorial freedom, the director is not allowed to choose his own technicians: a Querejeta production comes automatically with the producer's own tight-knit team of trusty film professionals, and the producer is notoriously unforgiving when working with those outside his collaborative team.[7] Often referred to as 'la factoría Querejeta', his regular crew has, over the years, included some of the very best technicians of the Spanish film industry: the aforementioned Luis Cuadrado, Teo Escamilla, Alfredo Mayo and José Luis Alcaine as directors of photography; Pablo G. del Amo as editor; Luis de Pablo as a composer; Primitivo Álvaro as production manager; and Maiki Marín, to whom the producer was married, as costume designer. Moreover, the artist Cruz Novillo has designed the majority of the distinctive posters and promotional material of his films. To imagine these collaborators as belonging to a production factory, however, is misleading: it conjures up images of the slick and economically efficient studio production companies in Spain in the 1960s such as Agata Films, Asturias Films and Aspa Films, who specialized in genre films and, albeit on a much more modest scale, tailored themselves around the model of the Hollywood studio system. The

factory model is not only anathema to Elías Querejeta PC in terms of its commercial scale of production, reception and exhibition, but also tends to downplay the considerable artistic achievements of each of its collaborators. While, as Ettedgui writes, the cinematographer, editor and composer are usually regarded as mere technicians, and therefore 'below the line' in film production parlance (as opposed to the exclusive 'above the line' club consisting of director, producer, writers and cast) (1998, p. 8), Querejeta's collaborators wield a considerable influence on the formal and aesthetic dimensions of the film.[8]

Of all his technicians, the cinematographer, Luis Cuadrado, has been the most influential, and he worked on all of Querejeta's productions made during the Franco years. According to Cuadrado, his first brushes with experimentation took shape at the official film school, IIEC (Investigaciones y Experiencias Cinematográficas), where his cinematography sought to react against the prevailing style at the time in Spanish cinema, which he describes as 'una fotografía compensada, sin estridencias (. . .) gris como la sociedad de aquellos años' (Barroso, 1989, p. 229).[9] While at the film school, he worked as a runner on the subversive films *Los golfos* (*The Hooligans*) (Carlos Saura, 1959) and *El cochecito* (*The Little Car*) (Marco Ferreri, 1960), before working as a camera operator on Querejeta's earliest collaborations, *A través de San Sebastián* ('By Way of San Sebastián') (Antxón Eceiza, 1960) and *El próximo otoño* (Antxón Eceiza, 1963), and then director of photography from *De cuerpo presente* ('Present in Body') (Antxón Eceiza, 1965) onwards. His formative years therefore reveal the development of two crucial components of his visual style – namely, formal experimentation and political subversion – that would be integral to his collaborations with Querejeta. Most experimental was his colour photography, whose 'look' is instantly recognizable. In 'painting' with natural light and shadow, Cuadrado was able to create striking chiaroscuro, low-key lighting, which registered the textures and contours of landscapes and buildings in rich, dimensional relief. Critics have noted the painterly quality of his photography, and have drawn comparisons between Cuadrado's style and the sparely illuminated compositions of Spanish tenebrist painters such as Goya, Murillo, Ribero and Velázquez (Kinder, 1993, p. 474; D'Lugo, 1997, p. 143) and Zurbarán (Requena, 1989, p. 139). His style was achieved through a combination of various techniques: the use of indirect lighting (for instance, bouncing the light source off white reflectors and silks); a preference for the source of illumination to be positioned behind the action, so that diffused light falls on the subject, thereby creating silhouettes and imbuing the *mise en scène* with a striking richness; and opting for faster, more sensitive film stock and emulsions which, in turn, produce sharper, higher contrast images.[10] Most crucially, Cuadrado made expressive use of the slanting light at dawn and dusk – which he affectionately called 'la hora

bruja' [the witching hour] – and a preference for shooting on cloudy, overcast days. During the making of *Peppermint Frappé* (Carlos Saura, 1969), for instance, the production was on kept on hold for an entire week as Cuadrado was waiting for the sky to cloud over before he could shoot a particular scene (Hidalgo, 1984, p. 47). Not only does this anecdote illustrate both the absolute rigour and artistry of Cuadrado's cinematography, but it also reveals the relative autonomy allowed to Querejeta's technicians – a dynamic that Cuadrado has expressed as most unusual within the Spanish film industry (Delclós, 1976, p. 32). Indeed elsewhere Cuadrado's input has proved to be crucial even in the development stages of the film: after reading the initial script of *El espíritu de la colmena*, Cuadrado suggested to Erice that they should recreate the colour of honey through a symbolic emphasis on yellow in the film (Delclós, 1976, p. 33).

During the making of *Pascual Duarte* in 1975, Cuadrado tragically lost his sight. As camera operator, Teo Escamilla took over from his colleague, the latter having to be rushed to hospital for an urgent operation on his eyes. In the several productions that followed, most notably in *El desencanto*, *Cría cuervos* and *Elisa, vida mía*, his style of photography bears the influence of his mentor.[11] In later films such as *El amor brujo* (*A Love Bewitched*) (Carlos Saura, 1986), however, which were made outside 'la factoría Querejeta', Escamilla appears to find his own style of photography, experimenting with more artificial-looking high-key lighting. Two of Querejeta's most prominent cinematographers since the 1980s, José Luis Alcaine and Alfredo Mayo, have similarly expressed their debt to the work of Cuadrado and Escamilla. Alcaine, who was director of photography on *El sur* and *Tasio*, emulated Cuadrado's complex techniques of bounce lighting (Heredero, 1994, p. 70), while Mayo, who was cinematographer on *Los lunes al sol* (*Mondays in the Sun*) (Fernando León, 2002) and *Las cartas de Alou* (*Alou's Letters*) (Montxo Armendáriz, 1990), developed his style during his time as camera operator to Escamilla on *Deprisa deprisa* and *Dulces horas* (Heredero, 1994, p. 444).

The coupling of formal experimentation with political resistance has also shaped the style of Pablo González del Amo, who was the editor on nearly all of Querejeta's productions until his death in 2004. Del Amo was imprisoned from 1948 to 1952 for his affiliation with the communist party. While in prison, he learned the basics of editing from reading the works of Soviet film theorists Lev Kuleshov and Vsevolod Pudovkin, which had been smuggled into Spain from Toulouse (Hidalgo, 1987, p. 50). Like Cuadrado, del Amo engages with the film from the early scriptwriting stages. His editing style largely adapts to the needs of the individual directors, and while subsequently both varied and eclectic, its adherence to experimentation is consistently present throughout Querejeta's corpus. From his earliest collaborations with Querejeta, he challenged the conventions of the 'invisible'

editing of the continuity style, which, with a few notable exceptions, had held sway in Spanish cinema until the early 1960s.[12] Unlike the connective and self-effacing mode of continuity editing, his style is richly expressive and as such often calls attention to itself. For instance, the films *El próximo otoño, El último encuentro, Si volvemos a vernos* and *Las palabras de Max* adopt long and fluid takes, thereby respecting a Bazinian concern for spatial unity, while *De cuerpo presente, La caza* and *Los desafíos* show evidence of its precise opposite, with disruptive jump cuts and jarring shock cuts. Elsewhere, in *Pascual Duarte, El espíritu de la colmena, El desencanto,* as well as in *Tasio* and Armendáriz's other films, a more ambiguous, Bressonian style of editing is employed, where the spatial and temporal flow of the narrative is undercut through the use of ellipses.

The composer Luis de Pablo collaborated on fifteen of Querejeta's productions from 1960 to 1978. Like Cuadrado and del Amo, de Pablo has commented that he was allowed absolute freedom on the films, on the condition that his music was geared towards the experimental (Anon., 1984a, p. 139). De Pablo was a key figure of the 'Generación del 51', a group of innovative young composers who sought to open up Spanish classical music to the avant-garde influences of European modernist composers such as Webern, Schoenberg and Stockhausen.[13] Following the lead of these composers, the 'Generación del 51' were concerned with a rejection of classical harmony and tonality, instead experimenting with more contemporary European musical forms, such as minimalism and serialism. As well as experimenting with form, de Pablo's music also made use of the technological advances at hand: for instance, through the recent developments of electronic tape recording, he was able to create *musique concrète* – the recording and manipulation of 'found' everyday sounds – which would be integral to the scores of films such *A través de San Sebastián* and *Peppermint Frappé.* In 1965 the composer founded Alea, Spain's first electronic music studio, where he was able to generate the kind of eerie, reverbatory electroacoustic sounds that figure in the scores of *Los desafíos* and *Las secretas intenciones.* His collaborations with Querejeta served as a platform to launch his career as an exceptionally prolific and critically acclaimed composer in his own right. Indeed, the scores of *Madriguera* and *De cuerpo presente* served as 'works in progress' for his later published pieces *We* (1969–70) and *Heterogéneo* (1968) (Anon., 1984a, p. 140), and he continues to be Spain's foremost avant-garde composer to this day.

According to Querejeta, there is an 'intercambio igualitario' [equal exchange] (Angulo et al., 1996, p. 42) between all the members of his crew which as we have seen takes place right from the embryonic stages of the film. To examine fully the ways in which collaboration works in film is difficult; so much, after all, depends on the creative chemistry and atmosphere between the individual crew members, all too elusive to quantify, and

too spontaneous to pin down. Nevertheless, it appears that the success of Querejeta's collaborative approach is due to two crucial and consistently upheld factors: the relative aesthetic autonomy and trust given to each of his regular technicians; and the free and fertile communication that ensues during the film, where decisions are usually made together as part of a team. This approach to film-making has been explained by Querejeta as follows:

> yo trato de crear una forma de trabajo en la que la intervención de los numerosos elementos del equipo sea posible, porque creo que la mayoría de las veces no solamente es posible sino que, además, también es positiva. La mirada que se produce en la construcción, no en la contemplación, de una película es *una mirada múltiple*.[14] (Heredero, 1987, p. 7, my italics)

Authorship in Querejeta's productions, then, emerges as a consistently plural and democratic process, one that appears to vividly bear out Colin MacCabe's claim that 'it is obvious at a very simple level in the production of films that it is directly counter-intuitive to talk of one responsible author' (2003, p. 36).

Unsurprisingly, the consistency of his collaborative team has brought to bear a consistent method of production over the years. The making of a Querejeta film tends to be a slow and meticulous process.[15] With a limited amount of film stock at hand, the rehearsal stages of his productions are usually lengthy and intense. The films are then usually shot in continuity (i.e. where the scenes are shot in the actual order of the story) thereby allowing the actors to develop their characters and interact with the narrative in a more organic way. Querejeta's unswerving commitment to realism has been most clearly borne out through his pursuit of direct sound: his production *El Jardín de las delicias* (*The Garden of Delights*) (Carlos Saura, 1970) was the very first Spanish film to record sound at the moment of filming. (Like the majority of Italian films of the period, Spanish films before 1970 were post-synchronized.) His soundscapes therefore maintain the immediacy and spontaneity of sound, thereby mirroring our own everyday acoustic perception of the world, with all its inconsistencies and ambiguous overlaps. As with sound design, narrative structure in his films similarly participates in the construction of realism in the productions. Narrative in his fiction films is generally observational, episodic and loose-knit, and therefore generally lacking in the dramatic momentum and tight causality of commercial films. Moreover, his preference for location shooting, natural light and unobtrusive medium and long shots often held in deep focus, has similarly yielded an austere realism in much of his work. Crucially, these formal elements work together to create a particularly 'visual' style of film-making, which often places significant importance on the *mise en scène*. In maintaining their spatial unity, his films therefore tend to place a visual emphasis on geographical location: spaces, whether urban or rural, are often privileged within the frame.

Elías Querejeta has similarly employed consistent methods of casting, a stage of the film-making process in which, like all others, he bears a considerable influence. During the Franco years, his films frequently cast established actors against type, thereby lending a perverse sense of irony to their roles. The once-heroic star persona of Alfredo Mayo, for instance, which was famously cemented in the propagandistic films *Harka* (Carlos Arévalo, 1941) and *Raza* (José Luis Sáenz de Heredia, 1942), is ironically undermined in his roles as ageing and neurotic patriarchs in *La caza* and *Los desafíos*. José Luis López Vázquez, whose persona was built around the Spanish stereotype of the hapless, randy bachelor in the popular *comedias sexy* of the 1960s, similarly undergoes a striking transformation in Querejeta's films, with roles such as a provincial, sexually repressed murderer in *Carta de amor de un asesino*, an infantilized professor of linguistics who is inept at communicating in *Habla, mudita*, and, most movingly, a paralysed industrialist in *El jardín de las delicias*, whose abject body, according to Pavlovic, has been 'mutilated by the hypocritical and repressive system that created him' (Pavlovic, 2007, p. 157). Another strategy during the late 1960s and 1970s was to cast celebrated foreign actors in principal roles: most famously, Geraldine Chaplin starred in nine Querejeta/Saura collaborations, while Jean-Louis Trintignant and Haydée Politoff appeared in *Las secretas intenciones* (Antxón Eceiza, 1969). Not only did their cosmopolitan 'Europeanness' figure as an ironic counterpoint to the sham modernity of Spain's miracle years, but the appearance of foreign stars was a means of broadening the appeal of the films in film festivals and the international market. Since the 1980s, he has frequently cast non-professional actors in his films, such as the teenagers in *Deprisa, deprisa* (Carlos Saura, 1980), *27 Horas* (Montxo Armendáriz, 1986) and *Barrio,* as well as the children in *Tasio* (Montxo Armendáriz, 1984). In specifically casting local actors, these films underscore the importance of location in the formation of social identity, an aspect integral to the thematic and ethical concerns of social realism.

In adhering to this production method, 'la factoría Querejeta' has yielded a distinctive visual style.[16] For instance, the thirteen films that Carlos Saura made in tandem with Elías Querejeta PC are recognizably distinct from his later films which were directed without the team. The hermetic and modernist *Dulces horas* (*Sweet Hours*) (1981), the thirteenth and final Saura/Querejeta collaboration, is vastly different in tone from the dance films which he would later go on to direct, such as *Bodas de sangre* (*Blood Wedding*) (1981) and *Carmen* (1983). Similarly, the coolly detached, observational style of *Las cartas de Alou* (*Alou's Letters*) (1990) and *Historias del Kronen* (*Stories from the Kronen*) (1995), films which Armendáriz directed under Querejeta, is strikingly at odds with that of his later *Secretos del corazón* (*Secrets of the Heart*) (1997) and *Silencio roto* (*Broken Silence*) (2001), which are

markedly more melodramatic in tone. More crucially, the consistency of the collaborative team also works to unify Querejeta productions *between* different directors, a dynamic that has been shored up by the money-saving devices of the producer. For instance, surplus cutaway shots of the landscape and the sky in Gutiérrez Aragón's *Habla, mudita* were reused the same year in Víctor Erice's *El espíritu de la colmena* (Angulo et al., 1996, p. 142). Furthermore, some of the music of Antxón Eceiza's *El próximo otoño* (1963) reappeared in Saura's *La caza* (*The Hunt*) (1965), while Schubert's piano sonata which appears frequently in Chávarri's *El desencanto* crops up again some years later in Gutiérrez Aragón's *Feroz*.

Producing resistance

Querejeta has remarked that in spite of working with a range of different directors, all of his films share a similar ethical perspective (Alameda, 1972, p. 23). This perspective is informed by a moral responsibility to expose and inform: from the 1960s to the present day, his films have held up a mirror in which Spain has been able to see the true conditions of its existence. As such, he has frequently referred to his vision of film-making as 'un cine como conocimiento' [cinema as knowledge] (Leyra, 1998), and has emphasized that it should be possible to 'abordar la información a través del cine' [approach current issues through cinema] (Anon., 1976). As is well known, his practice of raising awareness of social and political issues won him notoriety throughout the Franco years, when the propagandistic No-Do – 'Noticiario y Documentales' (News and Documentaries) – was the principal source of national news, and representations of Spanish life were subject to state censorship. Since the transition to democracy, the producer has continued to attack the Spanish film industry – albeit a little unfairly – for its apparent eschewal of realism, and his commitment to exposing social injustice has become all the more pronounced.[17] Indeed, in the past decade, he has collaborated on a number of documentaries such as *Invierno en Bagdad* (*Winter in Baghdad*) (Javier Corcuera, 2005), which offers a journalistic exposition of the Iraq War and *La espalda del mundo* (*The Back of the World*) (Javier Corcuera, 2000), an observational treatise on the current state of international human rights. Other recent documentaries present real-life 'reconstructions' as a means to explore social issues: *Buscarse la vida* ('On The Streets') (Chumilla Carbajosa, 2007) follows the experiences of a homeless man, while *Cerca de tus ojos* ('Close to your Eyes'), actually directed by the producer himself in 2009, hinges on the travels of a foreign correspondent (played by Maribel Verdú) who reports on contemporary breaches of human rights. These later films illustrate Bill Nichols's definition of the 'blurred boundary' between fiction and reality (1994), a common

characteristic of contemporary documentary film-making, where 'being' and 'acting' are presented in an increasingly complex form.

In attempting to show and expose, his ethos of film-making subsequently explores the possibility of change and progress, thereby illustrating the writing of Cesare Zavattini, a key scriptwriter and theoretician of Italian neo-realism, who contended that to describe social problems is to protest against them (1996). Querejeta's conception of cinema, therefore, can be best understood as a tool for social and political change, and, most crucially, a form of resistance. During the Franco years, a good number of his films mounted a critique of the oppressive ideology of National Catholicism and the social and geographical repercussions of accelerated modernization. As is well known, in films such as *La caza, Pascual Duarte* and *Los desafíos*, political contestation was, by necessity, conveyed through an opaque and allegorical style of film-making.[18] Their polemical messages therefore not only evaded the literal-minded censors, but also captured the attention of film festivals and international film critics, who feted the films for their formal creativity and personal expression, a vivid illustration of the truism that great art is borne of constraint. Since the transition to democracy, the struggle has been directed against Spain's embrace of neo-liberalism, or, more specifically, those who have been left behind in its wake. Whether they focus on dispossessed rural peasants (*Tasio*), urban delinquents (*Deprisa, deprisa*), dislocated immigrants (*Las cartas de Alou*) or the unemployed (*Los lunes al sol*), his more recent productions have enunciated the social reality of Spain from the geographical speaking position of the oppressed. Political struggle in his films has therefore shifted from the *grand narratives* of ideology and religion, to the localized *petites histoires* of different social identities, and the power structures that constitute and contain them.

Querejeta has frequently defined his method of production as 'un acto de libertad' [an act of freedom] (Anon., 1978a, p. 17) or 'un ejercicio de libertad' [an exercise of freedom] (Heredero, 1987, p. 8). This freedom not only refers to the creative and artistic freedom given to his collaborators, who work outside the framework of commercial constraints, but also to the relative industrial freedom that his production company, Elías Querejeta PC, has enjoyed over the years. In carefully positioning his films as 'cine de calidad' [quality cinema], the vast majority of his productions have been beneficiaries of state subsidies; since the 1980s, moreover, many of his films have been subsequently co-financed by Televisión Española. In maintaining a consistently high level of production values and a pronounced sense of social commitment, he has ensured that his films have maintained a celebrated presence at international film festivals. Moreover, where possible, he carefully chooses smaller less commercial national distributors, who are open to experimental film-making and more willing to take risks (Angulo et al., 1996, p. 54).

During the Franco years, however, his struggle for freedom gave rise to a fraught, complex and often bitter relationship with the authorities. During this period, the producer's success was chiefly due to his tenacious and canny managerial style, which chiefly involved providing a false script for the censors, but using another more politically subversive script for the actual shooting (Hopewell, 1984, p. 27). As his films from the late 1960s onwards were increasingly met with rapturous acclaim in international film festivals, the censors had to begrudgingly accept the final version of the film. After all, to seriously impede a director's creative vision would be seen by Franco's image-conscious technocrats as disastrous for Spain's cultural standing abroad. As his international success as a producer grew, so too did his reputation as a risk-taker and polemicist. The aborted premiere of *Peppermint Frappé* in Cannes in May 1968 was a case in point. At the beginning of the screening, the producer took to the stage with a microphone to demonstrate his support for the strikers, and to denounce Robert Favre Le Bret, the president of the festival. Meanwhile, Carlos Saura and Geraldine Chaplin were joined by Jean-Luc Godard and François Truffaut, who halted the screening by climbing the cinema curtain and 'hanging off it like grapes', as Roman Polanski has recently recalled (Grey, 2008).

While for much of western Europe and the United States, the tumultuous events of May 1968 signalled a generational shift towards younger, more liberal ideals, this same period saw Spain's political landscape slide inexorably back towards a more authoritarian, hard-line stance. In 1969, Elías Querejeta PC was struck by a double blow. The repercussions of the Metesa scandal had a disastrous impact on the Spanish economy, and, in particular, the Spanish film industry, where credit for film production was frozen. This was compounded by the appointment of the rabidly conservative Alfredo Sánchez Bella as minister of information and tourism (who would remain in the post until June 1973), who in turn appointed Enrique Tomás de Carranza, a man who disliked cinema, as the new director of the ministry's film division. Unsurprisingly, it is during this period that Querejeta's struggle with the administration was at its most fraught, culminating in the Querejeta/Saura collaboration *La prima Angélica* (*Cousin Angelica*), the most incendiary of all his productions and, much to the consternation of the authorities, Spain's official entry for Cannes in 1973. At the festival, news broke out that four masked teenagers had attempted to steal reels of the film from a projection booth during one of its Madrid screenings; unable to fit the reels into their bags, they fled with just twelve metres of the film. The youngsters were caught up in the wider moral panic which surrounded the film: the Spanish right-wing press were outraged by an infamous scene in which a wounded Falangist soldier is depicted with his right arm in a cast, caught in a permanent fascist salute. Despite mounting pressure from the government to cut the scene and public protests to boycott the film,

Querejeta steadfastly refused to compromise, stating publicly 'No transigiré ante ninguna presión que intentara suprimir lo que fue debidamente aprobado' (Galán, 1974, p. 144).[19]

La prima Angélica centres on Luis, a middle-aged man from Barcelona (played by José Luis López Vázquez), who travels to Segovia to bury his mother's ashes. The journey triggers off his childhood memory of the Civil War, when he was forced to live with his nationalist relatives in the town. Its fluid temporal frame, where present events and past memories bleed seamlessly into one another, brings to the fore the film's thematic emphasis on memory. As Querejeta writes in the published screenplay of the film: '*La prima Angélica* es más una reflexión sobre el tiempo y la memoria que una reflexión política. Pero abismarse en el tiempo conduce inevitablemente al encuentro con el dato histórico y político' (Saura, 1976, pp. 140–1).[20] Here, the producer demonstrates how political resistance arises from the formal structure of his film-making. Indeed, elsewhere, he has commented that the social message of his films has always arisen from their form, rather than the other way round (Hernández Velasco, 1993, p. 48). Integral to this politicization of form, this book argues, is an exploration of the Spanish landscape. Through its preoccupation with time and memory, *La prima Angélica* not only alerts us to the duration of the shot, but to its spatial properties as well. Through the film's persistence of long shots and takes, the frame presents us with a rich topography of spaces which are simultaneously both mental and physical, imagined and material. In visually privileging Segovia and the surrounding flat landscape of the *meseta*, space becomes one of the subjects of the film, rather than a mere setting or backdrop to the narrative. Crucially, the complex mappings of space in the film provide a way of deciphering the political message of the film. As Richardson has written, the film examines the relationship of space to power (2002, p. 115). The open spaces of the Castilian *meseta*, which in chapter two are discussed as iconic landscapes of Francoist ideology and hegemonic control, are reconfigured in the film as 'sites of abandonment, sickness, and oppression' (2002, p. 120). As such, space in the film is therefore emphasized as a dynamic and unstable creation, whose meaning is largely contingent and subject to change and contestation.

In its imbrication of space with political resistance, *La prima Angélica* is typical of many of Querejeta's collaborations. As the following chapters will make clear, space occupies a central position in Querejeta's film-making: from his early productions in the 1960s to those of the present day, it emerges as a mechanism which unifies much of his vast body of work. Of all the geographical spaces which are explored in his productions, it is the Spanish rural landscape that has recurred with most frequency. Born and raised in the Basque village of Hernani, Querejeta has been described by the journalist Javier Pradera as 'un fiero hijo de Hernani, defensor de los

valores rurales' [an authentic son of Hernani, and proud defender of rural values] (Cristóbal, 1997, p. 71). Indeed, Stone has observed that his rural childhood has shaped his films; as a result, 'a sense of lost innocence and an awareness of rural hardship and injustice under the dictatorship' are, according to Stone, two themes which dominate most of the films with which Querejeta is associated (2002, p. 2). Since the early 1980s, however, his attention has predominantly shifted to Spanish urban spaces, bringing into focus the social issues that are generated by rapid urbanization. As in *La prima Angélica*, space emerges in his films as a site of ongoing political and social struggle; it is a terrain on which the dialectic between hegemony and resistance is played out. Viewed in its entirety, therefore, the corpus of Elías Querejeta PC can be read not only as a narrative of the geographical transformations of Spanish society, but as a *counternarrative* of these changes. From the idyllic littoral backwaters of *El próximo otoño* to the globalized spaces of *Los lunes al sol* (Fernando León, 2002), the films chronicle the fading legacy of a fascist agrarian state to the emergence of a democratic country of cityscapes. The experience of these spatial transform-ations, however, are largely focalized through the hidden perspective of the oppressed or the marginalized, whose practices of everyday life reveal the contingency of the Spanish landscape.

Producing space

In recent years, there has been a growing preoccupation with space across the humanities. As an intrinsic field of enquiry, the study of space trad-itionally received little critical attention. It was seen merely as a passive backdrop, an empty container which was waiting to be filled. Rather than space, it was the notion of time which was privileged in critical discourse. Reflecting on this bias, Michel Foucault famously remarked in an interview that 'space was treated as the dead, the fixed, the undialectical, the immo-bile. Time, on the contrary was richness, fecundity, life, dialectic' (1980, p. 70). For Foucault, this privileging of time over space was strikingly anachronistic: in an age of increasing modernity, he argued, the question of space has never been so relevant:

> The present epoch will perhaps be above all the epoch of space. We are in the epoch of simultaneity: we are in the epoch of juxtaposition, the epoch of the near and far, of the side-by-side, of the dispersed. We are at a moment, I believe, when our experience of the world is less that of a long life developing through time than that of a network that connects points and intersects with its own skein. (1986, p. 1)

In a world of ever-advancing mobility and fragmentation, our social exist-ence is, for Foucault, defined in spatial rather than temporal terms.

Foucault's emphasis on space is also shared by Henri Lefebvre, who maps the development of capitalist modernity in spatial terms. In his ground-breaking work, *The Production of Space* (1974, first translated into English in 1991), Lefebvre similarly calls into question the traditional interpretation of space as a static, pre-existing entity. He proposes instead an altogether different conceptualization of space, which he terms 'the (social) produc-tion of (social) space' (Lefebvre, 1991, p. 26). For Lefebvre, social space is not so much a material entity as a cultural and social construct, an ongoing process which is 'produced' by human thoughts, relations and representa-tions.

Building on the writing of Foucault and Lefebvre, human geographers such as Ed Soja (*Postmodern Geographies*, 1989), Doreen Massey (*For Space*, 2005) and David Harvey (*The Condition of Postmodernity*, 1989) have pro-moted the study of space as an interpretive category per se. In foreground-ing the geographical dimensions of human life, the authors seek to *spatialize* the ways in which we study history and society. This is not to say, however, that their writing calls for a displacement or an outright rejection of the temporal. Rather, they attempt to hold geography in the same critical esteem as history, and to connect and conflate the two categories in new and revealing ways. In so doing, the project of capitalist modernity becomes both a historical *and* a geographical project: its historical making is largely dependent on spatial factors. Capitalist modernity is no longer just inter-preted as the next stage of a temporal development, as a chain of a vertical sequence which progressively follows what came before; it is reconceived, rather, as a horizontal *process* which develops unevenly across space.

In the context of Spain, the process of widespread industrialization and urbanization lagged behind much of the rest of western Europe. Spain's sudden and accelerated process of modernization, known as *desarrollismo*, began in 1959, when Spain opened up its economy to outside investment. Significantly, this has been intimately bound up with far-reaching geograph-ical change. Mass migration from the country to the city, the rapid expan-sion of urban conurbations and the overdevelopment of its Mediterranean coastlines have each played their role in the success of Spain's moderniza-tion. Since the 1980s, these have been accompanied by further spatial transformations, which have arisen from Spain's embrace of neoliberal capitalism: namely, the tension between the urban centre and the periph-ery, and the subsequent geographical exclusion of the dispossessed; the flux and flow of immigration and global capital; spatial competition and out-sourcing; and the geographical division of labour. Right from the beginning of Querejeta's career, this modernizing process has provided a persistent backdrop to his work: *A través de San Sebastián* (1960), his first venture into film-making, was made just one year after the beginning of *desarrollismo*

(economic development). In mapping geographical transformations, Querejeta's corpus tells – or rather, *spatializes* – this story of modernization.

Significantly, the work of Lefebvre and his followers not only demonstrates the shaping influence of capital on space, but also alerts our attention to its political dimensions. They point to the politicality of space, highlighting the multiple ways in which ideology and politics are woven into its very fabric. However, we are most often unaware of the extent to which power operates through space: given that it has traditionally been perceived as a static backdrop to human action, we are most likely to take space for granted. In calling for a 'critique of space' (1991, p. 92), Lefebvre impels us to question its apparent innocence, stating that 'an authentic knowledge of space must address the question of its production' (1991, p. 387). In exploring the corrosive influence of the environment on the individual, the majority of the films discussed in this book similarly articulate a critique of space. The spatial realism of Querejeta's productions, which, as we have seen, frequently privileges the importance of location, serves as an ideal form through which the production of space can be explored. In doing so, his films expose and contest the multiple ways in which power operates through space, and the subsequent impact of this power on the practices of everyday life.

The emphasis on the notion of everyday life here is important. Social space, for Lefebvre, is *lived space,* and is localized and produced through everyday social relations and processes. It is precisely at this microlevel of the everyday where resistance is carried out. The critical category of the everyday, and the political potential that it brings to bear, is usefully described by Ben Highmore as follows: 'Everyday life is not simply the name that is given to a reality readily available for scrutiny; it is also the name of aspects of life that lie hidden. To invoke an ordinary culture from below is to make the invisible visible, and as such has clear social and political resonances' (2002, pp. 1–2). This definition resonates with Querejeta's ethical vision of film-making, for whom the political is similarly located in the fluidity of the everyday. According to Querejeta,

> para mí la política no es un elemento extraño, ajeno a la vida del hombre, sino metido en la cotidianidad del hombre (. . .) La política es cosa de todos: no es una ciencia oculta, sino una actividad vital, absolutamente vital para la supervivencia (Anon., 1974, p. 31).[21]

Moreover, as we have seen, his pursuit of the everyday similarly manifests itself in 'making the invisible visible', where his films have reclaimed the voices of the dispossessed and the marginal. In his pursuit of realism, his films are similarly imbued with the aesthetics of the everyday, which valorizes the ordinary over the spectacular, and observation over narrative.

The writing of Lefebvre has, in part, led to an increasing attention to spatiality across the humanities, and the contemporary field of film studies is clearly no exception. Cinema, write Shiel and Fitzmaurice, is 'the ideal cultural form through which to examine spatialization precisely because of cinema's status as a peculiarly spatial form of culture' (2001, p. 5). According to the authors, this is because cinema is best understood in terms of the organization of space: that is, the space of the shot; the space of the narrative setting; the geographical relationship of different sites repre-sented in the film (2001, p. 5). But there is another crucial way in which film can be considered a spatial form: not only does it represent space, but following Lefebvre it works to *produce* space. From familiar to unexplored places, film is able to shape our understanding of the world around us; it structures our spatial imaginary, forming the images that we carry around of cities and landscapes. A good number of Querejeta's films, however, also unearth the ways in which these geographical imaginations have been taken for granted over the years, thereby calling into question the 'naturalness' of the landscape. Moreover, his films provide crucial means of exploring marginal, everyday and alternative spaces – spaces that remain largely outside the official Spanish geographical imaginary. In rendering these invisible spaces visible, his collaborations have been a crucial vehicle for national and international audiences to imagine a different production of space. Querejeta's geographical spaces therefore simultaneously both reveal and resist, expose and contest. His conception of 'cine como cono-cimiento', which has consistently given voice to social issues, injustice and inequality, also informs and empowers audiences to view cinema as a transformative force for change and social good.

About this book

In recent years, this 'spatial turn' has been felt increasingly within studies on Spanish cinema, and a number of scholars have made significant inroads into exploring the relationship between geography and Spanish cinema. Katherine S. Kovács was the first to observe the particular importance of landscape to Spanish cinema, and in her seminal article, 'The plain in Spain: Geography and national identity in Spanish cinema' (1991), she provides an astute analysis of several key auteurist Spanish films, including the three Querejeta productions *La caza, Pascual Duarte* and *El espíritu de la colmena*.

Following Kovács's lead, Steven Marsh has investigated the construction of urban space of Madrid in *Barrio* (2003), while Sally Faulkner has dedi-cated a chapter of her study *Literary Adaptations in Spanish Cinema* (2004) to the tension between the literary and filmic representations of rural and

urban spaces, providing an excellent analysis of the Querejeta productions *Pascual Duarte* and *Historias del Kronen* through a discussion of Lefebvre's notions of abstract and absolute space. In his book, *The Moderns: Time, Space, and Subjectivity in Contemporary Spanish Culture* (2000), Paul Julian Smith explores the production of space in the films of Bigas Luna, and Ann Davies investigates the representation of landscape in Spanish culture in her forthcoming monograph, *Spanish Spaces: Landscape, Space and Place in Contemporary Spanish Culture*. Other notable contributions include book chapters by Santiago Fouz-Hernández (2005), Alberto Mira (2000), Isabel Santaolalla (1999) and Marvin D'Lugo (2010). The deeply entrenched historical opposition between the country and city in Spanish literature and cinema has also provided the focal point of two books: Nathan Richardson's *Postmodern Paletos: Immigration, Democracy and Globalisation in Spanish Narrative and Film, 1950–2000* (2002) and García de León's *El campo y la ciudad* (1996). Although each of these authors has made a valuable contribution to the field of Spanish film studies, there nevertheless remains to be written an in-depth, book-length study on the representation of space and landscape in Spanish film. To the best of my knowledge, this book is the first major study of its kind to fill this crucial gap, and its particular emphasis on the politicality of space is one that has been largely overlooked in the field of film studies as a whole. Moreover, it is the first monograph in English to focus specifically on the work of Elías Querejeta, or indeed any other European producer. The Spanish books *El cine de Elías Querejeta, un productor singular* (1986) by Juan Hernández Les and *Elías Querejeta: la producción como discurso* (1996) by Jesús Angulo provide a wealth of invaluable empirical information on his method of production, but neither seek to engage critically with the films on which he has collaborated, nor do they reveal how his productions reflect the social and historical circumstances in which they are made.

The book will show how, from the early 1960s until the present day, Querejeta's films have consistently documented the dramatic historical and social transformations of Spain through the production of space. I will show how in developing a particularly spatial visual language, Querejeta and his team of regular collaborators *spatialize* this narrative of Spanish modernization. It logically follows that my analysis arises from the spatial properties of the films themselves. Thus, the organization of the frame, and the cinematic and geographic spaces that it depicts and creates, provide a central means of teasing out the industrial, social, political and, most crucially, geographical contexts and meanings of the twenty-nine films studied in this book. The contextualization of the films is further illuminated through a number of different theorists of spatiality – namely Henri Lefebvre, Michel Foucault, Doreen Massey, Homi Bhabha, Gilles Deleuze and Martin Heidegger – as well as Emmanuel Levinas, a philosopher whose work, while not explicitly

concerned with questions of space, is nevertheless approached from a spatial perspective. Although each thinker provides a different evocation of spatiality, their work is used to demonstrate the key premise which runs through the whole of my analysis: that is, the production of social space is inherently political in nature. Given the producer's vast and sprawling corpus, there are films which regrettably fall beyond the scope of this book. For instance, an investigation of his co-productions in the early 1970s is not provided, given that his intervention was informed by commercial motives, and the films were not made with all of his regular crew.[22] Furthermore, the five films which are directed by his daughter, Gracia Querejeta, are not included; unlike the majority of his other productions, her films do not concern themselves with questions of space.

Across the following six chapters of this book, the geographical struggle between hegemony and resistance will be located within three different sociocultural contexts. In light of Foucault and Lefebvre above, who underscore how the production of space is imbricated in the unfolding of history, each of these three contexts will be emphasized as both a historical *and* geographical period. Thus, chapters 1 and 2 ground his early films within the miracle years (1959–73), a period during which Spain underwent three key spatial changes – the tourist boom, the unprecedented exodus of the rural population, and the subsequent growth of urbanization – which sat awkwardly alongside the prevailing stagnant social structures of Francoism. Chapters 3 and 4 span the period from Spain's recession (1973–84) to the formation of its autonomous regions. Here, geographical transformation manifests itself in three areas: the sudden decline in rural to urban migration, the continuing demise of rural life, and the rise of environmentalism. Chapters 5 and 6, which correspond to the period from the 1980s to the present, centre on the uneven geographical fallout of the post-miracle years, and global neoliberalism respectively. In examining the films of Elías Querejeta PC within a broad sweep of history, it is hoped that this book will illuminate the open-ended, fluid and ever-changing dimensions of Spanish space. In bringing together both the importance of cinematic *and* spatial production, the twin focus of this book intends not only to make an original contribution to film studies in its unique focus on a producer, but also to Spanish cultural geography.

Chapter 1

Geographies of Anxiety

Elías Querejeta's earliest foray into film-making, *A través de San Sebastián* (1960), captured a Spain on the cusp of modernization. Just one year before its release, the Spanish economy had been opened up to foreign investment, ushering in a period of accelerated economic growth, otherwise known as Spain's economic miracle. Significantly, this development was dependent upon rapid urbanization and coastal tourism, and these geographical transformations not only transformed the fabric of everyday life, but revealed acutely just how far Spanish society had been lagging behind the rest of western Europe. Economic liberalization suddenly threw into relief the static and conservative social mores of Franco's Spain, creating a narrative of modernization fraught with social anxiety and unease. Nevertheless, it was precisely this narrative that shaped the thematic and formal concerns of Querejeta's earliest collaborations, and provided the impetus for the *nuevo cine español* (NCE), in which Elías Querejeta Producciones Cinematográficas would occupy a pivotal role.

This chapter traces the development of Querejeta's early career, from his short films *A través de San Sebastián* (1960) and *A través del fútbol* (1962), to his involvement in the NCE in the films *El próximo otoño* (Antxón Eceiza, 1963), *De cuerpo presente* (Antxón Eceiza, 1965) and *La caza* (1965). In embracing location shooting and new technologies, Querejeta's collaborative team brought to bear a particular method of film-making, which would visually privilege the landscape. As we will see, the films mobilize the Spanish landscape as a dynamic space of modernity. It is a location where the limitations of superficial modernization are brought into relief, and where the social anxieties generated by the alienating effects of migration, tourism, consumerism and, most crucially, sexuality are worked through. Finally, through Henri Lefebvre's writing on social space, I will show finally how the production of space in Querejeta's collaborations enacts a clear and trenchant critique of the miracle years. As we will see, Lefebvre's writing exposes the ways in which political resistance operates primarily through space – a dynamic which would inform the vast majority of his productions to come.

Towards a new production of space and place

In the 1950s, Querejeta's close friendship with fellow student Antxón Eceiza led to a mutual passion for European art cinema. The Conversaciones de Salamanca in 1955 had proved that they were not alone in their interest. The conference provided an opportunity for dialogue between government officials and film professionals, and revealed a collective frustration among intellectual film-makers towards a stagnant industry that largely churned out escapist, ideologically compliant genre-based films. This dissatisfaction was encapsulated by Juan Antonio Bardem, who famously declared at the conference that Spanish popular cinema was '1. politically futile; 2. socially false; 3. intellectually worthless; 4. aesthetically valueless; 5. industrially paralytic' (Hopewell 1986, p. 57). Although Querejeta and Eceiza were not present at Salamanca, the repercussions of the conference were pivotal to their early film education. Despite the fact that the conference did not bring to bear immediate changes in production, its legacy lived on in the prolif-eration of regional *cine-clubs* and intellectual film journals, and Querejeta and Eceiza played a hand in the development of this.[1] The pair organized *cine-clubs* in San Sebastián and later in Cantabria, providing local audiences with the rare opportunity to view the work of European film-makers such as Robert Bresson and Carl Theodor Dreyer (Angulo et al., 1996, p. 69). Having obtained his law degree in 1956, Eceiza moved to Madrid one year later where he enrolled at the IIEC (the Instituto de Investigaciones y Experiencias Cinematográficas). Querejeta dropped out of his degree programme in law and chemistry, and followed his friend to the capital in 1959 where he would find work at *Unión Industrial Cinematográfica* (UNINCI) – a production company which Querejeta later referred to as 'una auténtica cueva de marxistas más o menos revisionistas' (García, 1988, n.p.).[2] The company was responsible for a number of subversive comedies in the 1950s such as *Bienvenido Mr Marshall* (Berlanga, 1953), and was known most notoriously for its scandalous involvement with *Viridiana* (Luis Buñuel, 1961), whose anti-clerical content finally forced the company into liquidation. Although Querejeta fulfilled a number of junior roles there, he was given the opportunity to co-write, along with Eceiza and the director Juan Antonio Bardem, the script of *Los inocentes* ('The Innocents') (Juan Antonio Bardem 1963), an Argentine–Spanish co-production which articu-lated a critique of the bourgeoisie. Although brief, his training at UNINCI was crucial to his own role as a producer: their commitment to political resistance and approach to collaborative film-making would be central to the conception of his own production company. At the same time, Querejeta made invaluable contacts with Eceiza's fellow graduates, who would soon make up the collaborative team for their first production together.[3]

During these early years in Madrid, Querejeta and Eceiza found themselves at the centre of an emerging culture of cinephilia. While at film school, the latter collaborated with *Film ideal* and from 1959 *Nuestro cine*, journals which sought to elevate the social and artistic status of Spanish cinema. *Nuestro cine*, in particular, was addressed to a liberal, cine-literate readership and, in providing critical debates around the status of film as art, fostered an intellectual climate of film criticism. In this period, the scope of the journal lay chiefly in two areas: the emerging European art cinema of the time and the promotion of a socially conscious national cinema. Thus, alongside articles on heavyweight *auteurs* such as Resnais, Visconti and Losey, there could be found interviews with young, emerging Spanish film professionals who had recently graduated from the IIEC, as well as information on local *cine-clubs*.

During this time, the journal also devoted some of its attention to Spanish documentaries, providing both reports of documentary film festivals and short reviews of the documentaries themselves. In an article entitled 'Panorama del cine documental español' [An overview of Spanish documentary cinema], Jesús García de Dueñas wrote that the Spanish documentary was failing to realize its potential. Rather than providing a source of reality or individual expression, the medium predominantly served to promote towns and villages as touristic destinations or show regional festivals and customs to the rest of the country, mainly because local councils and regional building societies were the chief sources of funding (1961, p. 11).

It was within this context that Querejeta made his first film, *A través de San Sebastián* (1960), which was directed both by Eceiza and the producer himself. Funded by UNINCI and Real Sociedad, the football team for which Querejeta had played as striker between the years 1953 and 1959, *A través de San Sebastián* is a documentary composed of short, impressionistic vignettes of everyday life in the Basque city, from people sunbathing on the beach to men eating *pintxos* in a local bar. Although just over ten minutes long, it provided an effective blueprint for Querejeta's future production method, bringing together for the first time several of the members of 'la factoría Querejeta', the producer's tight-knit team of regular collaborators: Luis Cuadrado, a student at the IIEC, was brought in as cameraman; Pablo G. del Amo, who had previously been working in Portugal, as editor; and Luis de Pablo, who had no previous experience in film, as the composer of the score. Eceiza recalls the team's entirely collaborative approach to the film, whereby composition of each and every shot would be discussed in meticulous detail (Angulo et al., 1996: 71). In using a tourist resort as its subject matter, the film at first glance appears to adhere to the promotional touristic documentaries that had hitherto dominated the industry. A closer analysis of its style, however, reveals that the film in fact works to subvert this

kind of film-making. Indeed, the censors maligned the film for its 'estupidez cinematográfica' [cinematographic stupidity], and scoffed at its 'planos y escenas inconexas, referencias anacrónicas y pretensiones vanguardistas' [disconnected shots and scenes, anachronistic references and avant-garde pretensions] (Hernández Les, 1986, p. 160).

The film opens with a series of images of old-fashioned sepia postcards of San Sebastián, with the final image briefly animated in stop motion. In shifting from the still to the moving image, the city is at once presented as a dynamic space, subject to flux and transformation. That we first capture a glimpse of the city through the mediation of a postcard is significant. As mass-produced objects, postcards actively participate in the geographical imagination of a place; through their repetition of a familiar set of images, they inscribe spaces with popularly held meanings. Significantly, in the film that follows, the experimental visual language works to break with the picture-postcard clichés of the resort, reshaping its topography in a highly poetic way.

The tension between the still image of the past and the moving image of the present is mirrored by the film's formal juxtaposition of tradition with modernity. This is most strikingly conveyed through del Amo's use of disjunctive and associative editing strategies, which strongly recalls the techniques of montage editing. In the second scene, for instance, an image of a modern car, with fumes billowing out of its exhaust pipe, is succeeded by that of the stern of a wooden steam boat, with vapour rising up from its blow holes. The graphic matching of the two shots, which are paired through the similarity of both their composition and subject matter, serves to contrast the two images by association. A similar effect is created a few moments later: a long shot tracks the buildings of the city's old town; this is followed by a similar tracking shot of modern apartment blocks. This contrast is similarly developed via a further disjuncture between image and sound. The opening credits, for instance, consist of old photos of men in bowler hats that are accompanied by the sound of a car's engine being accelerated. Elsewhere, images of old, traditional buildings are defamiliarized by the accompaniment of the eerie, distinctly modern, electronic sound of a theremin. The most innovative element of the film's score, however, is its use of *musique concrète*: in a later scene the image of a water hose jetting its spray onto the street is overlaid with actual 'found' sounds recorded in a bathroom.[4]

Elsewhere, stasis and movement are contrasted with each other in a series of freeze-frame images of people sunbathing on the beach, which is followed immediately by a hand-held camera shot which abruptly zooms in on the same sunbathers. In another scene, the moving camera weaves its way through the city streets, filming the faces of passers-by. This is then succeeded by three carefully composed *tableaux vivants* of people sitting on a

street bench, in various elaborate poses. The observational, almost ethnographic depiction of people moving within their own geographical milieux, would appear to invest the film with a *cinema vérité* feel. However, in its creative and playful treatment of actuality, the collaborative team seek to shape or interpret reality, rather than merely to depict it. As Eceiza recalls: 'Nosotros teníamos una idea sobre el realismo, que no se basaba en la banalidad del realismo puro y duro' (Angulo, 2003, p. 276).[5] In its emphasis on the everyday, the film deploys a modern and experimental form as a means of playfully interacting and engaging with the city, presenting an image of the city as a 'lived' and mobile space. As its title *A través de San Sebastian* forcefully suggests, the film traverses the city: it moves *through* space, at once disengaging it from its clichéd and static picture-postcard images, while imbuing it with dynamism and movement. In mobilizing the city from different and shifting viewpoints, and contrasting these with the fixed city view of the postcard, the film brings to bear a new production of space. Crucially, this is a space that is created from the bottom up, through the diverse experiences of everyday life within the city.

Even more daring was *A través del fútbol*, Querejeta's and Eceiza's second collaboration together, which was financed by the Opus Dei production company PROCUSA. The film attempts to recount the nation's recent history via the development of Spanish football. A series of illustrated stills of a football match are accompanied by an ironic voiceover that narrates the key events of the twentieth century. For instance, a football championship serves to represent King Alfonso XIII's accession to the throne; the footballer Ricardo Zamora's record-breaking transfer to Real Madrid in 1931 is seen as the rise of the Republic; the outbreak of the Civil War is narrated via the image of a goalkeeper diving for a ball. The film, which originally stood at eleven minutes, was cut to a mere seven minutes owing to stringent censorship that omitted all references to the Civil War (Hernández Les, 1986, p. 161). Although Elías Querejeta has since dismissed both *A través de San Sebastián* and *A través del fútbol* as naïve (Hernández Les, 1986, p. 56), these early films bring to light several of the concerns that would be central to his method of productions to come. If the first shows how the collaborative adoption of a modern film language gave rise to a new production of space, the second anticipates the cryptic, allegorical mode of storytelling that would characterize many of his productions during the Franco years. Furthermore, in making a subversive film for a company whose national Catholic beliefs ran counter to his own, *A través del fútbol* would prefigure a funding strategy which would define his managerial style during the years to come. Biting the proverbial hand that fed him, Querejeta would exploit government subsidies in order to establish his own production company and become one of the pioneers of the NCE. Before examining these years,

it will first be necessary to situate his work within the sociohistorical context of Spain's so-called miracle years, to which this chapter will now turn.

The economic miracle and the *nuevo cine español*

If Querejeta's film-making looked beyond the borders of Spain, then so did the Spanish socio-economic landscape, which was poised to undergo a radical transformation. 1959, the year before *A través de San Sebastián* was made, was a key date in the shaping of modern Spain. Francoist technocrats sought to completely overhaul the structure of the Spanish economy: slow, inward-looking and predominantly agrarian, they intended to bring it into line with its modern European neighbours. In July of that year, the Stabilization Plan (Plan de Estabilización y Liberalización) was drawn up by Commerce Minister Alberto Ullastres. Pivotal to his plan was *apertura,* the opening up of Spain's economy to foreign investment. Price controls and trade restrictions were subsequently deregulated (Harrison and Corkhill, 2004, pp. 9, 77) and, in a bid to lure international investors, the peseta was lowered to a rate 29 per cent below its previous value (Pack, 2006, p. 26). With the restructuring of the economy in place, the stage was set for a spectacular pattern of growth. While Spain in 1959 was still classified as a developing nation by the UN, by 1973 it had become the world's ninth industrial power (Hooper, 1995, p. 18). During this period, which would come to be known as 'los años de desarrollo' (the years of development), Spain's industrial growth period was almost unparalleled in the western world: only Japan would boast a higher rate (Harrison and Corkhill, 2004, p. 76).

As is well known, this process of modernization led to a massive exodus from the country to the cities, where the majority of the new jobs in industrial and service sectors had been created. Shubert shows that between the years 1951 and 1970, 3.8 million Spaniards moved from the country to the city (1990, p. 21), while Riquer i Permanyer demonstrates that Madrid alone had grown by two million (1995, p. 263). By the mid-1960s, people employed in the secondary sector for the first time in Spanish history outnumbered the country's agrarian population (Harrison and Corkhill, 1995, p. 71). Rapid demographic movement inevitably resulted in the overcrowding and pollution of cities, with many migrants settling in *chabolas* (shanty towns), and later in high-rise apartments (Carr, 1980, p. 190). According to Shubert, this urban expansion took place in a political context in which no plans or controls were applied and in which greed and corruption were left unchecked (1990, p. 220). As developers were allowed to build at high densities, Spanish city centres, which already had among the highest population densities in the world, became even more crowded (Shubert, 1990, p. 220).

While the burgeoning cities saw the arrival of millions of migrants, the Mediterranean coast also swelled with unskilled workers, taking advantage of its thriving tourist industry. According to Pack, The Stabilization Plan provided an immense benefit to the tourist industry: the cheap peseta and the removal of red tape led to the opening of a floodgate of foreign tourists and property developers respectively (2006, pp. 82–3). The appointment of Manuel Fraga as minister of information and tourism in 1962 was also key to its success. Fraga's ministry was keen to promote tourism as the driving agent of Spain's economic and social transformation, and it was thus advocated as a 'conceived national cause' (2006, pp. 103,137). But again, the fallout of socio-economic change would have its geography. While the Spanish were brought into closer contact with their European neighbours, their own environment was blighted by overdeveloped resorts. As Pack notes, inflated property values led property developers to build rapidly, densely and often shoddily, in order to maximize their investments (2006, p. 101).

For Fraga, tourism was not only pivotal to Spain's modernization but also its perceived standing within Europe. Fraga was eager to shake off Spain's image abroad as the quaint and exotic backwater of Europe. The infamous 'España es diferente' (Spain is different) advertising slogan, which had served to exploit Spain's sociocultural insularity from Europe, was subsequently dropped in favour of a more diverse approach where regional particularisms received broader representation (Pack, 2006, p. 149). Fraga also identified cinema as a means by which a new image of Spain could be projected (Triana-Toribio, 2003, p. 72). As a result, he brought in José María García Escudero as director general de cinematografía in 1962, who was given the task of creating a 'quality' national cinema which would serve to showcase Spain as a modern country at international festivals.

García Escudero set forth his far-reaching changes for the Spanish film industry in his book *Cine español*, published in the same year. He considered the 'tres pecados capitales' [three main sins] of his national cinema to be its refusal to deal with social issues, its absence of realism and lack of intelligence (1962, p. 122). In place of a popular cinema characterized by 'ese carnaval zafio, ese tosco carrusel del pueblo, ese abigarrado escaparate para turistas, ese plato pintoresco de los festivales' (García Escudero, 1962, p. 20), he called for 'cine de calidad' [quality cinema] (1962, p. 105).[6] García Escudero made a series of reforms to facilitate this new style of film-making. The principal film school, IIEC was renamed the Escuela Oficial de Cinematografía (EOC) in November 1962. Its graduates who made artistically ambitious films were awarded *interés especial* (special interest) status and automatic subsidies of 15 per cent of box-office takings. This state intervention also intended to consolidate larger production companies in a country where too many small companies disappeared after just

one film (Triana-Toribio, 2003, p. 72). Taking his cue from other international young cinemas (*nouvelle vague*, British new wave, *cine nôvo*), García Escudero designated the films the *nuevo cine español*.

Significantly, the creation of Querejeta's production company in 1963, Elías Querejeta Producciones Cinematográficas, was made possible precisely because of these new reforms. Complicit in the promotion of Spain's economic boom, his company can therefore be considered a product of capitalist modernity. From his very first feature-length production, *El próximo otoño* (Antxón Eceiza, 1963), Querejeta proved to be particularly adroit at tailoring his films to the style required of the NCE.[7] In a recent interview, García Escudero commented that:

> el más vivo de todos [los productores] fue Elías Querejeta, fue el que tuvo más inteligencia para montar una producción sobre el Interés Especial (...) Querejeta montó un plan sobre esta base y, además, tuvo la inteligencia para utilizar el Interés Especial como una base para un cine que pudiera tener un cierto arraigo en las taquillas. (Riambau, 2003, pp. 62–3)[8]

Although relatively disparate, the films of the NCE all attempted to break away from the visual language which had been largely employed in Spanish popular cinema. Genre-based box office hits – namely comedies, melodramas, child-based musicals, epics – were predominantly made in the 'invisible' continuity style of classical Hollywood. Because of its associations with reactionary values, the continuity style was viewed with suspicion by the film-makers of the NCE, and Elías Querejeta was no exception. On several occasions, the producer has – somewhat sweepingly – attacked Hollywood for its apparently duplicitous nature (Hernández Les, 1986, p. 30). Indeed, 'rompiendo los esquemas de la programación previa impuesta por el cine americano'[9] was one of the central concerns of his production method, along with securing state protection and maintaining a regular collaborative team (Hernández Les, 1988, p. 40). Antxón Eceiza, Carlos Saura and Francisco Regueiro, the three directors who collaborated with Elías Querejeta Producciones Cinematográficas between 1963 and 1967, were at the forefront of the *nuevo cine español*. Along with contemporaries such as Basilio Martín Patino, Jaime Camino, Jesús Fernández Santos, Mario Camus and Manuel Summers, the work of these NCE directors rejected the unobtrusiveness of the continuity style, and marked a shift towards a looser, more modern style of film-making in Spanish cinema.

According to Bordwell, film space in the cinema of the continuity style must be minimized and serve merely as a 'vehicle for narrative' (Bordwell et al., 1988, p. 50). Space is presented 'so as not to distract attention from the dominant actions' and, as such, 'space as space is rendered subordinate to space as site for action' (Bordwell and Thompson, 1976, p. 42). Film space must be read therefore as story space: it must always

serve the flow of the narrative. In order to encourage us to read filmic space as story space, classical film-makers employ narrational strategies such as centring, balancing, frontality and depth (Bordwell et al., 1988, p. 59). To achieve a smooth, transparent style, where no space remains unaccounted for, techniques such as classical continuity editing and graphic continuity are used (Bordwell et al., 1988, p. 59). Conversely, in the modern style of film-making, film space is not necessarily subjugated to narrative. Uncoupled from its economic function as a backdrop to the story, space in films of modernist directors such as Yasujiro Ozu at times 'becomes foregrounded to a degree that renders it at times the primary structural level of the film' (Bordwell and Thompson, 1976, p. 42). In adopting a more modern style, the films of the NCE marked a shift from static narrative spaces, to more open and fluid geographical spaces. Space is no longer restricted to just a setting; rather, it often constitutes a more central element to the film.

While the NCE was still in its nascent stages, the writer Ramón Redondo in *Film ideal* called for an exploration of space in Spanish film, lamenting that it had for too long been made peripheral in its national film-making: 'Ni he visto aún una sola película joven que nos descubra el paisaje . . . El paisaje español, lo mismo el natural que el urbano, sigue siendo un protagonista casi desconocido' (Redondo, 1964, pp. 684–5).[10] In favouring location shooting over studios and taking full advantage of the technolo-gical advances available to them, the films of the NCE arguably served as a corrective to this. The availability of the handheld, lightweight Arriflex camera, for instance, enabled directors to make the most of these locations (Heredero, 2003, p. 151). Querejeta's five NCE films, *El próximo otoño, De cuerpo presente, La caza, Último encuentro* and *Si volvemos a vernos* are exemplary of this: space, to an extent, becomes a character in itself in these films.[11] As we have seen, the great social transformations of *desarrollista* Spain provided the backdrop to the creation of this new film language. As such, the foregrounding of film space occurred at a time when the nation was undergoing profound geographical change. This intertwining of both modernist film space and modernizing geographical space provides the focal point of the following section, which examines *El próximo otoño* and *De cuerpo presente*. While Fraga intended the NCE to portray Spain abroad as an economically progressive country, the representation of space in these films serves to achieve precisely the opposite: the technocrats' economic miracle is shown to bring into relief the sexual and social repression of 1960s Spain.

Geographies of superficial modernization

Set in Málaga (but filmed on location in Almuñécar, Granada), *El próximo otoño* registers the upheavals of a sleepy village awakening to the influx of

international tourism. *De cuerpo presente*, which was filmed and set in Madrid, depicts the accelerated processes of urbanization. Made in 1962 and 1965 respectively, the films point to two defining moments of Spain's economic miracle described above: the first, when Fraga declared tourism to be a national cause, and the second, when Spain first officially became a predominantly industrial country. In both films, everyday life is disrupted through the presence of an outsider, who captures the experience of space caught in the grip of modernization. The spatial tensions in the films are mirrored by an undercurrent of sexual tension, which is created through the appearance of French actresses Sonia Bruno and Françoise Brion. Each signifying European modernity, their presence brings into relief the superficial nature of Spain's economic miracle.

El próximo otoño centres on a fleeting romance between two teenagers: Juan (Manuel Manzaneque), a poor local fisherman, and Monique (Sonia Bruno), a wealthy French tourist. The film opens shortly after the death of the protagonist's father. Previously training to be a priest, Juan has had to leave the seminary to support his family through fishing. Monique, who is on summer holiday, is staying with the family of Don Joaquín, a wealthy property developer. Although shy at first, Juan soon succumbs to Monique's advances; as the relationship develops the latter decides to stay for another few days so that they can be together. Juan's grandfather dies and Monique returns to France to start her university course.

The novelist Luis Martín-Santos accompanied Eceiza for part of the shoot, and recorded his experiences in his book *Condenada belleza del mundo* ('The Condemned Beauty of the World'). Published posthumously in 2004, the book provides a poetic meditation on the changing local landscape which served as the location, as well as containing an invaluable, first-hand account of the making of the film. The author recalls the collaborative approach to the film, which often led to heated discussions between the director, assistant director Víctor Erice (who also co-wrote the script) and cameramen Luis Cuadrado and Luis Enrique Torán. In one passage, he describes how an argument between the director and Erice called into question the authorship of the film, describing the director as appearing 'con la expresividad del mozo humillado y con la comprensión total de una situación que en el fondo no ha nacido de su espíritu' (Martín-Santos, 2004, p. 45).[12] Similarly, the script arose from an entirely collaborative project, written by Eceiza and his colleagues at *Nuestro cine*, Víctor Erice, José Luis Egea and Santiago San Miguel. As in their prestigious French counterpart, *Cahiers du cinéma*, the theoretical concerns of the writers of *Nuestro cine* were mirrored in their film-making. Carmen Arocena has observed how the journal publicized the film as 'la puesta en práctica de toda una teoría de la crítica estética que a lo largo de sus dos años de existencia *Nuestro cine* ha ido

exponiendo' (Arocena, 2003, p. 393) celebrating it elsewhere for its 'autén-
tico sentido de la narrativa moderna cinematográfica' (2003, p. 393).[13]
Indeed, the film contains many of the hallmarks of a modern European
film: a loose-knit plot, jazz-inflected score, thematic emphasis on alienated
youth, the protagonist as anti-hero. In favouring a free hand-held camera
over eye-match shots, its style clearly defines itself against the norms of
classical film language. Its most defining stylistic feature, perhaps, is its use
of the extended sequence shot – described by Martín-Santos as 'antonio-
nesco' (Antonioniesque) (2004, p. 51) – which serves to open up the
potential for space, luring the eye onto the surrounding landscape. Indeed,
so long and complex were these sequence shots that Luis Cuadrado al-
legedly experienced pains in his neck (Martín-Santos, 2004, p. 55).

In both the opening and closing sequences of the film, the image of a
moving long-distance train is accompanied by the voice of Monique, who is
heard reading out a letter to her friend. Her opening lines, which are
spoken during her journey towards Spain – 'Querido Jean-Pierre, acabo de
entrar en España . . . Comienzo el largo viaje hacia el sol' [Dear Jean-Pierre,
I've just arrived in Spain . . . My long journey towards the sun begins] – and
her closing lines, spoken whilst returning to France – 'Aún quince horas
para llegar a París' [Still fifteen hours before I get to Paris] – accentuate the
physical distance that separates Spain from the rest of Europe. The com-
ments of Don Joaquín's wife, who is restless and unhappy in the village,
serve to reinforce this further, when she tells Monique that: 'Lo único que
queda cerca aquí es el mar' [The only thing close to here is the sea].

If the presence of Monique underlines the physical distance of the village
from Europe, it also throws into relief the struggle between modernity and
tradition in Andalusia, during the incipient stages of its tourist boom.
Monique's modernity serves as a counterpoint to Juan, who is racked by
shyness and constrained by devotion to both his church and family. Elegant,
cosmopolitan and sexually confident, the French girl typifies 'el sueño de
los países subdesarrollados' [the dream of underdeveloped countries]
(Martín-Santos, 2004, p. 60), while Juan bears out Martín-Santos's claim
that 'el varón de los países subdesarrollados está crónicamente frustrado'
[the men from underdeveloped countries are chronically frustrated] (2004,
p. 66). The somewhat Manichean contrast between the two characters is
reinforced in their styles of acting: Juan delivers his dialogue tongue-tied,
often turning his back away from Monique while speaking, and paces
around endlessly with his fists clenched; Monique saunters as she walks,
smokes in the street, and models her hairstyle on that of Jeanne Moreau,
whose photo she admires in her copy of *Paris Match*, a magazine whose
aesthetic was a reference point for Luis Cuadrado and other contemporary
NCE cinematographers, such as Enrique Torán and Juan Julio Baena
(Heredero, 2003, p. 159).

This contrast, more significantly, is played out in the film's examination of space. The second sequence opens at the beach, a site in which much of the narrative will unfold. The camera introduces us to a group of young fishermen dragging a large trawl net away from the sea; a new long-shot then moves onto various people sunbathing, among whom can be found Don Joaquín, his family and Monique. The use of non-diegetic music helps to contrast these two shots: ponderous, descending notes accompany the first shot, as if to evoke the strenuous, 'heave-ho' of the youngsters' work, while modish jazz music serves as the backdrop for the shot that follows. From the outset, then, the coastal landscape is presented simultaneously as one of labour and leisure, production and consumption. The contrast which is established, however, hinges not only on the tension between Spain and Europe, but between two different social classes that exist internally within the country. A property developer, Don Joaquín forms part of Spain's emerging entrepreneurial sector, feted by the technocrats, which reaps the financial rewards of post-*apertura* deregulation. His children are equally keen to embrace the changes that modernization has brought to bear: taking Monique for a tour of the area in his slick, convertible sports car, Joaquín's eldest son is quick to dispel her opinion that Spain is still a cultural backwater, assuring her that the majority of Spaniards now have 'un nivel europeo' [a European level]. Later, wandering outside a roadside bar, Monique stops at a nearby stall that sells tacky tourist souvenirs such as bull-fighting and flamenco figurines; Monique buys one as an ironic present for the son, who responds with a wry 'gracias'. The souvenir serves as a reminder of the contradiction which lay at the heart of *desarrollismo*: although Fraga aspired to unburden Spain of its perceived image of exotic isolationism, it would nevertheless continue to be the nation's most enduring stereotype.

El próximo otoño bears witness to the indelible print that tourism has left on the local landscape. Looking down towards the coast from a high vantage point, Joaquín shows his wife a hotel that his company is building. She is unimpressed with the view: the prosaic, breeze-block construction sits incongruously with the surrounding landscape. The destruction of the surrounding natural beauty provides the focus for much of Martín-Santos's account of the shoot, hence the title *Condenada belleza del mundo*. The author draws on the hackneyed trope of pure, untouched femininity to describe the beauty of a landscape that is about to be defiled by tourism: 'Llegó tu hora, virgen: serás profanada. Llegarán las caravanas de europeos para mofarse de ti' [Your hour has come, virgin: you will be defiled. Hordes of Europeans will come to scoff at you] (Martín-Santos, 2004, p. 8). Filming the landscape, writes the author, provides a way of capturing its untainted natural beauty on celluloid before it is soon lost forever (Martín-Santos, 2004, p. 9).

According to Arocena, the beauty of Spanish rural life in the film is refracted through the 'orientalist' gaze of Monique, the European outsider (2003, p. 395). During the opening credits, the voice of Monique can be heard reading a letter to her friend, signalling that the film will be enunciated from her point of view. Later on, the film ascribes a good deal of importance to Monique's camera, which invites us to share her 'European' way of seeing. In one scene, for instance, Monique wanders into the upper reaches of the village alone, taking photographs of the dilapidated houses and cobbled streets. Her free, ambulatory movement through space does not add to the progression of the narrative; rather, it makes for a leisurely exploration of the local landscape, contributing largely towards the desultory feel to the film. Earlier in the film, Juan and his best friend, Manuel, take her to the village cemetery which overlooks the village and the surrounding coastline. While Monique snaps away breezily, Juan serves as her guide, recounting the history of his region to his girlfriend. Relayed through an external point of view, traditionally Spanish sites such as this become at once unfamiliar and exotic. In constantly moving within space, the presence of the meandering camera serves as a pretext to examine the local landscape.

If the presence of an outsider places a different inflection on the local landscape, then so does the adoption of a modern film style. Monique's European way of seeing therefore finds its parallel in the European film language – a style that, as we have seen, was central to the creation of the NCE. The overlapping of these two aspects can be found when Monique watches a religious procession pass by. A crowd of villagers follows a statue of the Virgin Mary as it winds its way through the narrow streets. This is seen via a succession of seven brief, hand-held shots that emphasize the faces of the villagers from different, often surprising angles. An eighth shot moves from the crowd towards Monique, who is seen taking several photographs of the event. A new shot shows Juan watching Monique from a bar window above the street, and a stranger comments in reference to the French tourist, 'esas extranjeras no paran con las máquinas de fotos . . . ' [these foreign women don't stop with their cameras]. The dynamic pace of editing, unusual framing and contrasting angles of the different shots work together to foreground space as the structuring principle of the scene. In eventually connecting these shots to that of Monique and her camera, modern film language is conflated with the external, European gaze. The ease with which Monique uses her camera is contrasted with Juan, who is unable to work one. In another scene, Monique asks him to take a photograph of her; embarrassed, he responds that he does not know how. Unlike Monique, Juan – and by extension, Spain – has yet to possess the European way of seeing.

De cuerpo presente follows Nelson (Carlos Larrañaga), a young man who has come to the city to find a girlfriend. He awakes to find himself in a coffin, dressed in his pyjamas, ready to be buried. On discovering that a gangster (Alfredo Landa) poisoned him with Coca-Cola because he was seen kissing his girlfriend Mairin (María Asquerino), he quickly escapes. Every woman that he encounters while fleeing falls madly in love with him, including Edna (Françoise Brion), and he soon becomes known around the city as 'el sátiro del pijama' [satyr in pyjamas]. Eventually caught by the gangster, the protagonist falls to his death into a large tub of red paint. Based on the eponymous novel by Gonzalo Suárez, the script was co-written by the author himself, as well as by Eceiza, Querejeta and Francisco Regueiro, who would later go on to direct two Querejeta productions: *Si volvemos a vernos* (*If We Meet Again*) (Francisco Regueiro, 1967) and *Carta de amor de un asesino*. Previously second cameraman in *El próximo otoño*, Luis Cuadrado was made the director of photography for the first time in *De cuerpo presente*, and Teo Escamilla was enlisted as his assistant. This pairing would henceforth remain consistent for a total of sixteen Querejeta productions together. Again, contemporary interviews throw light on the collaborative authorship of the film. Regarding the making of the film, Cuadrado commented that he and the director had been working together since their first assignment at IIEC, while Eceiza declared that 'la imagen, en todas sus características, la inventamos entre los dos' [we create the image between the two of us in every aspect] (Monleón, 1966b, p. 9). In a more recent interview, the director has agreed with critic Jesús Angulo's assertion that Cuadrado's innovative composition and lighting technique have created a 'uniformidad formal' (formal uniformity) among the films of various directors he has worked with (Angulo, 2003, p. 281).

If *El próximo otoño* poses a critique of the uneven modernization of the Mediterranean coast, then *De cuerpo presente* is equally critical of the accelerated expansion of urban life. As in the former, the presence of an outsider captures the experience of space caught in the grip of modernization. Nelson's presence, however, does not open up the potential of space; rather, his movement through the city is trammelled by a structure of claustrophobia and anonymity. His actions are frequently complicated by the urban milieu, which appears to afflict his movement with a child-like helplessness. In its emphasis on the irrational and the absurd, the film appears to be completely at odds with the worthy exploration of reality provided by *El próximo otoño*. According to the director, however, 'the film is completely weird, but profoundly realist. Its themes were those that preoccupied us all at the time' (Faulkner, 2005, p. 209).

High-contrast lighting, where dark expressionist shadows are cast upon the urban landscape, manufactures a texture of foreboding. This effect was achieved by bouncing light off the ceiling, a technique which bears its

influence from Raoul Coutard, Jean-Luc Godard's regular cinemato-
grapher (Angulo, 2003, p. 282). Inside buildings, low camera angles
emphasize the prominence of the ceilings, thereby adding to the oppressive
texture of the *mise en scène*. The breakneck pace of editing, along with the
dizzying use of whip pans and jump cuts, form a picture of the city that is
chaotically fragmented; the conspicuous lack of establishing shots gener-
ates an overriding sense of disorientation. Shallow focus photography often
captures Nelson in close-up shots, cocooning the protagonist from his
immediate surroundings, and emphasizing his experience of alienation.

Like Juan in *El próximo otoño*, Nelson is first presented as 'un varón
crónicamente frustrado' [a chronically frustrated male]. Nervous and
sexually inexperienced, it is therefore ironic that he should suddenly
become an object of sexual desire. Announcements across the radio air-
waves warn of Nelson as the 'sátiro del pijama' (satyr in pyjamas), who is
likely to seduce any woman in sight. As a roaming mythological creature
that represents unfettered virility, the satyr is an unlikely figure for the
sexually repressed Spanish male. Indeed, the absurd comparison is height-
ened further through his emasculating choice of costume, a neatly ironed
striped pair of pyjamas. The film points to the fact that in spite of Spain's
economic development, sexual liberation was but a mere pipe dream for
most Spaniards. Indeed, the protagonist's experience of free love also turns
out to be a passing fantasy. Later on in the film, a man coincidentally falls
out of a window in the same apartment block in which Nelson is hiding,
causing the police to believe that the satyr has fallen to his death. From this
moment onwards, women cease to succumb to Nelson's charms, causing the
protagonist to cry out repeatedly '¡no soy nadie, nadie!' [I'm nobody,
nobody!].

As dream seemingly becomes nightmare, so Nelson loses himself further
within the reaches of the dystopian city. As in *El próximo otoño*, male sexual
anxiety throws into relief the tension between tradition and modernity. Like
the character of Monique, Evelyn embodies European modernity, accentu-
ated by the nationality of the French actress, Françoise Brion. Both alluring
and threatening, her cosmopolitan sexuality is as ultimately inaccessible as
the modern city. In frequently panning rows of modern apartments with
tight medium and close-up shots, the buildings are perceived as dislocated
fragments, seemingly divorced from their wider surrounding milieux. With
each edifice resembling the next, the shots point to the soulless standardiza-
tion of the modern city, where distinctiveness is rapidly usurped by drab
uniformity. The urban landscape is presented as one of unrelenting trans-
formation: building sites often figure in the external shots and, in one early
sequence, the protagonist is chased into one. Moreover, the structures of
urbanization rapidly sprawl outwards; like a set of unfurling tentacles, they
appear to engulf everything that lies in their path. At the edge of a road that

straddles the *meseta*, Nelson has reached the edge of the city – a space which is described as follows in the script: 'Nelson camina pensativo por la carretera de acceso a la fábrica. Por ambos lados, se extiende un campo yerto que, en el futuro, ocuparán, sin duda nuevas factorías.'[14] Even with the rural countryside on the horizon, escape appears to be impossible: his flight from the city is abruptly foreclosed by the arrival of two cars, driven by the gangster and his assistant respectively, which suddenly flank either side of the protagonist. A rapid zoom underlines his entrapment, as a helicopter deftly swoops down to return him to the depths of the city. Nelson is not the only character to be alienated by the city. In escaping from the gangsters, Nelson hastily climbs out of the window of one apartment and stumbles into a neighbouring one; there he encounters a corpulent, middle-aged lady who is attempting to commit suicide. The woman represents one of the two million internal migrants to be lured by the economic miracle of Madrid during the miracle years (Riquer i Permanyer, 1995, p. 263). Since her arrival, however, she has failed to adapt to the mechanized monotony of the booming service industry, and is overwhelmed by loneliness, explaining to Nelson that 'Mi vida se centra en levantarme a las siete . . . comer en la empresa . . . y en esa media hora libre siempre estoy sola . . . Yo esperaba mucho de esta ciudad'.[15]

As the narrative progresses, Nelson's experience of the city becomes increasingly caught up in the glossy simulacra of media and advertising. Eceiza has commented that he wanted to portray an entirely artificial vision of the city: 'Lo que se muestra es una visión de realidad de "slogans", de frases' (Monleón, 1996b, p. 36).[16] In emphasizing the sway these 'slogans' hold over Nelson, the film criticizes the persuasive power of modern consumerism, the very thing on which *desarrollismo* depends. Far from offering personal choice, consumerism is presented as a form of social control – a critique that recalls the central idea of Herbert Marcuse's book *One-Dimensional Man* (1964), published just one year before the film was made, in which consumerism is described as an authoritarian and dehumanizing force, which creates a perpetual state of 'unfreedom'. This is most strikingly borne out when a powerful advertising tycoon (Alberto Closas) blackmails Nelson into spearheading a publicity campaign for the new drink 'ron sin cola' [rum without coke]. According to the chief of advertising, the protagonist will become a millionaire if, when interrogated by the police, he repeats the product's slogan 'Beba ron sin cola y viva mejor' [Drink rum without coke and lead a better life]. When interviewed by a journalist, a photographer takes some photographs of Nelson, exclaiming: '¡No hable, no hable . . . su imagen es lo que importa! Cualquier imagen tiene valor. De aquí su superioridad sobre la palabra.'[17] While the advertising chief interpellates the protagonist as a commodity, the photographer regards him as a depthless image that is as unreal as the heavily constructed

environment that surrounds him. Though, like most of the films of the NCE, *De cuerpo presente* is in black and white, its final sequence is filmed in colour. When, in this sequence, Nelson finds himself trapped inside the advertising office of 'ron sin cola', the *mise en scène* appears to revel in its own artificiality: its walls are covered in a hotchpotch montage of pop art paintings and advertising posters; their alluring, saturated colours brought forward by the distinctive use of glossy film stock. As Nelson clambers through the office, running from the gangsters, a sudden whip pan shows his body jumping through a flimsy poster of a Lichtenstein painting. Cornered at last, Nelson is lowered into a barrel of red paint. The final shot of the film comprises a close-up of the barrel, which is covered with an advertising poster of the mouth of a grinning woman, whose lips are painted with a lustrous red lipstick.

Just as the artificial city has devoured Nelson, so too has the castrating threat of the modern European woman. And it is precisely this fear which also besieges the male protagonist of *El próximo otoño*. During the scene in which Monique decides to stay with Juan for a few more days, Luis Martín-Santos helped to instruct the actors so that they would understand their roles more effectively. He allegedly told Manuel Manzaneque that his character, like the average, frustrated Spanish male, is ultimately terrified of possessing a woman:

> Pero si la logra, en el momento de haberla conseguido, se aterrorizará. El terror sagrado ante la hembra, el terror a la vagina dentata. Sabe que la hembra es la más fuerte. Cree en el mito de la *mantis*. (Martín-Santos, 2004, p. 67)[18]

In both films, therefore, the anxiety towards Europeanization finds its parallel in the fear of an autonomous, female sexuality.

Spaces of resistance

The modern and shifting geographical spaces in these films can be further illuminated through the writing of Henri Lefebvre. As we have seen in the introduction, for Lefebvre, social space should not be viewed as an empty container in which events happen: he does not propose a means of analysing *things in space*, but an *investigation of space itself* (1991, p. 89). In advancing the notion of '(social) space is a (social) product' (1991, p. 26), his aim is to explore how space is socially and politically constructed. Lefebvre subsequently follows much the same path as post-structuralist theorists such as Foucault, Kristeva and Butler, who have argued that social identities are not immutable and given, but are in constant dialogue with environmental forces and hegemonic structures of power. Just as these writers privilege

identity as a site of political negotiation, so Lefebvre lays claim to the crucially political dimension of social space: 'space is becoming the principal stake of goal-directed actions and struggles' (1991, p. 410).

He demonstrates the political nature of space by breaking it down into three, interrelated moments: *spatial practices, representations of space* and *representational spaces*, which he describes as perceived (*perçu*), mental (*conçu*) and lived or social (*vécu*) space respectively. Because of their morphological similarity to one another ('representations of space', for instance, can be easily confused with 'representational spaces'), Lefebvre's three terms prove somewhat cumbersome to work with. For sake of clarity, therefore, I will refer to the key descriptions that he sets forth for each term: perceived, mental and social. Querejeta's films expose the process by which social space is produced. In drawing on Lefebvre's conceptual triad, we are able to unravel the mechanisms of this process, and show how space becomes a social and political product.

Lefebvre refers to 'spatial practice' as *espace perçu*, which is space considered as an empirical, material reality:

> The spatial practice of a society secretes the society's space; it propounds and presupposes it, in a dialectical interaction; it produces it slowly and surely as it masters and appropriates it. From the analytical standpoint, the spatial practice of a society is revealed through the deciphering of its space. (1991, p. 38)

This can be seen as the traditional way of viewing space which has dominated centuries of discourse and has focussed solely on its material dimensions. In reference to *The Production of Space*, Edward Soja suggests that Lefebvre's spatial practices 'tend to privilege objectivity and materiality, and to aim toward a formal science of space' (1996, p. 75). 'Spatial practice' therefore *perceives* the quantitative rather than the qualitative, the physical rather than the social or cultural. Perceived space, however, cannot stand alone as a concept; rather, it is locked in an ongoing dialectic with conceived space, which Lefebvre sets forth as the second moment in the production of space.

For Lefebvre, 'representations of space' are *espace conçu*, which he defines as

> the space of scientists, planners, urbanists, technocratic subdividers and social engineers as of a certain type of artist with a scientific bent . . . *This is the dominant space in any society* (or mode of production). Conceptions of space tend, with certain exceptions to which I shall return, towards a system of verbal (and therefore intellectually worked out) signs. (1991, pp. 38–9)

'Representations of space' point to the mental abstraction of place. It refers to how a place is imagined, to the thoughts that the place might evoke. As the way in which we conceive a landscape or cityscape is invariably informed

by their hegemonic representation, this kind of space can be seen as an embodiment of ideology, power and control. These are therefore 'dominating spaces', as the dominant discourse recirculates representations of spaces that become embedded in the national consciousness. In the move from perceived space to conceived space, the landscape takes on cultural and historical meaning. If the perceived landscape is a signifier, at its moment of mental abstraction it becomes signified. It should be stressed once more, however, that these two conceptualizations of space do not stand in isolation: they come, rather, to 'embody and nourish each other' (1991, p. 30), so that the perceived and conceived often blur into one.

The tightly bound relationship between material and cultural space forms the conceptual thrust of Simon Schama's *Landscape and Memory* (1995). The author goes as far as to suggest that

> landscapes are culture before they are nature ... Once a certain idea of a landscape, a myth, a vision, establishes itself in an actual place, it has a peculiar way of muddling categories, of making metaphors more real than their referents; of becoming, in fact, part of the scenery. (Schama, 1995, p. 61)

Schama offers a way of understanding how under Franco, landscape was inextricably linked with ideology. Moreover, it illuminates how ideology, in assuming 'part of the scenery', effaces itself under the guise of nature. Further to this effect, Wright argues that 'myths create and reinforce archetypes so taken for granted, so seemingly for granted, that they go unchallenged' (1993, p. 5). What Wright shows is that in spite of the blurring between perceived and conceived space, hegemony attempts to deny landscape as a cultural process, forcing it back onto the realm of perceived.

Lefebvre's paradigm lends itself particularly well to the critical analysis of film which, as we have seen, as a cultural medium is especially effective at transforming our perception of the landscape that we view around us. This is strikingly borne out in much of the popular cinema of the Franco years. For instance, in the *españoladas* directed by Luis Lucia such as *Lola, la Piconera* ('Lola, the Coal Girl') (1951), *Un caballero andaluz* ('An Andalusian Gentleman') (1954) and the Franco-Spanish production *El sueño de Andalucía* ('An Andalusian Dream') (1951), a rural and folkloric Andalucia is reimagined as a national space. A few years later, Lazaga's comedies, *La ciudad no es para mí* ('City Life is Not for Me') (1965) (see Faulkner, 2006; Richardson, 2002; García de León, 1996) and *Sor Citroën*, (1967), deflect attention away from paradoxes of *desarrollismo* by propagating the myth of a unified, rural Spanishness. These films map out an imagined community of idealized Spanish identity, which is isolated from social and historical forces. Through their adherence to the continuity style and static set design, the

landscape quite literally becomes 'part of the scenery' in these films. At first, they could be said to be taking on the dimensions of perceived space – a type of space which, as we have seen, society 'secretes' and 'presupposes' (Lefebvre, 1991, p. 38). Looking closer, however, we see that these films bear witness to the bleeding of *conceived* dominating space into *perceived* physical space. The ideologically charged landscape in Lucia's and Lazaga's films masquerades as raw, material nature, so that the representation of landscape becomes a taken for granted, naturalized reality. The transparency of the continuity style, therefore, rendered invisible the process by which nationhood was symbolically constructed, enabling the films to naturalize the patriotism and ideology of the landscape.

'Representational space' is defined as *espace vécu*, lived or social space, and constitutes the third part of the triad.

> This is the dominated – and hence passively experienced – space which the imagination seeks to change and appropriate. *It overlays physical space, making symbolic use of its objects.* Thus representational spaces may be said, though again with certain exceptions, to *tend towards more or less coherent systems of non-verbal symbols and signs.* (Lefebvre, 1991, p. 39, emphasis added)

As it is 'linked to the clandestine or underground side of social life, as also to art' (1991, p. 33), social space can be viewed as a form of resistance against the 'dominating' conceived space. Social space is inherently political in its nature: it is a 'counterspace' (1991, p. 381), a site where the struggle for freedom is able to take place. As a 'dominated' space (1991, p. 39), social space cannot exist without the dialectically related perceived and conceived spaces. Social space can therefore be defined both as the *result* of these two spheres, and as a way of *opposing* their authority. As such, Lefebvre's paradigm of social space is multi-layered, resembling a complex palimpsest made up of geographies and their concomitant representations.

Just as social spaces are 'dominated' by the sway of conceived spaces, the position of the directors of the NCE was 'dominated' by the system of state protectionism. Compromised by the conditions of García Escudero and censorship, government subsidies were a means of control, which constituted, in the words of Sally Faulkner, a 'policy of keeping your friends close and your enemies closer' (2006, p. 17). This lays particular stress on the contradiction at the very heart of the NCE: on one hand they opposed the regime, while on the other, they were complicit in it by taking their subsidies (Faulkner, 2006, pp. 14–15) and Querejeta, as we have seen, is no exception. In 1966, the producer argued in defence that 'trato de luchar contra la estructura empleando sus mismas armas' [I try to fight against the system by using its own weapons] (Monleón, 1966a, p. 6); and, more recently: 'no era el régimen de Franco el que nos utilizaba a nosotros, sino nosotros quienes les utilizábamos a ellos' [It wasn't the Franco regime that was using us,

rather we were using them] (Angulo et al., 1996, p. 30). In spite of imposed ideological constraints, the films of the NCE and Elías Querejeta PC clearly constituted a form of resistance through a cryptic visual style that intended to evade the censors. Unlike the dominant conceived spaces, social space for Lefebvre is a 'work of artistic creation' (1991, p. 43). These works teem with symbols: 'the only products of representational spaces are symbolic works. These are often unique; sometimes they set in train "aesthetic" trends' (1991, p. 42). These descriptions resonate firmly with the NCE which, as we have seen, constituted a symbolic art cinema that also drew on contemporary aesthetic trends. More specifically, central to the symbolism of the films examined in this chapter so far has been the investigation of space. Just as social spaces 'overlay physical space, making symbolic use of its objects' (1991, p. 39), so do *El próximo otoño* and *De cuerpo presente*, which sought to supplant two geographical spaces privileged by Franco's techno-crats with their own critical vision.

The film that most eloquently exemplifies Lefebvre's writing on social spaces is *La caza* (*The Hunt*) (Carlos Saura, 1965), the third Querejeta production to receive subsidies. It is also the film that most famously epitomizes both the aesthetic and political intentions of the NCE. Like Eceiza, Saura had been a student of the IIEC and in 1958, one year after graduating, he became a lecturer at the school. In first gaining experience through directing three documentaries, his early career also suggests a similar trajectory to that of Eceiza. Like several documentaries of the period, his third film, *Cuenca* (1958), was commissioned as a publicity film for regional tourism; the finished film, however, turned out to be a more of a cynical look at Francoist provincial life than a promotional tool (D'Lugo, 1991, p. 23). In a similar vein to *A través de San Sebastián*, the representation of the town departs from how it has been shaped in the national imaginary. *Cuenca* therefore signals a shift from conceived space to social space, from a site of ideology to an oppositional space of resistance.

A similar spatial strategy informs the representation of landscape in *La caza*. Its plot is well known: three veterans of the Spanish Civil War, Paco (Alfredo Mayo), José (Ismael Merlo) and Luis (José María Prada) reunite after several years on a rabbit hunt, accompanied by Paco's young nephew, Enrique (Emilio Gutiérrez Caba). As the day progresses, longstanding feelings of resentment between the three men bubble to the surface, culminating in their sudden and violent deaths; horrified, Enrique flees from the scene. As in the previous two films discussed, space is almost foregrounded as the protagonist of the film: César Santos Fontenla, at the time of its release, wrote that landscape was 'un elemento decisivo' of the film and is 'tratado con una seriedad y dotado de una fuerza absolutamente inhabituales' (1966, p. 17). Though the importance of landscape in *La caza* has also been discussed by D'Lugo (1991), Kovács (1991) and Zunzunegui

(2003), further insight into the meanings of the cultural landscape can be gleaned through the writing of Lefebvre:

The choice of location is redolent in symbolism. As Marvin D'Lugo has pointed out, *La caza* was shot at a site which once witnessed a Civil War battle similar to the one described in the dialogue (D'Lugo, 1991, p. 57). Signalling to two cavernous holes that have been dug into the valley, Enrique asks '¿Eso es de la guerra?' [Is that from the war?]. The non-diegetic sound of a steady, militaristic drum roll can be heard as José replies, 'Aquí murió mucha gente y ahora sólo quedan los agujeros. Buen lugar para matar'.[19] Filmed near the provincial town of Toledo, the rural setting of the Castilian plain points to the moral heartland of centralist Spain – a region where, as Graham and Labanyi note, many peasant farmers became the footsoldiers of Francoism (1995, p. 15). A hegemonic site of power and ideology, the symbolic landscape reveals itself as a conceived space – a space that, as we have seen above, Lefebvre has advanced as the 'dominant' cultural space of the imagination. Conceived space, however, can only exist in an antagonistic dialectic with perceived space. Just as conceived space attempts to conceal itself as a cultural process, thereby forcing itself back onto the realm of the perceived sphere of material space, so the censors attempted to efface the geographical and historical specificity of the land-scape in *La caza*. Originally named 'Bar España' in the script and adorned with a Spanish flag, the bar which features at the beginning of the film had to remove any specific reference to Spain (Hernández Les, 1986, p. 164; D'Lugo, 1991, p. 56). Moreover, any mention of the Spanish Civil War in the script had to be modified to the more generic 'la guerra' (the war) (Hernández Les, 1986, p. 164; D'Lugo, 1991, p. 56). The attempts of the censors therefore constituted a means of naturalizing the hegemonic mean-ing of the landscape, refiguring it as a perceived space – a self-effacing 'part of the scenery'.

Despite the best efforts of the censors, resistance is achieved in the film through the use of space. Cuadrado's high-contrast black and white photo-graphy, made possible by the invention of Tri-X high exposure film stock (Torán, 1989, p. 103), coupled with the natural daylight of the intense late summer sun (Llinás, 1989, p. 245), create an image of the landscape that is claustrophobic and oppressive – an observation that has been made by several critics (D'Lugo, 1991; Kovács, 1991). By means of the collaborative team's modern film language, the landscape becomes a 'social space' that 'overlays physical space, making symbolic use of its objects' (Lefebvre, 1991, p. 39). Conceived and perceived spaces are superimposed and resisted with the critical social space created by the film. Santos Zunzunegui's description of the landscape in the film as 'una geología de la historia' [a geology of history] and as a 'lugar de sedimentación del pasado' [place which bears the sediments of the past] evokes the palimpsest-like descriptions of

Lefebvre's social space as containing a structure 'reminiscent of flaky *mille-feuille* pastry' (1991, p. 86); also places of social space are 'intercalated, combined, superimposed – they may even collide' (1991, p. 88).

The landscape becomes especially prominent in the sequence where Paco and José take a siesta on the *meseta*. Consisting of two long takes, the first shot comprises a slow, extreme long shot of the landscape. For Sally Faulkner, this scene constitutes an 'idle period' which disrupts the otherwise brisk pace of the film (2006, p. 161). The formal representation of this idle period, according to the author, is meant to 'transcend narrative and challenge the viewer's perception of time, space and the body' (Faulkner, 2006, p. 163). Unmoored from the narrative flow, this scene exemplifies the modern film style of the NCE where, in the words of David Bordwell, space 'becomes foregrounded to a degree that renders it the primary structural level of the film' (Bordwell and Thompson, 1976, p. 42). Furthermore, as in *El próximo otoño* and *De cuerpo presente,* the perception of the landscape is relayed through an outsider: unlike the older men, the teenager Enrique is new to the hunting site. According to Saura, Enrique is a spectator (Bilbatúo, 1966, p. 21). Moreover, the role of a 'witness observer' is further ascribed to the boy through his constant use of binoculars and camera (D'Lugo, 1991, p. 61). Again, the figure of the outsider serves as a pretext to critically examine the landscape, denaturalizing the cultural production of space. Symbolizing the 'new Spaniard' (D'Lugo, 1991, p. 57), Enrique is linked to youthful modernity – a fact that is accentuated in his dancing with the gamekeeper's niece to the *ye-ye* pop song 'Loca juventud' on the radio. It is therefore revealing, perhaps, that immediately after the 'idle period' of the siesta, an extreme long pan of the valley from the point of view of Enrique can be seen; this is then followed by an extreme close-up through the lens of Enrique's binoculars of Luis's girlie magazine of a blonde model. The modernist break within the narrative, which provides us with the examination of the *meseta,* is therefore enunciated through Enrique's detached way of seeing. In following the landscape shot with the magazine, modernity is invoked once again in tandem with the fascination of the cosmopolitan woman.

Conclusion

This chapter has shown that from his earliest experimental documentaries, Elías Querejeta established both a regular collaborative team and a looser, more experimental film language. Through their embrace of location shooting and modern film style, his early films 'opened up' the Spanish landscape to the camera, foregrounding it as a character in its own right, with all its inconsistencies and contradictions. The landscape in their films is one of flux and transformation, and provides a compelling narrative of

the early part of Spain's miracle years. As we have seen, this project of modernization is organized spatially, and it therefore finds its ideal expression through the distinctly 'spatial' film language developed by Elías Querejeta PC. Through the writing of Lefebvre, I have shown how their films examine the production of modernizing space, and throw into relief the sharp contours of its limitations. As we have seen, the irresolvable tension between modernization and modernity – or, rather, the lack thereof – is not only played out through space, but *produced* by space, through its accelerated transformation and deregulation, and its structural inequalities and uneven organization. As we have seen in *A través de San Sebastián, El próximo otoño* and *De cuerpo presente*, these geographical changes are captured through the practices of everyday life, which articulate a social structure of anxiety and dislocation. My analysis of *La caza* anticipates the focus of the next chapter, which discusses several of Elías Querejeta PC's films that were also filmed in the region of Castile and the *meseta*, in the years that immediately followed the NCE.

Chapter 2

Spaces of Violence

By December 1967, possibilities for artistic film-making in Spain had become scarce: García Escudero left his position as director general de cinematografía, subsidies were reduced, and the category of 'interés especial' was suppressed. Just four years after its inception, the excitement which surrounded the so-called *nuevo cine español* had dissipated. As a result, several of the careers of directors who had dissipated under García Escudero's system were suddenly cut short, with a good number, such as Julio Diamante and Jesús Fernández Santos, disappearing into obscurity altogether. In spite of these considerable setbacks, Elías Querejeta PC continued to produce artistically ambitious films.

Meagre budgets and production offices in Madrid meant that the majority of his productions (excluding co-productions, a total of fourteen out of nineteen feature-length films between 1967 and 1979) were shot in the surrounding region of Castile. Although collaborating with a number of different directors, the recurring landscape of Castile lends a degree of visual unity in his productions of this period. Indeed, several of these films were shown as part of an Elías Querejeta retrospective at the National Film Theatre in London during October and November 1985. In a brochure accompanying the season, John Hopewell wrote that the insistence on certain landscapes was key to the production team's unified visual style: 'Querejeta's "look" comes from his setting locations in a worn, decaying "second" Spain of drab provincial towns, dismal plateaux, and apartment blocks which rise like red-brick washing' (1985, p. 20). Although primarily motivated by economic factors, the recurrence of this location can also be explained through the producer's own personal fascination with the region. In 1977, Querejeta began work as director on an unfinished documentary entitled *Hoyuelos*, an observational documentary about the tiny Castilian village which provided the setting for *El espíritu de la colmena*.

As well as sharing the same setting, the majority of these films also converged in their thematic exploration of violence. According to Kinder, 'by the end of the 1960s, a new language was emerging for the representation

of violence, one increasingly associated with the independent productions
of Querejeta' (1993, p. 183). As this chapter will show, this emerging
aesthetic of violence in his films is intimately linked to the landscape in
which it unfolds. In an interview about the Querejeta collaboration *Los
desafíos,* one of the co-directors, Claudio Guerín, mentioned the film's
'expresión de una violencia soterrada que puede estallar en cualquier
momento, eso es algo que está en el ambiente' (Torres, 1969, p. 46).[1]
Guerín's observation, that violence is somehow buried or hidden in the
landscape in the film, resonates with a number of Querejeta productions of
this period. As this chapter will show, the landscape of the *meseta* can be read
as a palimpsest in which the immaterial traces of a violent past appear to
haunt the present. That this violence should erupt in the location of Castile
– the centre of Spain – in particular is pertinent. In the official geographical
imaginary of the regime, the region was projected as the mythical and
ideological heartland of national Catholicism. In the construction of this
imagined space, however, all traces of rural suppression and brutality and
political dissent were forcefully erased from the landscape. The production
of space in Querejeta's films in this period therefore demythologizes the
official geography of Francoism, thus laying bare the ways in which geog-
raphy is both invisibly and inextricably bound up with ideological and
hegemonic forces.

This chapter will provide an analysis of *Los desafíos* (Claudio Guerín,
José Luis Egea, Víctor Erice, 1969), *El espíritu de la colmena* (Víctor Erice,
1973) and *Pascual Duarte* (Ricardo Franco, 1976), three films which
expose the violence of the *meseta,* as well as an examination of represen-
tation of provincial Castile in *Peppermint Frappé* (Carlos Saura, 1967),
Carta de amor de un asesino (Francisco Regueiro, 1972) and *El desencanto*
(Jaime Chávarri, 1976). I will also explore how the *meseta* is used as place
of spiritual refuge and emotional exploration for urban characters, and
will examine Carlos Saura's *Los ojos vendados* (*Blindfolded Eyes*) (1978) and
Elisa, vida mía (1977), as well as briefly investigating its function as a
backdrop to journeys in *Las palabras de Max* (*Max's Words*) (Emilio
Martínez-Lázaro, 1978), *Stress es tres, tres* (*Stress Is Three, Three*) (Carlos
Saura, 1968) and *Las secretas intenciones* (*Secret Intentions*) (Antxón Eceiza,
1970). In building on Deleuze's concepts of the 'time image' and
'impulse image', I will tease out the relationship between space and
violence in the films. I doing so, I show how a prevailing structure of
violence was integral to Franco's hegemonic control and naturalization
of geography. In exposing the complex and invisible ways in which power
and violence operate in and through space, the landscape in these
collaborations becomes a terrain of social and political struggle.

Demythologizing the *meseta*

It is difficult to mention Spain without conjuring up the rural landscape of the *meseta*, the vast, arid tableland which makes up a third of the country's surface area. Its furrowed plains, which have traditionally provided Spaniards with wheat and barley, cover most of Spain's central regions, Castile and León and Castile-La Mancha (which, before 1983, were known as New Castile and Old Castile), stretching as far as the corners of Extremadura and Murcia. Over the centuries, this iconic landscape has emerged as the spiritual centre of the nation, a marker of authentic Spanishness. Many critics have commented on the central position that the *meseta* has occupied in Spanish nation building and culture.[2] According to Kovács, 'the ruins of Castile bear witness to Spain's past glories and present exhaustion. They symbolize the drive towards unity and centralization as well as the contradictory movement towards insularity and isolation characteristic of Spanish history' (Kovács, 1991, p. 19). As is well known, Castile and agrarian life were fundamental to Francoist mythmaking: in the early years of the regime, the dictator upheld what Adrian Schubert has termed 'the sovereignty of the peasant ideology' (1990, p. 88). During the early years of Spanish fascism, the regime believed that 'people would be saved from the divisive evils of progress and returned to their 'oneness' with nature' (Labanyi, 1989, p. 38). The peasants who most embodied the values of national Catholicism were those from Castile, who were eulogized as the moral backbone of the nation. As the historian Juan Andrés Blanco Rodríguez has pointed out, Franco attributed the Castilian peasant with the virtues required of each and every Spaniard: hardiness, honesty and austerity (1998, pp. 368–9). Castilians exemplified the Spanish 'caste' at its purest (Blanco Rodríguez, 1998, p. 368), and were key to the Nationalist state-building programme, which in order to form a centralized united Spain sought to elide all vestiges of regional identity. The role which Franco ascribed to the *meseta* clearly echoed the earlier regenerationist pastoral writing of the 'Generación del 98' – namely Miguel de Unamuno, Pío Baroja, Azorín and Antonio Machado. Having borne witness to the Spanish–American war and the loss of Spain's dwindling colonies, the writers considered their nation to be in rapid decline. In order to 'regenerate' Spain and rebuild a national identity that was solid and cohesive, they believed that the true essence of the nation should be rediscovered in the plains of the region. Seizing power during the devastating and divisive Civil War (1936–9), Franco sought a similar conceptualization of the nation. Vast and spare, the *meseta* served as the ideal *tabula rasa* on which to reconstruct a unified Spain: a nation scrubbed clean of all political and regional differences and rewritten anew.

Although the importance of Castile and the *meseta* to Francoist mythmaking has come under a good deal of scrutiny, its symbolic relationship with violence deserves more critical attention. Franco's Castilian idyll would bear witness to violence and social deprivation: in order to return the people to nature, peasants were subjected to a 'repressive system of agricultural labour', where they were compelled to work the soil under the most brutal of conditions (Sevilla-Guzmán, 1976, p. 103). The main objective of government agrarian policy between 1939 and 1951 was, according to Sevilla-Guzmán, to maintain the dependence of the peasants on the large landowners who controlled the labour market (1976, p. 104). As in fascist Italy and Nazi Germany, the most direct method in the creation of this system was physical violence and intimidation (Sevilla-Guzmán, 1976, p. 104). Behind the privileged space of Castile, therefore, lay a regime of violence which concealed itself under the guise of 'la España eterna' [the eternal Spain], erasing the historical specificities of a starving, war-torn nation through the creation of a mythical geography. Culture was reduced to nature – or, to once again rely on Lefebvre, conceived space was turned into perceived space. In unpicking the ideological meanings ascribed to the *meseta*, therefore, nature and violence become inextricably linked, with the former always endeavouring to efface the evidence of the latter.

The social reality of the Castilian peasant during Spain's miracle years was strikingly at odds with its mythical status of the early years of the regime. As few measures were taken by the regime to mitigate the social cost involved incurred by mass migration, village communities were left crippled (Sevilla-Guzmán, 1976, p. 115). Most affected by this depopulation were villages of Castile, Extremadura and Andalusia (Sevilla-Guzmán, 1976, p. 118), regions whose geography is predominantly characterized by the *meseta*. Shubert demonstrates that in the Castilian provinces of Ávila, Palencia, Segovia, Soria and Zamora, the population by 1975 dwindled to less than it had been some seventy-five years earlier (1990, p. 92). This ever-widening gulf between reality and myth was explored by Spanish writers of the 1950s, 1960s and early 1970s. The social realist novels of Miguel Delibes sought to document objectively the contemporary lives of Castilian peasants; *Las ratas* (*Smoke on the Ground*) (1962), for example, centres on farmers whose land does not yield harvest. The quasi-ethnographic 'libros de viajes' (travel books) of Jesús Fernández-Santos, such as *Los bravos* (1954), explored the forgotten villages on the Castilian plains, reporting on the dire working and living conditions of its farmers. Moreover, Luis Martín-Santos's *Tiempo de silencio* (*Time of Silence*) (1961) enacted bitter critiques of the Francoist 'rural idyll' myth. While these writers' portrayals of life on the *meseta* stand in contrast to the nostalgic and patriotic lament of the Generación del 98, they also share a common aim: both groups of writers invoke the *meseta* as a way of exploring Spanishness in times of social and political unrest. The project of Delibes,

Martín Santos and Fernández-Santos would suggest some similarities with the films of Querejeta, in that their work touches on the tension between the real Castile and its mythical counterpart, between the social specificities of everyday life in the region and its privileged location within national imaginary.

Violence and space

The relationship between space and violence is theorized by Gilles Deleuze in his writing on film. In his books *Cinema 1: The Movement Image* (1986) and *Cinema 2: The Time Image* (1989), Deleuze maps the formal development of Hollywood and non-Hollywood cinema to several different categories of images and sounds. Central to his project is the theorization of the transition from classical (which he terms 'movement-image') to modern cinema ('time-image'). For Deleuze, the break between the two modes occurred after the Second World War, which saw the development of Italian neo-realism and the various new waves which followed in its wake. With the development of the time-image, Deleuze explains, 'what tends to collapse is the sensory-motor schema which constituted the action-image of the old cinema. And thanks to this loosening . . . it is time, "a little time in the pure state", which rises us to the surface of the screen. Time ceases to be derived from the movement, it appears in itself' (1989, p. xi). By 'sensory-motor schema', Deleuze means the classical style of Hollywood narrative, which privileged linear chains of cause and effect. The rational world that this creates is one in which characters are agents of action, who move purposefully and economically through space. In the cinema of the time-image, on the other hand, emphasis is shifted from rational causality to non-linear narratives of hesitation, rupture and irrational cutting.

As we have seen, Querejeta and the NCE actively sought to break away from the 'movement image' of the continuity style, and embrace a cinema of the 'time-image'. For instance, the elliptical and discontinuous editing strategies of Pablo G. del Amo, which have been discussed in *A través de San Sebastián*, *De cuerpo presente* and *Último encuentro*, would appear to bear out the irrational cutting which is so characteristic of the time-image. Characters within the time-image film are defined by Deleuze as 'pure seers' (1989, p. 41) and elsewhere as 'a kind of viewer' who 'records rather than reacts. He is prey to a vision, pursued by it or pursuing it, rather than engaged in an action' (Deleuze, 1989, p. 3). This similarly resounds with Querejeta's early productions: as we have seen in *El próximo otoño*, *De cuerpo presente* and *La caza*, space is observed through the gaze of a curious outsider.

The vast majority of the *meseta* films produced by 'la factoría Querejeta' during the late 1960s and 1970s can be viewed as a continuation of the modern time-image film which first proliferated under the NCE. Indeed, the recurring images of bare and unyielding plateaux in these films are an example of another key characteristic of the time-image film: the image of the 'any-space-whatever'. According to Deleuze, an 'any-space-whatever' is a space that has become uncoupled from the demands of the sensory-motor schema, and can be found across different categories of film. In a time-image film, this kind of space most frequently finds its expression in disconnected or emptied spaces (1989, p. 5). The philosopher draws on the films of Luchino Visconti, Michelangelo Antonioni and Yasujiro Ozu to illustrate how this kind of space is created. In the case of Visconti, 'any-spaces-whatever' are manifested through 'objects and settings [that] take on an autonomous, material reality which gives them an importance in themselves' (1989, p. 4). In Antonioni they can be 'dehumanised land-scapes of emptied spaces that might be seen as having absorbed characters and action' (1989, p. 5). In the films of Ozu, they reveal themselves in 'empty spaces without characters or movement' which may be 'interiors emptied of their occupants, deserted exteriors or landscapes in nature' (1989, p. 16). In several of Querejeta's productions, particularly *Los desafíos, Pascual Duarte, El espíritu de la colmena, Los ojos vendados* and *Elisa, vida mía,* the frequent images of the *meseta* are often surplus to the demands of the narrative, and are thus formally rendered as an 'any-space-whatever'.

For the purposes of this chapter, the most relevant category of film which Deleuze establishes is that of the impulse-image, a cinema of cruelty which contains and expresses acts of unmotivated violence. His writing on the impulse-image is particularly useful as it sheds light on the tightly inter-woven relationship between space and violence in the films discussed in this chapter. According to Deleuze, this kind of cinema is strongly associated with naturalism. As in its literary counterpart (in the work of naturalist novelists such as Emile Zola, Frank Norris and Theodore Dreiser), the naturalist film revolves around characters who are victims of external forces and originary impulses (Deleuze, 1986, p. 127). Moreover, as so often occurs in the naturalist novel, the narrative of the impulse-image is defined by paths of attrition, decline, degradation, loss or destruction (Deleuze, 1986, p. 127). The Querejeta productions under scrutiny in this chapter, which all share a similar vision of brutality and entropy, lend themselves particularly well to Deleuze's description of the impulse-image. The major-ity of the films revolve around the theme of murder: *Stress es tres, tres, Los desafíos, Elisa, vida mía, Pascual Duarte, Carta de amor de un asesino, El espíritu de la colmena* and *Los ojos vendados.* Moreover, with the exception of these last two films, which depict killings organized by the state, the murders in these films are largely represented as unmotivated. Several characters in the films

under scrutiny encounter a melancholy sense of loss, brought about either through the legacy of the Civil War (Ana and her family in *El espíritu*) or by the later demise of Francoism itself (the Panero family in *El desencanto*). Destruction finds its most extreme expression in suicide, a theme which fascinates Querejeta, and occurs again and again in several of his productions; *Las secretas intenciones, Los desafíos, Las palabras de Max* and *Carta de amor de un asesino.*[3]

According to Deleuze, the violent forces and impulses do not derive from the diegetic world of the film but from the 'originary world', a primordial space of cruelty and violence. These two worlds – the world represented within the film and the originary world – should not be viewed as isolated from each other: 'the originary world does not exist independently of the geographic and historical milieu that serves as its medium' (Deleuze, 1986, p. 129). As a result, residual traces of the orginary world can often be found in the real world and, when this occurs, they manifest themselves in sudden irruptions of violence. This explains why violence appears to be sparsely motivated: rather than examining the psychology behind the crime, the films appear to point externally to originary space as its source. John Hopewell has recognized the importance which has been ascribed to setting in Spanish films: 'Actions in many Spanish films seem undermotivated . . . the driving force of conduct lying outside the film is Spanish history itself. Hence the extreme importance of background detail and secondary characters in Spanish films' (Hopewell, 1986, p. 28). It follows that Sally Faulkner has drawn on Hopewell's observation to show how space is the motivation behind the violence in Querejeta's production *Pascual Duarte* (2004, p. 58). In this film, Faulkner argues, the representation of rural space is portrayed in a hostile way so as to 'debunk the Francoist myth of nature and, by implication, attack the entire ideology of the regime' (2004, p. 49). Faulkner's analysis of rural space in *Pascual Duarte* can also be extended to the other Querejeta productions examined in this chapter. In applying the theory of the impulse-image to the twelve films, further insight can be gleaned into Querejeta's political production of space.

Various similarities can be seen between Deleuze's 'originary space' and Lefebvre's theories of spatiality. As a pre-social realm of violence, originary space would suggest parallels with Lefebvre's perceived space of nature, on which the natural Spanish origin and essence was projected through violence. Moreover, just as the originary world is inseparable from the geographical and historical milieu in the film, so perceived space depends on the existence of conceived and lived spaces. Deleuze's description of the space within the impulse-image as milieux which 'constantly emerge from the originary world and retreat into it: they only barely emerge from it, like sketches which are already doomed, already scribbled over' (1986, p. 129) chimes with Lefebvre's descriptions of social spatiality as a palimpsest of

intercalated, heterogeneous spaces which bleed into one another. Similarly, it is through the tension between the originary and the diegetic world in film that brutality manifests itself: 'The originary world only exists and operates in the depths of a real milieu, and is only valid through its immanence in this milieu, whose violence and cruelty it reveals' (Deleuze, 1986, p. 129). Just as traces from the originary world haunt the profilmic world, so the suppressed legacy of violence haunts the space of the *meseta.*

The impulse-image film is defined by 'constant predator–prey relation-ship[s]' (Deleuze, 1986, p. 132). According to Deleuze, prey in these films may also be 'predator and the non-satisfaction of the impulse' (Deleuze, 1986, p. 133). This blurring between predator and prey corresponds to the blurring between humans and animals, which also characterizes the impulse-image film. Actors resemble animals ('human-animals'), driven by brute forces in a world of inevitable and violent material forces and impulses (Deleuze, 1986, p. 128). This is because the impulses that they embody proceed from the originary world, in which there are no clear differentiations between animals and humans (Deleuze, 1986, p. 128). Again, Deleuze's theory resounds strikingly with the Spanish context: Hopewell has commented that 'film-makers return time and again to the brutality of the Spaniards, their residual animality of conduct, with an insistence even on the same broad metaphor – human relations as a hunt' (Hopewell, 1985, p. 27).

So far, the impulse-image would appear to define several of the character-istics of Querejeta's *meseta* productions. This category of film, however, does not fall into the mode of the modern time-image but into that of the classical movement-image, a style which, as we have seen, was largely anathema to Querejeta and the NCE. Nevertheless, this should not be viewed as an obstacle. Pisters argues that original violent impulses can also be visible in time-image films (2003, p. 82). This is because in the impulse-image film 'time makes a very prominent appearance in the cinemato-graphic image' (Deleuze, 1986, p. 130). Indeed, in its narratives of degradation, destruction and loss, the impulse-image 'only grasp[s] the negative effects of time' (Deleuze, 1986, p. 132). In the *meseta* films, more-over, its prominence is also grasped in the *mise en scène* of crumbling, weather-beaten buildings, which the onslaught of time has transformed into part of the landscape itself. The sharply delineated texture of the rough land, and the sheer weight and volume of the buildings are thrown into relief by the cinematography of Luis Cuadrado and Teo Escamilla (see Introduction). As we have seen, critics have drawn comparisons between Cuadrado's style and the sparsely lit compositions of Spanish tenebrist painters such as Goya, Murillo, Ribero and Velázquez (Kinder, 1993, p. 474; D'Lugo, 1997, p. 143) and Zurbarán (González Requena, 1989, p. 139). The influence of the latter artist has been noted elsewhere in several earlier

Spanish ruralist films, such as *Las Hurdes* (Luis Buñuel, 1932), *La aldea maldita* (Florián Rey, 1942), *Condenados* (Manuel Mur Oti, 1953) and *Viridiana* (Luis Buñuel, 1961), in which the landscape takes on 'ciertos valores zurbaranianos: un estatismo casi absoluto y, sobre todo, intemporal, denso e inmune al paso del tiempo' (González Requena, 1989, p. 25).[4] The landscape in the *meseta* film, which as an originary space privileges nature over history, also lends itself well to this description. The image of stasis within the films, however, also arguably points to the *inmovilista* lethargy which from the mid-1960s had set into contemporary Spanish politics, with many of Franco's technocrats doubting that Francoist ideology would outlive the leader's death (Grugel and Rees, 1997, p. 74).[5] Dogged by long-term health problems and advanced senility, the rapidly deteriorating body of Franco would also become prey to the ravages of time. As the years of *desarrollismo* wore on, El Caudillo would become more frequently absent from public life: from a rapidly modernizing Spain, he somewhat fittingly sought refuge in the timeless realm of nature, hunting in a remote sierra (Preston, 1993, p. xviii). In light of Deleuze's theory, the analysis of the films which will follow focusses predominantly on the three interrelated areas which characterize the impulse-image: the relationship between originary space and violence, animal imagery and the negative effects of time, manifested through either degradation or stasis.

Exposing the violence of the *meseta*

Of the films discussed in this chapter, *Los desafíos*, *El espíritu de la colmena* and *Pascual Duarte* are the films which concern themselves most with the harsh brutality of agrarian life on the *meseta*. Limitless and vast, the emptiness of space in these films does not so much point to freedom as it does to a regime of brutal suppression. Made in 1969, *Los desafíos* stands out as one of Querejeta's most experimental projects. A portmanteau film, it consists of three separate episodes, each directed by a young graduate from the EOC: José Luis Egea, Claudio Guerín and Víctor Erice. Each section revolves around an American tourist (played by Dean Selmier in each part), whose appearance ruptures the equilibrium of each situation. As in the earlier films *El próximo otoño* and *De cuerpo presente*, the arrival of an outsider throws into relief the repressive mores of Francoist Spain.

The second episode (Claudio Guerín) revolves around a young American couple, Alan (Dean Selmier) and Bonnie (Barbara Deist), who trespass on the ranch of a wealthy Segovian landowner (Alfredo Mayo). Alan offers his girlfriend to the *patrón* for fifty dollars, and while they make love the protagonist attempts to seduce his wife, Lola (Julia Gutiérrez Caba) by giving her the same fifty dollars. Presiding over the vast *meseta*, the wealth

and power of the landowner is clearly articulated through the distribution of space. Looking out of their attic window, Lola points out the dramatic vista below to Alan. She intimates that all 6,000 hectares of the *latifundia* belong to her husband, as a slow aerial pan alerts us to the sheer size of the land. This is set in sharp contrast with the previous scene, where the home of the master's steward, Benito (Fernando Sánchez Polack), is seen: a small rickety shack in the corner of the settlement. Even this, however, must be given over to his master within a moment's notice: located beyond the reach of his wife's gaze, the hut makes an ideal love nest for the *patrón* and Bonnie. On their way to the hut to make love, Bonnie stops to touch some chickens which are locked in a coop. The caged birds mirror the entrapment of the downtrodden servant, who is represented as a landless serf, ever dutiful to his master. The historian Sevilla-Guzmán writes that neo-feudal power structures were still very much at the fore in the 1960s, where social problems brought about by migration diverted attention away from the exploitation which persisted in large estates. Moreover, between 1952 and 1964, writes the author, Franco actively maintained – and even reinforced – the traditional system of *latifundista* class exploitation (Sevilla-Guzmán, 1976, p. 112). It comes as no surprise, then, that the treatment of the farmer touched a nerve with the board of censors: a shot that further emphasized the servant and his family walking away from their home was forbidden, along with any representation of 'cualquier dato que refleje la humillación de estos asalariados' (Hernández Les, 1986, p. 175).[6] Described by one critic as 'el proletario de las películas mesetarias' [the proletariat of the *meseta* films] (Méndez Leite, 1969, p. 124), the actor Fernando Sánchez Polack also appeared as Juan, the downtrodden Castilian gamekeeper in *La caza* (see chapter 1) and the compliant valet in *Stress es tres, tres*. Indeed, the actor's weathered face, with his sharply drawn wrinkles and the deep grooves of his forehead mirror the furrowed land on which he works, almost as if he were an integral part of the landscape. Described in the script as 'mirando con resignación' [with a look of resignation], the subjugated figure of Benito is clearly at odds with the heroic model of the Castilian peasant, which was endlessly eulogized by the regenerationist writers and early Francoism. According to Daniel Grier, this attitude of resignation is a typical trait of those who work on the *meseta*, traditionally owing to the region's unpredictable weather, the vulnerability of the agrarian market, and a blind respect for authority figures (Grier, 1997, p. 90).

If the character Benito is linked to the caged chickens in the films, his master is associated with the bull. Before making love to Bonnie, the landowner introduces her to his most virile bull, El Zar. He tells Bonnie that the bull is the national symbol, explaining that the map of Spain resembles a bull's hide stretched out on the ground. In reimagining the cartographic space of Spain in the shape of the hide, the bull is not merely a signifier for

the landscape and the nation, but is reified as a material part of it. The vast plateau, in which the patron's bulls freely roam, therefore stands as a synecdoche for the nation. The iconography of the bull not only suggests an analogy with the land, but is exploited for its well-trodden symbolism of Spanish masculinity. He tells Bonnie that he envies the animal because 'es un semental: la sangre más noble, más brava y más fecunda de toda la ganadería. Cuando se encierre con cuarenta vacas no sale hasta tener experiencias sexuales con todas'.[7] The free reign of the patron's masculinity, however, soon comes under siege: the *latifundia* becomes a sexual hunting ground, in which the hippy free love of the Americans is pitted against the hypocritical polygamy of the Spanish male. Led to believe that his wife has also experienced free love with Alan, the *patrón* becomes furious and hits his wife. Unable to validate his masculinity through the exercise of authority over his land, he immediately resorts to violence: mounted on horseback, both he and Benito charge at the couple, impaling them with tilted spears. Benito sets fire to their multicoloured camper van, which is emblazoned with the slogan 'Civil Rights', and a ritualistic drum sound, as if evoking a Spanish religious festival, accompanies several different shots of the burning vehicle. In removing the modernizing liberalism that the Americans symbolize, tradition is violently restored to the *meseta*.

In the third section of the film (Víctor Erice), a group of young hitch-hikers, comprising American soldier Charlie (again, Dean Selmier), María (Julia Peña), Floridita (Daisy Granados), Julián (Luis Suárez) and their pet chimpanzee Pinky, arrive at a deserted village. The deserted village, whose remoteness is foregrounded through several panoramic shots of the endless surrounding landscape, is presented at once as eerie and unwelcoming. The non-diegetic music of electronic sounds, dissonant and strange, further accentuates the unfamiliarity of place. A ghost town that time has forgotten, the *meseta* recalls an otherworldly landscape from a science fiction film. Indeed, when they arrive at the village, Julián asks for their whereabouts while getting out of the car. A disorientating freeze-frame suspends the action in the scene, and the off-screen voice of María can be heard, responding that they are 'en la luna' [on the moon]. The following shot is of a lake, whose brilliant surface shimmering in the sun recalls the face of the moon. Charlie later says 'en este pueblo todos están muertos' [everyone is dead in this village]. The village in which they find themselves is representative of many Castilian villages and settlements which were abandoned because of heavy flows of migration.

The empty location provides the setting for a carnivalesque reversal of roles, as Pinky, the chimpanzee, becomes increasingly attributed with authority in the film. For instance, on the balcony of a building, Pinky holds a cigar while the visitors pretend that he is a president. Holding up one of the animal's arms, Charlie announces: 'El presidente ha dictado una nueva

ley: el amor es libre' [The president has passed a new law: love is free] as the others start to cheer. However, as in the second episode, free love is unable to exist within the wild terrain of the *meseta*. The apparent enlightenment of Pinky soon finds its negative image in the two men: as they violently jostle for the position of alpha male, the chimpanzee reads the Spanish transla-tion of Darwin's *On the Origin of Species*. Charlie becomes increasingly jealous as Floridita and Julián become lovers, and in an unexpected turn of events, suddenly blows up his fellow travellers and himself with dynamite, while saving Pinky. Again, Castilian space provides the setting for the violent impulse image, in which the roles of animals and humans, the exploiter and exploited, are ironically blurred.

The Castilian landscape is one of the most enduring images of Víctor Erice's first full-length feature, *El espíritu de la colmena* (1973), the most critically celebrated Querejeta production to date. Within this vast plain hides a republican fugitive, whom Ana (Ana Torrent), a young girl with a vivid imagination, believes to be the incarnation of Frankenstein's monster. In one particularly memorable scene, the immense landscape is filmed from a ridge above, as Ana and her sister run towards the abandoned sheep pen in the distance. Their movement through the *meseta* can be seen through a series of elliptical dissolves, their bodies increasingly more minute with each shot. In the final shot, the girls have seemingly disap-peared altogether into the landscape, as the dappled textures of light and shadow shift across the plains. Here, the image of the landscape vividly emerges as an 'any-space-whatever', an element that is autonomous to the fiction. Elsewhere, formal components in the film work together to imbue the *mise en scène* of Hoyuelos and the surrounding *meseta* with a strikingly static quality. The frequent use of protracted long shots, discrete camera movements and tableau-like frontal framing emphasize the fixity of space. Most often, space precedes action in the film: the lens is held steady as actors wander in and out of the frame. This creates a 'frozen' visual style, which not only alerts us to the importance of space, but provides a poetic meditation on the nature of time. The presence of time in the film is palpable: the ruined buildings, the long periods of silence which punctuate dialogue, and the vast landscape, all emphasize the presence of time unfolding on the screen.

The timeless, frozen landscape, however, is given an approximate histor-ical frame in the opening sequence. While the credits show the words 'Érase una vez . . . Un lugar de la meseta castellana hacia 1940' [Once upon a time. . . Somewhere in the Castilian meseta around 1940], the camera pans a vehicle as it cuts through the plateau and enters the tiny village. As the van disappears behind some buildings, the camera moves onto the side of the road, where a sign marked 'Hoyuelos' stands in front of a building whose

wall wields the Falangist yoke and arrows. As the crucial opening establishing shot suggests, Hoyuelos, like any other Castilian village in the 1940s, is under the iron fist of the Falange. The film's endless and vast horizons thus stand as a monument to life under the regime, thereby evoking an atmosphere of alienation and oppression. Kovács has eloquently observed the film's many images of 'claustrophobic enclosure and imprisonment' (1991, p. 28), writing that 'in this landscape, human figures appear dwarfed, not by any imposing buildings or mountains, but by the sheer emptiness of the space and the vastness of the silence' (1991, p. 31).

El espíritu de la colmena conceals as much as it reveals. Its skies and mountains, which are covered by perpetual clouds and mist, offer a poetic reflection on the characters, whose motivations in the film are purposefully obscured. Ana and her family are often illuminated by the yellow-coloured filtered light of the hexagonal, honeycomb-shaped window. Vicente Molina Foix has explored the metaphorical possibilities of the window and the beehive, where 'each character is confined in his or her own beehive, in his or her own separate world' (2000, p. 108). The architecture of the family house, both internal and external, eloquently conveys this separation: in one scene, a long shot captures Ana's body within a series of three door frames; in another, where Teresa calls out to Ana on the balcony after she has run away, a fortress-like external wall, complete with imposing turrets and flanked by line of tall trees, shelters the building from its surroundings. The geometrical structure of the beehive similarly informs Pablo del Amo's distinctive use of editing which, in avoiding the spatial continuity characteristic of most narrative films, creates a jigsaw of almost seemingly autonomous scenes, which Rob Stone describes as 'self-contained units that fit together like the cells in a hive' (2002, p. 90). Similarly, the formal properties of editing are mirrored through Luis de Pablo's modernist, web-like score: its motifs and phrases are like the hexagonal pieces of the window, repeatedly folding in on themselves. Through its echo and reverberation, the sound design evokes the spatial depth and emptiness of the landscape. Like the editing, the music underscores the dynamic of repetition and fragmentation; as such, our experience of the film is not so much by means of a linear narrative, as it is through a patchwork of repeated and disconnected 'any spaces whatever'. Paul Julian Smith has observed the importance of off-screen space in the film (1999, p. 110), a dynamic which further reinforces the autonomous structure of space. For instance, we hear the acousmatic sound of a distant train when Teresa (Teresa Gimpera), the mother, writes her letter, and later when she pretends to be asleep. A static camera captures Teresa and Fernando (Fernando Fernán Gómez) in two short scenes leaving the village in a van and by bicycle respectively, and elsewhere the iconic image of the train tracks which, according to Kovács, lead to an endless vanishing point (1991, p. 31). These sounds and images

all lead us to consider what lies beyond the confines of the frame, an effect which is compounded further by the frozen aesthetic of the film. Neil Burch, who refers to off-screen space as 'espace-hors-champ', writes that 'the longer the image deprives us of an action, body or object that holds our attention . . . the more likely we are to wonder what is happening outside the frame' (1973, pp. 41–4). What lies outside the frame, however, remains inaccessible to the viewer throughout, in the same way that the horizon is positioned beyond the reach of the residents of Hoyuelos. Off-screen space works to emphasize the geographical and social isolation of life on the *meseta* and, by extension, Spain in the 1940s. As the exotic yet immobile origami birds on Fernando's desk suggest, mobility and escape are only possible within the realms of the imagination.

The landscape in the film is both simultaneously real and fantastical, material and subjective. The central theme of *El espíritu de la colmena* is the creative power of the imagination. In an early scene, Ana watches James Whale's 1931 *Frankenstein* in the village cinema, and is mesmerized by the monster. Her sister, Isabel, tells her later that night that Frankenstein's monster is really a spirit, who is able to take on a human form. When encountering a republican fugitive hiding in the abandoned cottage, Ana believes him to be the spirit of the monster. As the opening credits strongly suggest – a series of children's coloured drawings of the characters, places and objects that populate the film – the film is focalized through the consiousness of a child. Significantly, the final picture that appears in the credits is of the village cinema, with the camera zooming in on the cinema screen, so that the drawing fills the entire frame. From the outset, then, the importance of seeing is foregrounded in the film: we are invited to see the world through the eyes of Ana, and are thus made complicit in her sense of wonder and creative imagination. But this image also suggests that the film's real centre of consciousness is the medium of cinema itself and the magical dream-like but ultimately duplicitous power that it can hold over its audiences. As Isabel tells her younger sister, 'en el cine todo es mentira' [in cinema everything's a lie], a comment that has particular resonance, given the Francoist codes of censorship during the 1940s.

This sense of revelation and wonder is also carried over into Ana's engagement with her everyday surroundings. The landscape provides an environment of open-ended play for the children, where their imagination is stimulated not only through sight, but through the senses of touch (for instance, the texture of the mushroom and the rim of the well) and sound (the vibration of train tracks). The landscape is a place of exploration and discovery, which, through their sensory engagement, gives free rein to their imagination and creativity. For Ana, in particular, the landscape is a projection of the film; it serves as a material extension of her fantasy. The discoveries of both the monster and the *maquis* are located deep within the

landscape: the former at a river's edge (much like the one that appears in Whale's film), the latter in the abandoned sheep pen, located in the isolated, windswept reaches of the *meseta*. Ana's movement within her environment is mysteriously transformative: it is as if her repeated journeys to and from the abandoned building leave deep but invisible tracks in the furrowed earth. The acute intensity with which a subject experiences their surroundings is a typical feature of the time-image film, which is often brought into relief through the appearance of children. For Deleuze, children in cinema are 'affected by a motor helplessness, but one which makes [them] all the more capable of seeing and hearing' (1989, p. 3). Ana is similarly positioned as a passive agent, whose confusion and vulnerability are central to the film's emotional power. Indeed, her ability to 'see' is felt most acutely when she is at her most disorientated, at the river's edge. In the cinema of the time-image, it is 'essential that not only the viewer but the protagonists invest the settings and the objects with their gaze' (1989, p. 4). As a 'seer', Ana's intense gaze imbues many of the film's images (the cinema screen, the beehive, the bonfire and, of course, the landscape) with a mysterious and revelatory quality, producing an effect that echoes in the mind of the viewer long after the film has ended.

As Hopewell has observed, Ana's curiosity about death arises from the fact that the version of *Frankenstein* shown in the village is, like most Hollywood films under Franco, censored: the pivotal scene, where the monster drowns the girl, is cut from the Spanish version of the film (Hopewell, 1986, p. 208). References to violence and death were actively suppressed by the regime in the 1940s. The trauma of the Civil War, and evidence of the murder and torture of dissidents in the following years, were actively erased from the Spanish cultural and historical memory. The civil guards soon discover the *maquis'* hiding place, and shoot him repeatedly inside the sheep pen. Represented in an elliptical night-time scene, the shooting is concealed by the external walls of the building, and indicated only through the muzzle flashes and noises of gunshots. The act of violence is thus hidden from the camera, in the same way that the scene from *Frankenstein* is concealed from public view. Again, the location of the *meseta* is significant: purged of all political resistance, the national landscape becomes a clean slate, where the act of cleansing, by necessity, erases itself. While officially 'absent' from Francoist discourse, death and violence are always close to the surface in Ana's and Isabel's world. The impulse-image manifests itself in several objects in the film. In one scene, Isabel dances over a bonfire, while in another Ana touches a deadly mushroom that their father has warned them about. In her bedroom, Isabel squeezes her cat so hard that it scratches her. Looking transfixed at her own reflection in the mirror, she smears her lips with her bloody finger. Her reflection dissolves into an image of the painting of Saint Jerome in her father's study, where

the camera lingers on the portentous figure of a skull. As with other Querejeta collaborations of this period, traces of the originary world haunt the representation of the *meseta*, revealing the censored violence on which Franco's 'España eterna' was built.

Of all Querejeta's productions, the *meseta* finds its most violent expression in *Pascual Duarte*, a film adaptation of Camilo José Cela's *La familia de Pascual Duarte* (1942). Set between 1882 and 1937, the film provides an unflinching examination of rural life in Extremadura, a historical and geographical context beset by austerity and feudalism, which culminates in the outbreak of the Civil War. Like the novel, the film centres upon the eponymous Pascual's (José Luis Gómez) descent into seemingly unmotivated violence. The narrative is conveyed in flashback, as we see the protagonist shoot his dog, hack a mare to death, shoot his sister's lover and pimp El Estirao, his mother, and finally the village landowner Don Jesús. As in *El espíritu de la colmena*, the frequent use of extreme long shots and long shots lays a particular emphasis on the landscape, and in many sequences, space similarly precedes action within the frame, with the camera lingering on the *mise en scène* after the action has ended. The austere style of the film, which is marked by an emotional and dramatic restraint and long periods of silence, encourages the viewer to read the film spatially rather than narratively. Indeed, Kovács has observed that the film's *mise en scène* 'dominates the characters and determines their actions and reactions', and that these long shots, as well as the 'small dimensions of the characters, and the vast spaces that engulf them . . . augment the impression that these people are overwhelmed by their environment' (1991, p. 27). As the director himself has pointed out in the introduction to the published screenplay of the film: 'Pero tan importante como esa violencia era para mí la desolación del medio en que ésta tenía lugar' (Lázaro, Querejeta and Franco, 1976, p. 104).[8]

In presenting events of Pascual's life in flashback, the narrative structure of the film emphasizes the notion that he is predestined to lead a life of hardship and violence. Indeed, at the beginning of the novel, Pascual Duarte, the narrator, acknowledges his predestiny: 'esa seguridad de que mis actos habían de ser, a la fuerza, trazados sobre surcos ya previstos, era algo que me sacaba de quicio' (Cela, 1963, p. 21).[9] As Pascual writes, the certainty that he has to follow paths, or to follow the Spanish more literally, 'surcos' (furrows) that have been chosen for him forges a connection between predestiny and his surrounding rural environment. This theme is established in the opening sequence, where a series of long and extreme long shots frame the protagonist with his hands tied, flanked by two guards. A cutaway to the dramatic landscape, silent and still, whose vastness dwarfs the figure of Pascual, foregrounds the indifference of nature to his plight. One of the guards rolls a cigarette for Pascual and places it in his mouth; a

tight close-up of Pascual's face shows his unsuccessful attempt at smoking it, with the cigarette falling to the ground. Here, the tightly trammelled and closely regulated movement of the protagonist underscores his absence of agency. Elsewhere, the sparse but striking use of close-ups serves to convey his sense of fragmentation. For instance, the camera registers Pascual's feet in the scene in which he kills the dog, and later his hands, as he loads the gun in order to shoot his mother. The close-up articulates his psychic separation from the social world that he inhabits, where his unmotivated actions are divorced from rational thinking. Elswehere, deep-focus photography articulates his inability to shape or determine the events that unfold around him. When in the family home, as El Estirao tells Pascual's mother that he is taking his beloved sister away to Trujillo, the camera lingers on the door frame, through which the sister can be seen embracing Pascual in the distance, before leaving him bereft and isolated in the landscape. The interplay between foreground and background in this scene therefore emphasizes the motor helplessness of Pascual: he is a passive agent who, rather than in control of the narrative, is swept along by it.

The film resists psychologizing – or humanizing, even – the character of Pascual. As Faulkner has observed, the film's sparse use of dialogue, long takes, long shots and use of static camera 'erect a Brechtian distance between spectator and film, negating any possibility of identification' (Faulkner, 2002, p. 59). In interior sequences, his face is frequently cast in a pronounced play of shadow and light, thereby concealing his facial expressions and withholding the opportunity for identification. Elswehere, the camera tends to decentre his body, or frame him from a distance. His absence of interiority impels the viewer to look elsewhere for the motivations behind the killings. As we have seen, Faulkner has argued that the landscape, in appearing in long shots which precede both the killing of the dog and the mare, can be seen 'as the only motivation behind these actions' (2004, p. 58). The visual language of the film, therefore, indicates the presence of Deleuze's impulse-image, whereby the primordial drives pass from the space of the landscape to the scenes of murder. This accounts for the sparsely motivated narrative: the plot and the characters appear to be secondary to the actual impulse itself. These impulses or drives are further signalled by the use of music in the film. Luis de Pablo's minimalist score, which consists of a cycle of repeated motifs played on wooden percussive instruments, can be heard either in scenes that immediately precede or follow Pascual's killings. In its limited range of notes and strong emphasis on percussive repetition, the score evokes the sound of music in its most 'primitive' character, and according to Kinder, 'helps to ritualize the most excessive acts of savagery' (1993, p. 186).

This resonates with the character of Pascual, who, according to the director, Ricardo Franco, is 'a pre-cultural being who cannot distinguish

between good and bad' (cited in Mínguez-Arranz, 2002, p. 91). If his character lacks interiority, this arises partly because an ambiguity is established between humans and animals in the film. This is expressed through the actor José Luis Gómez's boorish gait and physical performance, where the camera observes his bodily gestures and postures with a silent, anthropological distance. Either inscrutably blank or uncomprehending, emotions are not so much expressed in his face as enacted through his body, lending his character a distinctly primitive quality. A conspicuous use of framing sets up a thematic parallel between animals and humans in the film. In one early scene, the young Pascual accompanies his father on a visit to a farm in which the latter inspects a sick pig. As an observant 'seer', characteristic of the time-image film, the child looks curiously at the pig, whose body is shown through an eye-line match. A little later on, the young Pascual inspects his new-born baby sister with the same curiosity; her body, laid out on the crib, graphically rhymes with that of the pig. The compositional similarity of the two scenes, which thematically pairs humans with animals, is echoed elsewhere in the separate sequences in which he shoots his dog and his mother at point-blank range. In the first, a static two shot captures Pascual sitting to the right of frame opposite the dog; in the second, another two shot registers Pascual sitting at the left of the frame opposite his mother. In both scenes, duration is felt vividly: several seconds linger before and after the shootings, thereby emptying out the violence of its dramatic potential. The unflinching, immobile camera, and the conspicuous absence of cutaways that are usually characteristic of violent scenes in film, encourage a contempletation of the ethics of violence against animals and humans alike. This blurring between humans and animals, predator and prey, is a characteristic feature of the impulse image, in which both are driven by the same violent forces (Deleuze, 1986, p. 128).

Provincial Castile

While the Castilian countryside provided the 'Movimiento' with poetic and spiritual guidance, its provincial towns such as Ávila, Palencia, Valladolid and Zamora were home to many of its political and miltary elite (Blanco Rodríguez, 1998, p. 370). For Franco, the Castilian provinces were almost as ideologically important as the countryside. Indeed, the leader himself had spent much of his youth in Toledo, a town which for him was symbolic of the greatness of imperial Spain (Preston, 1993, p. 9). Alongside the Spanish cities during the miracle years, when European influences brought with them a degree of cultural change, the Castilian town appeared even more anachronistic and parochial. Comprising an ageing population which was largely untouched by the tourism of the coasts, *desarrollismo* barely even

reached the provinces (Pardo Pardo, 2003, p. 211). Asfixiating and static, the provincial town in *Peppermint Frappé, El desencanto* and *Carta de amor de un asesino* therefore provides the ideal setting for the nurturing of the impulse-image.

Peppermint Frappé centres on Julián (José Luis López Vázquez), a sexually repressed radiologist who becomes infatuated with Elena (Geraldine Chaplin), the English girlfriend of his childhood friend Pablo (Alfredo Mayo). Unable to contain his jealousy, the protagonist pours poison in the couple's favourite drink, Peppermint Frappé, places their inert bodies in their own car and pushes them over a cliff. Julián, who lives during the week in an apartment in Cuenca, spends weekends and holidays at what he affectionately calls his 'refugio', a building next to a disused spa in the countryside. Despite its idyllic location, the *mise en scène* of the villa would suggest that Julián has brought all the signs of contemporary urban living with him: white painted walls, minimalist decor, curved edges, functional furniture, a glass coffee table. His leather armchair, which resembles the driving seat of a sports car, suggests a frenetic desire for speed and mobility which is ironically at odds with his stolid pace of provincial life. In contrast, his apartment in Cuenca bears evidence of all the trappings of traditionalism: lugubrious colours, heavy mahogany and neo-baroque furniture abound.

On visiting the spa for the first time since his childhood, Pablo remarks: '¡cómo ha cambiado aquí!' [It's really changed around here!]. The building is in a state of picturesque disrepair: its crumbling walls, with tangled ivy climbing out of the cracks, have seemingly absorbed the autumnal hues of the nearby trees. Inside, old broken furniture and shards of glass are swathed in cobwebs and dust. In showing the couple around the grounds of the building, Julián's arcadian hideaway reveals itself as something altogether more sinister: their return to their childhood unearths memories that are not so much innocent as brutal. Julián shows Elena where they used to play as children, commenting that 'nos creímos en la selva' [we thought we were in the jungle]. Shortly after, Pablo digs up the skull of a pet dog they buried as children, which died after it was mysteriously poisoned. The death of the animal is portentous: Pablo and Elena will also soon be intoxicated in the same space by Julián's deadly cocktail, Peppermint Frappé.

Elena finds a copy of Antonio Machado's *Poesías Completas* on the bookshelf of the *refugio*, and Julián begins to recite 'Yo voy soñando caminos de la tarde' [I walk dreaming paths]. Like the regenerationist poet Machado, Julián likes to stroll alone in the Castilian countryside, silently contemplating the landscape. Ironically, however, the character of Julián epitomizes precisely what Machado most severely criticized: the insularity of Castile. According to Arthur Terry, Machado was critical of 'the mediocrity of those who pass for great men' who, haunted by the past greatness of Castile, were largely indifferent to outside influences (1973, p. 26). As in *Los desafíos*, it is

precisely the threat of European modernity which the protagonist seeks to destroy. In rejecting the book as a gift, Elena ridicules Julián's provincialism. The presence of Pablo, who frequently works abroad as a property developer, throws into further relief Julián's parochial attitude. A business partner of Elena's English father, he exemplifies the post-*apertura* Spain of deregulation and European free trade. In encouraging his friend to convert the spa into a tourist development ('no se hace nada especulando con los terrenos ... hay que construir'),[10] he attempts to transform it into an international space.

Pointing to the dance floor outside the spa, Julián reminisces over the beautiful women that as a child he would see dancing there. Incredulously, Pablo laughs: '¡Ya lo creo! ¡Era todo un espectáculo! Reumáticos, artríticos, con cálculos en el riñón ... todas las mujeres eran gordas ...'[11] Like the dilapidated spa, Julián's memories have become eroded with the passing of time. For Julián, this site of degradation is a *tabula rasa* on which memory is erased and recreated anew, a place of myth on which he projects his own regressive childhood fantasies. In privileging myth over historical reality, the space of Julián's spa echoes the mechanisms implicit in the moral geography espoused by early Francoism. It is the protagonist's obsession with this space which gives rise to the brutal impulse-image, which manifests itself in the murder that takes place in the film's final sequence.

While Cuenca provides the setting for *Peppermint Frappé*, the Castilian town of Astorga is the location of the documentary *El desencanto*, which centres on the family of a Francoist poet, Leopoldo Panero, who died in 1962. As Kinder writes, the disenchantment in the title refers to the gap between the idealized Fascist family displayed at ceremonies and the lives which lie hidden behind that façade (1993, p. 200). This tension between public and private worlds is played out in the film's opening sequence, which observes the unveiling of a statue of the late poet. The images of the ceremony, in which his widow Felicidad is seated alongside their two sons, Juan Luis and Michi, are juxtaposed against a shot which slowly tracks across an empty living room of the family home. Accompanying these images is the grandiloquent commentary of a No-Do newsreel, which heralds the legacy of the late poet. This voiceover is then followed by the words of Felicidad, who describes the great expectations she had of her life with Leopoldo in Astorga, before they were married. Her romantic vision of the provinces was soon shattered upon her arrival, as she explains how she fell subject to the prying gaze of her new neighbours. The poetic solitude that she sought thus gave way to ostracization and loneliness.

If her role as the wife of the regime's official poet failed to live up to expectations, so too did her life in Castile, the regime's privileged region. As in *Peppermint Frappé*, much of the film rests on the tension between the regenerationist Castile, which is bound up with myth and nostalgia, and the

social reality of a region which is wracked by parochial hypocrisy. The family's country villa, which is located in the nearby village of Castrillo de las Piedras, is conveyed in an even more critical light. Felicidad walks through the windswept grounds of their now abandoned former villa, the camera alerting us to its broken windows and doors. Continuing to reflect upon her disappointment, she intimates: 'yo pensaba "ya no estaremos solos": todo lo que había soñado había desaparecido.'[12] The tranquility of their country retreat was regularly broken by her husband's friends, who would spend countless days at the villa. While for Felicidad the village is redolent of unhappy memories, for Juan Luis it is a place of unrelenting rancour. The son recalls the 'tremenda crueldad del pueblo español' [the tremendous cruelty of the Spanish peasantry] that he witnessed on the day of his father's death, when the latter collapsed of a heart attack in their country home. After he died later on at the hospital, the son rushed back to the village, whereupon an old woman who was wearing black asked him '¿para qué corres si ya está muerto?' [why are you running if he's already dead?]

If the specific topography of Cuenca and Astorga is visually fore-grounded in *Peppermint Frappé* and *El desencanto*, the setting of Regueiro's *Carta de amor de un asesino* remains undisclosed throughout. Shot on location in the Castilian town of Guadalajara, the setting is emphasized as a generic 'ciudad de provincias' [provincial town], which witnesses the arrival of Blanca (Serena Vergano), a recently separated librarian. A middle-aged man, Antonio Díaz (José Luis López Vázquez), randomly shoots four people in a bar and then commits suicide; Blanca, soon after, receives a posthumous love letter from the murderer, with whom she soon becomes obsessed. Failing to reach even a limited distribution quota, the film was met with extreme hostility from the censors, who were perplexed by the apparent lack of motives behind the murder (Hernández Les, 1986, p. 186). Again, as in *Peppermint Frappé*, violent impulses would appear to emanate from the provincial town itself. The lugubrious *mise en scène* of the library and Blanca's apartment is frequently captured in full shots and long shots. The camerawork focusses our attention on the sheer scale and consistency of the huge mahogany furniture and high ceilings, which appear to dwarf the body of Blanca. Captured with gloomy low-key lighting, these images create an architecture of oppression, and prefigure the visual dynamic of the house in *Cría cuervos* (Carlos Saura, 1976).

Dreary and oppressive, the town in which the narrative unfolds recalls that of Juan Antonio Bardem's earlier provincial drama *Calle Mayor* (*Main Street*) (1956). As in Bardem's film, its undisclosed name strategically con-veys the impression that all Spanish provincial towns are tarnished with the same degree of uniformal gloom. This is especially borne out by the love letter that the protagonist receives: beneath her name, the envelope simply reads the word 'Ciudad' (town). The murders that Antonio commits can be

viewed as a means of escaping from his surroundings. In the bar where the shootings take place, the walls are covered in a striking wallpaper design of tall forest trees. Redolent of a faraway landscape, the image of the wallpaper establishes a connection between violence and potential for freedom.

The *meseta* as a space of isolation and exploration

In the films discussed in this section, the Castilian countryside provides a place of spiritual isolation and emotional exploration for city dwellers. Although in *Los ojos vendados* and *Elisa, vida mía* urban outsiders seek tranquility in the landscape, the *meseta* is configured as a site of torture, misanthropy and sexual repression. In *Las palabras de Max, Stress es tres, tres* and *Las secretas intenciones* urban protagonists embark upon journeys through the Castilian countryside. The landscape in these films would first appear to be nothing more than a hinterland that is merely peripheral to the narrative. Continually moving through space, however, the car journey provides a ready space for the exploration of the impulse image, which threatens to erupt even in transitional spaces.

Political violence is the subject of *Los ojos vendados*. Luis (José Luis Gómez), a theatre director, attempts to stage a play based on the testimony of an Argentine woman, Inés, whom he once saw recounting at a public tribunal on torture the story of her abduction. In spite of several anonymous threats, Luis asks Emilia (Geraldine Chaplin) to play the part of Inés, and during the performance gunmen break into the theatre and machine-gun the actors. On the importance of landscape in the film, Saura has commented: 'Este paisaje de Segovia, donde ya he trabajado otras veces, me fascina muchísimo y tiene una atracción sobre mí que no sé explicar' (Anon., 1978b, p. 51).[13] The *meseta* appears in three key scenes. In the first, Luis is driving down a country road and begins to feel chest pains; he stops to get out of the car, and lies on the plateau. The script describes the *mise en scène* as containing 'una luz bellísima, triste, invernal' [a beautiful and sad winter light]. In the second, he returns to the fields with Emilia and they make love in the same spot. Shortly before its third appearance, Emilia finds a photograph of Andrew Wyeth's painting *Christina's World* in Luis's study. In the foreground of the picture, Christina, a physically disabled woman, can be seen. With her thin, jagged limbs, she is attempting to crawl towards a distant farmhouse looming on the horizon. Between Christina and the building in the background lies the flat, unsparing landscape of New England, whose shades of burnt ochre and brown resemble those of the Castilian plateaux. Turning to Luis, Emilia says 'me gusta mucho ese paisaje. Leí una vez que la chica que le sirvió de modelo era paralítica y se llama Cristina de verdad. Fíjate en los brazos. Hay algo misterioso ¿no?'[14] Later on, when Emilia is performing the role of Inés in the play, she speaks of her

relief as the terrorists released her from their car, into the middle of the countryside. A cutaway to the *meseta* evokes the composition of Wyeth's painting, with Chaplin's emaciated body captured in precisely the same position as that of Christina.[15]

Andrew Wyeth has commented in an interview that 'some horrible thing – violence – always hits you in nature', and that he prefers 'the dead feeling of winter . . . something waits beneath it – the whole story doesn't show' (Geselbracht, 1974, p. 24). Regarding his trademark bare, minimal landscape paintings, he comments that 'I thrive on nothingness' (Geselbracht, 1974, p. 25). The artist further comments that in his painting, he endeavours to capture 'frozen motion' whereby 'time is holding its breath for an instant – and for eternity' (Geselbracht, 1974, p. 26). Hidden violence, empty spaces, temporal stasis – these are also all salient characteristics of Castilian originary space. Like the disabled figure of Christina, the prostrate bodies of Luis and Emilia are immobile and powerless in the face of this symbolic landscape, which, through the use of editing, also comes to represent the theme of performance. As D'Lugo has pointed out, each landscape scene follows and precedes a sequence in which an element of performance is foregrounded (the rehearsal room, and Emilia reading through her lines) (1991, pp. 152–3). Furthermore, after the gunmen have shot the performers, the vacant stage of the theatre echoes the emptiness of the *meseta* (D'Lugo, 1991, p. 154). In pairing the theatre with the originary space of the landscape, the Castilian field becomes a site of performance on which violent impulses are played out.

Precisely the same stretch of Segovian landscape is used in *Elisa, vida mía*, in which Elisa (Geraldine Chaplin) comes to visit her elderly father Luis (Fernando Rey), who for the last twenty years has lived alone in the country, estranged from his family. The landscape, which is privileged via the use of slow exterior pans, is also visible through the windows of many of the interior scenes. In one scene in which Luis is sitting at a desk, and in another in which Elisa is at a desk, the camera glides elegantly across the rooms of the house, visually echoing the landscape shots. With its brown furniture and ochre-coloured walls, the *mise en scène* within the cottage is resonant with the surrounding countryside, thereby playing with perceptions of inside and outside. According to D'Lugo, 'obviously borrowing from the Generation of 1988 poets, Unamuno and Antonio Machado, (Saura) highlights a Castilian landscape devoid of obvious monumentality, yet seductive in its tranquility' (D'Lugo, 1991, p. 139). Although the landscape provides a place of reflection and spiritual refuge for Luis, it is also haunted with memories of death. Both father and daughter recount to each other experiences which revolve around the theme of violence: Luis recounts the story of a woman whom he found murdered in a field near the house; Elisa tells of finding the decomposed body of a friend who had mysteriously gone

missing. Both of their accounts are ambiguous: neither father nor daughter discusses the motives behind the violence, nor any possible involvement with the police which may have taken place. After hearing her father's story, Elisa looks through her bedroom window and imagines herself being stabbed to death in the same field. At the end of the film, she finds her father who has collapsed dead in precisely the same spot. Again, violence would appear to erupt from the landscape itself.

In an early scene, Luis says to Elisa's brother-in-law Julián (Joaquín Hinojosa) that 'a mí lo que me gustaría en un acto de reflexión sería volver atrás, es decir, olvidar todo lo que he aprendido'.[16] He tells Julián that laws destroy humanity, drawing on a recent news story about a man whose neighbours had forced him into hiding, and who in the end was shot by police. He continues that despite the laws and rules of the land, humankind nevertheless presents itself as 'vindictivo and revanchista' [vindictive and vengeful]. Luis's overriding pessimism finds its source in Baltasar Gracián's allegorical novel *El criticón*, which Elisa finds on her father's desk. According to Sánchez Vidal, the thrust of the novel is encapsulated in the sentence 'Créeme que no hay lobo, no hay león, no hay tigre, no hay basilisco que llegue al hombre: a todos excede en fiereza' (cited in Sánchez Vidal, 1988, p. 87).[17] A dominant idea of the novel is that man is the most brutal of all animals, given that he is in possession of language and has an awareness of the consequence of his actions. In leading a spartan life on the *meseta*, Luis believes he has extricated himself from the structures of modern society. However, the brutality of man which he so emphatically denounces is repeatedly revealed within the context of his Castilian rural idyll. In attempting to 'unlearn' and return to a lost condition, Luis has found himself within the realm of originary space, which contains and articulates the violence of man in its most animalistic expression.

In *Las palabras de Max*, Max (Ignacio Fernández de Castro), a divorced academic, travels with his teenage daughter (Gracia Querejeta, daughter of Elías) to a friend's house in the country so that they can spend some time together. After Max's car breaks down, they hitch a lift from an unbalanced local man who happens to be driving in the same direction. On discovering that Max is separated from his wife, the driver intimates that he too is divorced, and that during his marriage he suffered from 'unos pensamien-tos terribles, tremendos' [awful, dreadful thoughts]. Much to their consternation, he then tells the passengers that he wanted to kill his wife. At the house, Max tells his daughter that he would like them to move together to the country; she anxiously replies that the countryside scares her. His daughter surreptitiously leaves the house in the early hours of the morning, and Max awakes to find himself all alone. From the magnificent vantage point of the house's terrace, the protagonist looks melancholically towards

the surrounding landscape, captured in a final freeze-frame full shot which underscores both his geographical and psychological isolation.

Unlike the disenchantment of *Las palabras de Max*, the Querejeta productions *Stress es tres, tres* and *Las secretas intenciones* represent a more misanthropic vision of human relations. The former follows Fernando (Fernando Cebrián), his wife Teresa (Geraldine Chaplin) and their friend Antonio (Juan Luis Galiardo), as they embark on a journey from Madrid to the coast of Almería. In the belief that his wife is having an affair with Antonio, Fernando's jealous obsession becomes increasingly more savage as they drive further south. Regarding the film, Saura has commented that 'como una especie de amenaza de ciencia-ficción que no sabe qué es, un poco incorporeal, hay algo extraño que va sucediendo; *sucede algo ya sea en el paisaje*, ya sea un accidente de automóvil, ya sea una acumulación de pequeñas cosas que van latiendo sobre la película' (Brasó, 1974, p. 213, emphasis added).[18] The Segovian landscape also provides the backdrop for a journey in *Las secretas intenciones*, in which Miguel (Jean-Louis Trintignant) is ensnared into an *amour fou* with Blanca (Haydeé Politoff), an unattainable young woman on the brink of committing suicide. He pursues Blanca from her home in Madrid to the surrounding Castilian countryside, where extreme long tracking shots convey their sense of alienation. Again, violence in this film appears to be wholly unmotivated: the script, which is noticeably sparse of dialogue, does not provide any clues to Blanca's self-destructive behaviour. Although the landscape appears fleetingly in these two films, it is treated in the same way as the other Querejeta productions under scrutiny in this chapter: characters are victims of the external forces of the *meseta*.

Conclusion

The relationship between violence and Castile and the *meseta*, which is explored with insistence in Querejeta's productions of the late 1960s and 1970s, has provided the focus for this chapter. In imagining Castile as both a rural idyll and ideological heartland of the nation, Franco's regime also sought to conceal the historical specificities of the region: brutal, impoverished and repressive, the social reality of Castile was painfully at odds with its mythical geography. As I have shown, Querejeta's productions work to expose how power and ideology operated through the production of space. The chapter has shown that this is achieved by means of three dominant themes, which are also the key characteristics of the 'impulse-image': the tightly bound connection between violence and space, animal imagery, and a pervasive sense of degradation.

Chapter 3

Infinite Landscapes

While many of Elías Querejeta's productions of the 1970s continued to make use of the landscape to convey their anti-Francoist messages, *Habla, mudita* (Gutiérrez Aragón, 1973) stands out somewhat as a departure from this politicized style of film-making. Its release also signalled the beginnings of a trend in Spanish film which explored the wilderness of the regions of northern Spain. *Habla, mudita* along with the later *Feroz* (1984), which is also marked by fascination with the northern wilderness, are the two films which Manuel Gutiérrez Aragón directed under Querejeta's production. In the decade which separates the two films, Gutiérrez Aragón continued to base his films in the Cantabrian forests in films such as *El corazón del bosque* (*Heart of the Forest*) (1979), *Demonios en el jardín* (*Demons in the Garden*) (1982) and *La mitad del cielo* (*Half of Heaven*) (1986). Taking his lead, other directors would also turn to the northern wilderness for inspiration: Mario Camus would explore the Asturian landscape in *Los días del pasado* (*The Days of the Past*) (1977), while two further Querejeta productions, *El sur* (Víctor Erice, 1983) and *Tasio* (Montxo Armendáriz, 1984, see chapter 4), would exploit the vistas of the breathtaking green forests and valleys of the Basque Country and Navarre respectively. If the sociohistorical context of chapters 1 and 2 was shaped by accelerated economic growth, urbanization and prosperity, the period between 1973 and 1984 was marked by recession, environmental crisis and the process of counter-urbanization. In this context, therefore, it is perhaps not coincidental that several Spanish rural film-makers turned to the rural for inspiration.

This chapter will explore the representation of wilderness in *Habla, mudita* and *Feroz* in light of these post-*desarrollista* transformations. I will discuss the way in which both spatial and social factors were caught up in these changes, and the fascination with the rural points to a growing dissatisfaction with urban life, a reversal in urbanization and the beginning of environmentalism in Spain. In scrutinizing further the encounter between the city and the country, I will draw on Emmanuel Levinas's account of the 'face to face'. In his essay *Totality and Infinity* (1969), Levinas

describes the 'face to face' as the encounter between the Self and the 'infinite Other'. Although not explicitly spatial in his thinking, Levinas develops a theory that serves as a useful framework for the elusive, powerful vision of nature which the films advance. The beauty of the mountains and forests in these films not only demands our attention, but is represented as a remote terrain, positioned beyond the reach of the urban gaze. In seeking to preserve the landscape as an 'infinite Other', the films articulate a collective anxiety towards the economic and ecological fallout of the miracle years.

Economic and environmental crisis: the post-*desarrollista* years

In the same year that *Habla, mudita* was released, Spain fell into a deep recession which marked the end of its miracle years. The slump in economic growth was representative of a larger global crisis, which was generated when Arab nations suddenly withdrew their supply of petroleum to Western allies who, along with the United States, had supported Israel in its conflict with Syria and Egypt. This withdrawal, otherwise known as the 1973 Oil Crisis, triggered an economic crisis which threw most of the developed world into a spectacular recession. The crisis had a particularly severe effect on Spain: its post-*apertura* economy was more reliant on external factors than most and as a result the repercussions of the crisis were more intensely felt (Lawlor and Rigby, 1998, p. 101). Moreover, while other countries reacted promptly to the crisis and made adjustments to their economies, Spain was slow to respond (Lawlor and Rigby, 1998, p. 102). This was due to a gross underestimation of the impact the crisis would bring to bear, and to the fact that the crisis coincided with the last days of Franco's ailing regime (Lawlor and Rigby, 1988, p. 102). As a result, the Spanish economy was unable to emerge from its recession until 1984 – over an entire decade later (Riquer i Permanyer, 1995, p. 270).

The impact of the energy crisis on Spain forms the premise of *El increíble aumento del coste de la vida* (*The Incredible Rise in the Cost of Living*) (Ricardo Franco, 1975), a thirteen-minute short film produced by Querejeta which, although not concerned with geography, provides a social commentary on Spain's particular reaction to the global crisis. A peculiar mix of surrealism and *esperpento* (grotesque realism), the film follows an elderly lady (played by veteran comic actress Rafaela Aparicio) who cannot afford to do her food shopping while the rates of inflation are so high. On discovering that the price of sardines has risen yet again in her local market, the lady complains to a frustrated market trader (played by the director Jaime Chávarri), who responds impatiently: '¿No ha oído usted que hay crisis de energía?'

[Haven't you heard about the energy crisis?]. Returning to her flat empty-handed, the old lady explains to her talking cat that there is to be no meal for him. Pointing to a poster of a smiling Bedouin that she has just fixed to the wall, the lady tells the cat to blame 'los moros' (the Moors) for the inflation. Imagining that the Bedouin is laughing at her, the lady throws tomatoes at the poster. As food prices continue to soar over the following months, the lady becomes increasingly more desperate. She is caught stealing some chorizo sausages, but is later let off with a caution; still hungry, she decides to eat both her pet budgie and cat. Forced to steal again, the authorities are not so lenient the second time: the final scene constitutes a freeze-frame close-up shot of her hand being chopped off.

The film presents a dark satire of the insularity of the Spanish nation. The ignorance of the lady is representative of all his customers, and by extension the Spanish people, who according to the enlightened market trader, 'no se enteran na' de na" [don't know anything]. The old lady apportions the entirety of the blame to the Arabs, who in the film are represented by a 'primitive' Bedouin, a tribal desert-dweller. But, as the ending attests, the Arab world has the last laugh. In eating her own beloved pets and stealing, it is precisely the behaviour of the old lady that veers towards the primitive. Her final punishment, whose dramatic impact is heightened via a gruesome freeze-frame, is suggestive of that of certain Arab states: the dismembering of a hand for theft. If Spain is suffering, the film appears to suggest, it only has itself to blame. The film therefore not only satirizes the parochial attitudes of the Spanish, but enacts a critique of an economic policy which was too readily dependent on other nations.

The economic crisis led to far-reaching spatial and social changes. As most of Spain's rapid urban development had started to slow down, the effect of fourteen years of short-sighted urban development became apparent. The downturn in economic growth led to a massive increase in the level of unemployment, from 2·9 per cent of the active population, to 17 per cent in 1982, which was the highest rate in Europe at that time (Harrison, 1985, p. 176). Declining investment meant that it was mainly within the industrial sector that jobs were lost, subsequently impacting most on the employment rates and urbanization of the city. The city, which during the 1960s was emblematic of progress and modernization, became for many in the 1970s an ugly symbol of unrestrained capitalism and unemployment. If the miracle years saw a massive exodus from the country to the city, the years of recession witnessed a rapid cooling of this migratory pattern. Harrison and Corkhill note that there was a process of 'counter-urbanization' between 1976 and 1985 in response to the crisis, whereby some of the population were in fact returning to the countryside (Harrison and Corkhill, 2004, p. 41).

The impact of this crisis on cultural production in Spain has gone unexplored. The shortage of petroleum prompted Western nations to reassess their consumption habits, which in turn generated an increased awareness of the natural environment. The journalist Pedro Costa Morata demonstrates that Spain was no exception to this rule, noting that 1973 was the year in which Spanish environmentalism gained momentum (1985, p. 171). It could be argued, moreover, that cinema also responded to this environmental crisis. In contemporary films such as *Walkabout* (Nicolas Roeg, 1972), *Picnic at Hanging Rock* (Peter Weir, 1975), *O Lucky Man!* (Lindsay Anderson, 1973) and *Deliverance* (John Boorman, 1972), man is pitted against an untamed, hostile rural environment. Nature is the true protagonist of these films, while humans are merely passive agents, swept along by its omnipotent force. Rules of civilization do not apply here, and characters' attempts to re-establish the Symbolic order are continually thwarted throughout. Although these films do not point directly to the energy crisis, they arguably play on the collective anxiety over the environment at the time. As this chapter will make clear, the landscape in *Habla, mudita* and *Feroz* articulates a very similar dynamic. The rural landscape in these films is not represented as one of comfort or nostalgia, but of a hostile and mysterious force which cannot be contained.

The Spanish urban gaze

Habla, mudita and *Feroz* are set principally in the luscious, mist-covered forests of Cantabria and the Basque Country. *Habla, mudita* centres on Don Ramiro (José Luis López Vázquez), a middle-aged linguist on a family holiday in a Cantabrian village. He falls in love wth a mute girl (Kitty Manver), and tries to teach her how to talk. In *Feroz*, Luis (Fernando Fernán Gómez), a psychologist, finds a boy who has transformed into a bear while on holiday in the countryside, and takes him back to the city with him and teaches him how to become a person once again. The films are both strikingly similar in both location and plot: the forest provides an encounter between the urban outsider and the rural. In both films, the part of the academic city-dweller was originally conceived for the actor Fernando Fernán Gómez (Torres, 1985, p. 38). Although the actor appears in *Feroz*, he was unable to take the role in *Habla, mudita*, and José Luis López Vázquez was drafted in as a replacement. Although perhaps unconvincing as an intellectual, he is referred to as 'el del bigote' (the one with the moustache) in the film, his urban moustache differentiating him from the scruffy facial hair of the villagers. Fernán Gómez's star image as an intellectual, on the other hand, had been nurtured both off-screen through his play and screenwriting and directing of dissident films such as *El extraño viaje* (*The*

Strange Journey) (1964), and on screen in his appearance as the bookish, taciturn father in *El espíritu de la colmena* (see chapter 2).

Both films strongly convey the notion that the landscape can only be shaped from the perspective of the urban dweller. One of the fundamental tenets of Raymond Williams's groundbreaking study *The Country and the City* (1973) is that it is only 'outsiders', such as industrialists, owners and artists, who perceive of nature as 'landscape', and not those who live in the rural area in question. Although Williams's study tackles the city–country opposition in English literature, his writing is equally applicable to Spain. In an interview, the ruralist writer Miguel Delibes comments that countrymen and women see the countryside in a completely different light from those who live in the city (García de León, 1996, p. 243). When asked for his opinion of Emile Zola's maxim 'los campesinos no ven el campo' [peasants don't see the countryside], Delibes responds: 'Sí ven el paisaje, naturalmente que lo ven, pero no desde un punto de vista estético sino económico' (García de León, 1996, p. 243).[1] But while Williams demonstrates how the literary representations of the English landscape have been suffused with a soothingly familiar structure of nostalgia, its Spanish counterpart emerges as something altogether more mysterious. Miguel Delibes stresses the ignorance of Spanish intellectuals towards their native rural land: 'el intelectual no se ha acercado al campo, no lo conoce' (García de León, 1996, p. 241).[2] This ignorance is strikingly borne out by the actions of the intellectual protagonists in the films, where rather than attempting to understand the villagers' way of life, they attempt to impose their own urban codes of behaviour onto them. This dynamic similarly informs much of Delibes's work, most notably in *El disputado voto del señor Cayo* ('The Contested Vote of Mr Cayo') (1978), a book which reprises many of the features of the nineteenth-century Spanish regional novel.

As in the films discussed in the previous chapter, the establishing shots of the two films are often superfluous to the flow of the narrative. In *Habla, mudita*, the landscape is repeatedly presented through the point of view of Don Ramiro. For instance, standing outside the guesthouse at the foot of the valley, José Luis López Vázquez gazes at the landscape; his large, expressive eyes lending his character an air of child-like fascination. An eye-line shot then languidly pans the spectacular view of the mountains, making the viewer complicit with the child-like wonderment of the protagonist. In *Feroz*, the panoramic shot is even more abundant. During the opening sequence, there are two high-angle crane shots which capture the enormity of the valleys. This is further accentuated through the diegetic sound of a boys' choir singing 'La Villa de Madrid'; where their voices echo and reverberate, filling the vast scope of space with their music. A montage comprises a series of nine different shots of the surrounding landscape, including the forest in autumn, the rapid river, a tree, a snow-covered river

bank. The composition of each image lovingly emphasizes the pictorialism of the landscape: trees are framed symmetrically, while the river is framed at oblique angles. The slow and consistent pace of editing, where autumn is contrasted with winter, mirrors the internal and cyclical rhythms of nature, while Luis de Pablo's folk-inflected violin score imbues the image of the landscape with local, *costumbrista* colour.

As these extended landscape sequences suggest, the visual style of *Feroz* and *Habla, mudita* is not motivated merely by narrative: the films appear to attribute as much importance to the landscape as they do to the plot. The landscape therefore stands out from the fiction, thereby freezing the flow of the narrative, and offering it up for contemplation. Laura Mulvey famously addresses the tension between narrative and display in her benchmark 1975 essay, 'Visual Pleasure and Narrative Cinema'. Mulvey argues that the visual presence of the woman 'is an indispensable element of spectacle in normal narrative film, yet [it] tends to work against the flow of the story line, to freeze the flow of action in moments of erotic contemplation' (Mulvey, 1975, p. 16). Disconnected from the narrative, the landscape is similarly aligned as spectacle in these films. Mulvey's 'woman as image/man as bearer of the gaze' can be, by way of analogy, extended to the rural as spectacle and the urban outsider as bearer of the gaze. In projecting 'his look onto that of his like, his screen surrogate', the viewer identifies with the urban protagonist.

Enunciated through the vantage point of the inquisitive urban gaze, rural Spain is presented as a mysterious domain, an isolated and hermetic Other to contemporary city life. This resonates with what Urry famously terms 'the tourist gaze', whereby the experience of tourist destinations is one of visual spectacle. Like the urban gaze, the tourist gaze, according to Urry, is always constructed through difference, for it 'depends on what it is contrasted with; what the forms of non-tourist experience happen to be' (2002, p. 1).

If the presence of an outsider sees the landscape as 'aesthetic' and the local sees it as 'practical', a similar separation can be made between 'consumer' and 'producer' (Williams, 1973, p. 121). For tourists, holiday destinations are sites of consumption (Urry, 2002) and correspondingly the visitors' movement within rural space in the films is 'non-productive' in several ways. For instance, the importance of visual consumption in *Habla, mudita* is exemplified by the guesthouse in which Ramiro stays. Nestled at the foot of the mountains, its location serves as the perfect vantage point from which to engage in the visual consumption of the landscape. Indeed, in the *mise en scène* of its dining room, the window serves as the central focal point of the composition. In another early scene, in which Ramiro and an elderly villager walk along a mountain footpath, the impact of consumption on the landscape is made more explicit. The villager points into the distance

and laments the forest that has been cut down to make way for tourists, whom he refers to as 'la Armada invincible' ('the Spanish Armada') and 'los que sobreviven' ('the survivors'). While the guesthouse underlines the visual consumption of the region, the process of deforestation points to its literal consumption and the subsequent exploitation which this entails. Like the rapidly vanishing forest, rural life is also under threat.

Othering the landscape

The relationship between the body and the landscape in *Habla, mudita* recalls the neorealist emphasis on characters and their surroundings, where characters are 'moulded' into the image of the landscape (De Santis, 1978, p. 126). Throughout the film, an organic unity between the primitive mutes and nature is established through location, framing, compositions, photography and lighting. In certain scenes, the colours of the characters' costumes match the chromatic register of the *mise en scène*. In one sequence, Kitty Manver's costume – brown T-shirt, tan cardigan – along with her mousy-brown hair all suggest earthy colours, which is further matched by the earthenware brown jug that she carries in two scenes. The overall coherence of the colour system symbolically ties her physical appearance to the brown, wet earth. Her brother, on the other hand, wears shades of silvery grey and khaki, colours which connect his body with trees. While Ramiro and the *mudita* (the mute) are in the foreground in various scenes in the forest, he is often framed in the background, jealously watching over them. For instance, when Ramiro teaches the mute to speak for the second time, the brother is lying on the collapsed trunk of an oak tree. Both the trunk and his supine body lie in the same diagonal position, until a medium shot of the tree/brother occurs. Here, he jumps forward onto the ground to state his presence, which has until this point not been perceived either by the viewer or the two other characters. The colours of his clothes create the effect of his fading into the tree, as if in camouflage.

The effect of fusing body and nature is also produced through light and shadow. The greyish autumnal light edges its way through the gaps in the leaves of the tree, casting dark shadows and unclear definition of the different planes in the composition. In two shots, the use of shadow is especially important. For example, when leaving the location of action, instead of leaving the frame, the brother and sister 'disappear' into the dimly-lit distance. This effect is created in the final scene of the film, in which a static long shot shows the pair scaling the rocky slopes of a valley, the landscape absorbing their bodies so that they become an inherent part of nature. It also occurs at the end of an early scene, in which the pair run away into the forest together. The camera traces their movement into the more

distant dimly-lit planes of the forest until they are engulfed by dark cast
shadow. The characters are therefore not just moulded by their environ-
ment, they are in constant dialogue with it: they are inscribed symbolically as
an integral part of the forest.

According to Short, forest dwellers have for long been seen by both
urban and agrarian communities as uncivilized people of the wilderness
(1991, p. 8). This is exemplified by the etymology of the word 'savage',
which, according to Short, derives its original meaning from 'pertaining to
the woods' (1991, p. 8). It follows that the role of the forest, in which
demons and dangers abound, has been especially prominent in European
traditions of folklore (Short, 1991, p. 8). It is not coincidental, then, that
contemporaneous reviews draw comparisons between Gutiérrrez Aragón's
two films and the fairy tale genre (Villate, 1974, p. 33; Casas, 1984, p. 90).
After losing himself in the misty forest, Ramiro first chances upon the
mutes' empty ramshackle house. The protagonist, who curiously inspects
the contents of the kitchen table, which has been laid out with empty bowls,
recalls Goldilocks in *The Three Bears*. Like Ramiro, Goldilocks also loses
herself in the forest, and her encounter with nature upsets the tranquil
status quo of rural life. With its emphasis on human to animal metamor-
phosis, the narrative *Feroz* similarly turns on a well-known fairy tale motif. It
is only when Pablo has become human again and taboo is foreclosed that he
is able to kiss Ana, thereby mirroring the famous stories of shape-shifting
romances such as *The Frog Prince* and *Beauty and the Beast*.

The appearance of animal imagery in *Habla, mudita* works to bring into
focus the primitive and savage dimensions of the mute children. For
instance, an elderly villager tells Ramiro that when UNESCO came to Spain,
they considered the *mudo* to be 'el más burro de España' [the thickest in all
of Spain] and compared him to prehistoric man. The casting of the actor
Francisco Algora plays on this: his broken nose, harelip and mane-like hair
lend him a brutish, leonine appearance. This is compounded further by the
way in which he moves his body. In one sequence, a group of women
attempt to seduce him during a card game, whereupon the actor jumps
onto the table, beats his chest like an ape and jumps on top of one of the
women, pretending to rape her. His raw, animalistic nature appears to
captivate the young women, who taunt him with the words 'animal', 'bruto'
(brute) and 'machote' (tough guy) to encourage him. While the brother is
linked to apes and lions, the sister is linked to goats. Stumbling on her
family's shack for the first time, Ramiro calls out '¿Hay alguien?' [Is there
anybody there]: the response is the off-screen sound of a goat's bleating.
The following shot then reveals the girl, hiding behind a door, cleaning a
pair of goat horns. Towards the end of the film, she descends the rock face
to follow the car transporting Ramiro back to the city. Attempting to
enunciate the word 'Ramiro', we instead hear the noise of a goat, again

off-screen. Her connection with animals is further accentuated in another scene, in which Ramiro tells the girl 'hueles a ganado' [you smell of cattle] and encourages her to wash. In discussing nature's traditional association with the Other, Sibley argues that 'the relegation of some groups to nature, where they are "naturally" wild, savage, uncivilized is . . . expressed in the representation of people as animals, either as animals generically distinct from humans or as particular species which are associated with residues or the borders of human existence' (Sibley, 1995, p. 26). The marginalization of the brother and sister is manifested through their alignment with animals. Located on the interstices between human and non-human, culture and nature, their transgressive identities pose a threat.

Revolving around the metamorphosis of a boy into a bear, the narrative of *Feroz* brings the theme of transgression into even sharper focus. Neither as a human nor as an animal does Pablo retain a fixed, coherent identity: Pablo displays residual traces of animal behaviour when human, and human behaviour when animal. For instance, as a boy, Pablo finds himself unable to speak, has a liking for honey and a fear of dogs; as a bear, he learns to talk, read and write and displays emotion. In an early scene where Pablo is taken to hospital, his identity is balanced precariously between the two states: his body and face are human but his hands have turned into paws. Here, Pablo displays 'a hybridization in which self and other become enmeshed in an inclusive heterogeneous, dangerous and unstable zone' (Sibley 1995, p. 26). His borderline identity is reflected in the location of his parents' home, adjacent to the motorway: situated between the rural landscape of production and the urban landscape of consumption, the motorway reflects the in-between, liminal identity of Pablo. Like Pablo, it also signals a site of danger which is especially conveyed in the opening scene: the parents walk slowly across the treacherous motorway, seemingly unaware of the great speed of the vehicles driving along it.

Pablo's liminality is a considerable source of anxiety for Luis, thereby prompting him to take the boy/bear away to civilize him and contain the threat which he poses. We first encounter Luis while he is showing a group of young schoolchildren how to play the card game 'matching pairs'. He instructs the children to match the cards of the lion and the gardener with their corresponding pairs, the jungle and the garden. In seeking to place animals and humans in their respective habitat, the card game symbolically anticipates Luis's attempts at returning Pablo to the world of civilization. The game is interrupted by the sudden clamour of dogs barking. Luis sees that the dogs have chased Pablo through the forest, who has fallen into a trap which was set out for their prey. Attempting to free the boy from the trap, Luis says angrily to Andrés, the gamekeeper: 'tus perros deberían distinguir las personas de los animales' [your dogs should learn to distinguish between people and animals]. In seeking to eradicate all vestiges of

Pablo's transformation, Luis attempts to suppress this ambiguity. In both visually rendering the peasants as an intrinsic part of nature and drawing on the symbolic use of animal imagery, the films foreground the Otherness of the peasant life.

Worlds apart: the encounter between the rural and the urban

In the encounter between the urban mentor and the rural protégé, the identity of the latter is positioned as culturally marginal. Dumb and illiterate, the characters are assigned to a realm outside of culture and language. This is most exemplified by the fact the mute brother and sister do not possess a name, and are referred to throughout the film only as 'el mudo' and 'la muda'. Without names, they are divested of identity and are therefore unable to enter the Symbolic order. In teaching the *mudita* and Pablo how to speak, the intellectuals hope to extricate their students from their 'primitive' status, and reinstate them in the civilized. For example, in *Habla, mudita*, the girl is not only taught to speak, but to dress, wash, comb her hair and look like 'una señorita de verdad' (a proper young lady). Similarly, in *Feroz* the psychologist not only teaches the bear how to speak, but instructs him on etiquette when drinking tea and engaging in polite chit-chat. When forcing the bear to learn how to type, the animal's large claws continually slip off the keyboard; as a result, Luis attempts to cut off his nails, and in so doing reduces his 'animalness'. Furthermore, in repeatedly telling the bear 'eres una persona' [you are a person] and instructing the animal to write its human name, Pablo, on a blackboard, the protagonist attempts to interpellate the bear, instating it into the Symbolic order. By introducing the protégés to their own language and codes of behaviour, the protagonists endeavour to make the actions of their students intelligible from their own, literate perspectives. In so doing, the intellectuals seek to contain the threat they pose and erase the Otherness that they personify. The efforts of Luis and Ramiro reflect the traditional western view of Otherness, which the philosopher Levinas critiques thus: 'Western philosophy has most often been an ontology: a reduction of the Other to the Same by interposition of a middle and neutral term that ensures the comprehension of being' (1969, p. 17). In other words, the formation of the subject has been traditionally dependent on diffusing the threat of Otherness, and incorporating the Other into the Same. In attempting to understand the Other, the subject draws on his own knowledge, language and experience; he understands the Other only by reference to the Self. In so doing, the Other is reduced to a mere object of knowledge and experience, in so far as it exists only within the framework of the Self. This dynamic is arguably

articulated in the films, in which rural life can only be understood through the intervention of the urban gaze. As such, the radical alterity of nature must be subsumed into the familiar structures of the urban subject. In imposing civilization on the rural inhabitants, the urban outsiders transform the Other into a projection of the same.

In his book *Totality and Infinity*, Levinas advances a different conceptualization of Otherness in what he calls the ethics of the 'face to face'. For Levinas, ethics does not so much address questions of morality as provide a way of describing the responsibility that arises in the encounter (or the 'face to face') with Otherness. At the very core of his thesis lies the question: 'But how can the same, produced as egoism, enter into a relationship with an other without immediately divesting of its alterity?' (Levinas, 1969, p. 38). In order to address this problem, Levinas aims to preserve the radical Otherness of the Other and to keep it as entirely separate from the Self. In 'preserving' both the same and the Other, they must remain autonomous and independent of each other. If attempting to understand the Other results in the weakening of its alterity, Levinas considers a failure of understanding to be crucial to its very preservation. The radical difference of Otherness depends on this lack of understanding.

Levinas emphasizes the way in which the Other is constituted through language. The encounter between the Self and Other brings about the need to communicate. He writes that

> the presence of the Other, or expression, source of all signification, is not contemplated as an intelligible essence, but is heard as language, and thereby is effectuated exteriorly. Expression, or the face, overflows images, which are always immanent to my thought, as though they came from me. (Levinas, 1969, p. 297)

The face is referred to as the 'source of all signification' because its presence impels us to communicate. Our desire to speak therefore emerges because we are addressed by the Other. Communication, or rather the inability to communicate efficiently, is a central concern of both films. Indeed, the importance of teaching others to communicate informs the professions of Ramiro and Luis, who work as a linguist and a child psychologist respectively. Ironically, their frustrated attempts at teaching their students how to speak results in their own inability to communicate, and both men subsequently feel frustrated, alienated and lonely. This, perhaps, finds its fullest expression in the figure of the tawny owl, which Ramiro refers to during breakfast with his family. Ramiro tells his family that the tawny owl (el cárabo) is a bird on the brink of extinction, and that apart from in Canada, it only exists in the mountainous region which surrounds the guesthouse. The protagonist adds that the male of the species will continue to sound his mating call, even if there are no females in the vicinity. Their

mating call, according to Ramiro, is 'un lenguaje sin comunicación, una comunicación sin lenguaje' [a language without communication, a communication without language]. As the narrative soon attests, Ramiro, who cannot communicate with his love interest the *mudita*, clearly aligns himself with the owl. This lack of mutual intelligibility is described by Levinas as follows:

> Egoist without reference to the Other, I am alone without solitude, innocently egoist and alone. Not against the others, not 'as for me. . . ' – but entirely deaf to the Other, outside of all communication and all refusal to communicate – without ears, like a hungry stomach. (Levinas, 1969, p. 44)

The loneliness to which Levinas refers in this passage indicates the absolute separateness between the Self and Other. Similarly, the failure of communication, which is personified by the tawny owl, points to the same separation. We are therefore reminded that the Other only exists because it is irreconcilable with the Self.

In *Habla, mudita*, the lack of understanding between Self and Other is reified in the symbolic use of space, and this is especially borne out in the final sequence of the film. Ramiro, delirious and semi-conscious after having slept much of the night under the rain, is saved by the *mudita* who finds a shelter for him in an abandoned burned-out bus. The vehicle is poised precariously halfway down the steep foothills. Above lies the sleepy village in which the action of the film has unfolded; below, a segment of flat land on which a country road snakes its way out of the valley. Hordes of villagers, who believe that Don Ramiro has raped the *mudita*, have spent much of the early hours of the morning searching for the fugitive. Ramiro's son, who has returned to the village concerned for his father, has asked his family to collect him, and they arrive shortly after the villagers find the bus. The performance of the thirty or so actors is pitched towards farce: older members heckle Ramiro in the bus, while grimacing, gesturing and cackling to themselves; younger members attempt to push the bus further down the slope, cheering at the spectacle. Throughout the sequence, the camera struggles to accommodate the improvised movements of the actors, scattered across the slope. Through framing the villagers' tortuous descent from a viewpoint below, the space of the village is denoted as inaccessible and forbidding: it is an autonomous space, impermeable to the urban gaze.

Busy and cluttered compositions of this scene are counterposed with those of the opening sequences of the film, in which Ramiro's family are having breakfast in the guesthouse. In this early scene, symmetrical compositions and long takes appear to echo the stifling conformity and monotony of bourgeois family life. Here, Ramiro ignores his family's bickering and longingly peers out of the window. The window, which marks the threshold between inside and outside, further develops this imagery of entrapment

and enclosure. It is employed again in the penultimate scene, where Ramiro is being driven back to the city. Turning his head round to peer out of the car's rear window, he sees the mute girl running towards the car. A point-of-view shot through the window reveals her image to get increasingly smaller, until she becomes but a speck in the landscape. Her body, which cannot be clearly seen through the frosted glass of the window, is a reminder of the impossibility of the merging of two separate worlds. Ramiro eventually turns away to look towards the direction of the road which leads to the city, resigning himself to his bourgeois existence.

The spatial separation between nature and civilization is reinforced through acting and characterization. The embarrassment of Ramiro's family, disguised under a veneer of bourgeois composure, is pitted against the manic gesturing and hyperkinetic facial expressions of the village folk. The signifiers for the uncouth rustic are exaggerated, thereby forming a kind of country-bumpkin *typage*: the actors, with their bulging eyes and over-sized chins and ears, appear to have been cast for their distinctively plebeian features. Moreover, their rapid, brusque Asturian accent contrasts with the enunciated Castilian Spanish of Ramiro and his family. The foreclosure of the rural from the urban similarly informs the visual language of *Feroz*. Again, the window denotes a symbolic threshold between the two spaces. In the clinic, for instance, a wall made of frosted glass prevents Luis from seeing Pablo properly. Convinced that Pablo's life is in danger in the woods, Luis places his sleeping body inside the boot of his car. Driving towards the city, he is pursued by the vehicle of Andrés, the park ranger, who is intent on keeping him in the forest. Luis's car abruptly careers off the winding road, falling into the rapid river that lies below. While he is able to successfully escape from his sinking car, Pablo, who remains inside the boot, is swept away by the inexorable current of the river. Directly complicit in the separation between the urban and the rural, the representation of water in this scene illustrates the antagonistic defiance of nature in the film. This defiance is further articulated in the figure of a huge oak tree, which appears repeatedly throughout the film. In the shots in which it appears, the tree dominates the composition; its thick, twisted branches reaching towards the upper and middle sides of the frame. Gnarled and twisted, its wide roots reveal the grand age of the tree. In the three instances where actors appear near the tree, a static camera observes from a distance, allowing them to enter and leave the frame while the tree looms large throughout. Enduring and strong, the tree serves as a counterpoint to the film's narrative of physical metamorphosis and societal change: the persistent recurrence of these shots works to disrupt the flow of the narrative, shifting our attention onto the eternal, omnipotent force of nature. A shot of the great oak even makes an appearance in the later stages of the film, when Pablo the bear is attempting to adapt to life in the city. Missing his

rural habitat of the mountains, the bear wistfully looks out of the window of Luis's house. A close-up shot, which shows the bear roaring, dissolves into the shot of the tree: nature is defiantly calling him to return to his home.

The second half of *Feroz* is in some ways an inversion of *Habla, mudita*: if the city encounters nature in *Habla, mudita*, then in much of *Feroz* nature encounters the city. In finding a job as a computer programmer, the bear at first seemingly integrates into post-Fordist working life, where clock time rather than the passing of the sun and the seasons determines his daily routine. Curiously, Pablo's new colleagues are not surprised that their new workmate is a bear. In fact, he is treated much as a normal person would be, when at the first day of work his colleagues shake not a hand but a paw – and without even a blinking of the eye. The 'acceptance' of the fantastical within a realistic representation of an office is unsettling, thereby accounting for the perplexed reviews at the time. Shown as part of 'Un Certain Regard' at Cannes, a *Cahiers du Cinéma* reporter was unnerved by the sight of the actor's eyes behind the bear costume, which was made from a real stuffed animal (Anon., 1984b).[3] The insertion of the strange into the familiar, or the fantastical into the real, gives rise to an unnerving *Unheimlich* effect which alienates the viewer and creates a critical detachment from the text. The human codes of polite behaviour, which constitute the urban bourgeois identity, suddenly appear to us to be arbitrary and far removed from nature. In creating a tension between fantasy and reality, identity formation is denaturalized, thereby laying bare the socially constructed nature of difference between the Self and the Other.

In both films, therefore, the town and the country are presented as two, neatly demarcated worlds. In foregrounding the impossibility of the two spaces coming together, the representation of alterity in the films preserves its radical status. The protagonists' attempts to incorporate the Other into the structures of the Same are constantly flouted and this manifests itself not only in the narrative, but also in the symbolic use of space. Just as alterity remains beyond the powers of the subject, so the rural landscape remains resistant to the urban gaze.

Infinite landscapes

Ramiro and Luis display a contradictory attitude towards rural life. On the one hand they are in awe of its surrounding wilderness and indulge in the visual pleasure it affords; on the other, they are in fear of its hostile brutality. In his discussion of imagined landscapes, Short suggests that feelings of reverence and fear towards the wilderness were commonplace in the Romantic imagination (Short, 1991, p. 6). Fear and reverence, he suggests, were not separate entities, but two sides of the same emotion (Short, 1991,

p. 6). To illustrate this, Short demonstrates that the verbs *fear* and *revere* share the same etymological root: they both originally signified 'to stand in awe' (Short, 1991, p. 6). The explicit tension between man and nature was one of the main concerns of nineteenth-century Romantic painting, and the affective power of the wilderness gave rise to the notion of the sublime. Ferguson notes that '[w]e love what is beautiful for submitting to us, for being less than we are; we react with dread and awe to what is sublime because of its appearing greater than we are, for being more, and making us acknowledge its power' (1992, p. 8). In forcing the viewing subject to react, the sublime nature is an autonomous, overwhelming force. In the face of awe-inspiring nature, man is represented in Romantic paintings as helpless and futile; the great depths and heights of forests and mountains reduce him to nothingness. Short argues that the nineteenth-century pictorial representation was concerned with representing the aesthetics of the infinite (1991, p. 16). This aesthetic finds its fullest articulation in the depiction of mountains which, according to the author, provided 'a point of contact with the infinite' (1991, p. 16). The Romantic vision of sublime nature clearly resounds with Levinas's conceptualization of Otherness, which he similarly terms 'the infinite': '(i)nfinity is characteristic of a transcendent being as transcendent; the infinite is the absolutely other. The transcendent is the sole *ideatum* of which there can be only an idea in us; it is infinitely removed from its idea, that is, exterior, because it is infinite' (Levinas, 1969, p. 49). The idea of the infinite, which is transcendental and external, foregrounds the elusive, remote nature of alterity. Like the sublime vision of the mountains, whose vastness and visual power reminds the viewing subject of his/her powerlessness, the infinite Other constantly eludes the Self. Continually repositioning itself outside the subject's grasp, the infinite Other asserts its difference and preserves its autonomy. In one passage, Levinas foregrounds this separation in terms of seeing:

> Inasmuch as the access to beings concerns vision, it dominates those beings, exercises a power over them. A thing is given, offers itself to me. In gaining access to it, I maintain myself within the same. The face is present in its refusal to be contained. In this sense it cannot be comprehended, that is, encompassed. It is neither seen nor touched – for in visual or tactile sensation the identity of the I envelops the alterity of the object, which becomes precisely a content. (Levinas, 1969, p. 194)

In being able to view what Levinas refers to as the 'thing', it loses its alterity. On the other hand the face (which here refers to the Other) refuses to offer itself to the field of vision, thereby retaining its absolute alterity.

Camera movement in *Feroz* and *Habla, mudita* articulates this impossibility of containing the infinite. Extreme long shots, and the horizontal panning and vertical tilting of the camera, mould a vision of nature as limitless. For

example, a long shot reveals Luis with his back to the camera, standing on the edge of the forest. The actor pauses for a few seconds and enters; immediately after, the camera tilts upwards to reveal the great height of the trees. A similar composition occurs when he enters a cave to search for the errant bear: in approaching the entrance, his body is submerged into darkness. In both scenes, the body dwindles into fearful insignificance in the face of nature. As Ramiro delves further into the reaches of the landscape, he becomes increasingly more helpless. Anxious to be close to the *mudita*, he sleeps on the floor outside her house. A heavy thunderstorm ensues, leaving Ramiro with nothing but a broken umbrella with which to protect himself from the heavy downpour. He curls himself tightly into a foetal ball, helpless against the onslaught of nature. The film's spectacular panoramic shots similarly point to the impossibility of visual mastery for, as we have seen, the field of vision is often too wide to be contained in the shot. This is quite literally borne in the scenes in which heavy mist descends, entirely obscuring the view of the landscape. The narrative and symbolic importance which is ascribed to the mist is exemplified in *Habla, mudita*'s promotional tagline: 'Como una aparición surgió de la niebla el ser que cambió a un hombre.'[4] That the *mudita* is likened to 'una aparición' is telling. As a non-corporeal being, a ghost is impossible to touch; as a concept, the figure of a ghost is impossible to comprehend. The ethereal *mudita*, like a ghost, is located beyond both Ramiro's physical and conceptual grasp. Emerging from behind the mist, she is linked to the mysterious domain of the infinite.

The sublime compositions and mist-covered landscapes give rise to an image of nature which is at once mysterious and fantastical. This clearly resonates with Levinas's conceptualization of the infinite Other, which evades sight and is completely unknowable.

> The Other remains infinitely transcendent, infinitely foreign; his face in which his epiphany is produced and which appeals to me breaks with the work that can be common to us, whose virtualities are inscribed in our *nature* and developed by our existence. (1969, p. 194)

Miguel Delibes, we remember, similarly underlines the unknown, 'infinitely foreign' nature of Spanish rural life. And it is precisely this structure of mystery which Gutiérrez Aragón seeks to convey in his films. The director has commented in an interview that 'el mundo rural me ha interesado siempre por su aspecto mágico. Tiene un lenguaje que hay que descifrar. . . . El campo presenta un misterio que no puede ser descifrado del todo: siempre queda algo oculto, enigmático, inaccesible' (Gutiérrez Aragón, 1998, p. 11).[5] The director manufactures a stylized portrayal of nature where the immediacy of the material landscape bleeds into fantasy. Landscape is therefore not so much a self-effacing static backdrop as it is mediated by an intensely poetic vision.

Conclusion

In seeking to represent the rural as remote, mysterious and ultimately unattainable, the films in this chapter have been shown to suggest an anxiety towards the economic and ecological fallout of Spain's miracle years. Situated within the context of the global economic crisis, the protagonists' desire to escape the constraints of urban bourgeois life also points to a growing dissatisfaction with post-*desarrollista* city life. The chapter has demonstrated that in both Spanish and other industrial cultures, there has been a general ignorance of the social reality of rural life. The representation of the rural, therefore, has been frequently enunciated from an urban point of view. I have shown that this is especially borne out in the case of *Habla, mudita* and *Feroz,* in which the landscape is visually privileged as a spectacle to be admired and consumed. If the landscape is aligned as a spectacle, then the identity of its peasant inhabitants is constructed as the urban Other, a transgressive threat which must be contained. In light of Levinas's writing on the relationship with the Other, rural life in the films is shown not only to be unknown, but largely *unknowable*: the landscape is visually rendered as inaccessible to the urban gaze. In seeking to maintain the rural and the urban as two discrete and antagonistic realms, the films signal a desire to retain the structures of rural life at a time when economic crisis led to both counter-urbanization and a growing awareness of environmental issues.

Chapter 4

Rediscovering Roots: Ecology, Land and Region

Tasio (Montxo Armendáriz, 1984) depicts the life of one of the last surviving charcoal burners in Navarre. In representing rural life in a region of northern Spain, the film at first glance suggests a parallel with the wilderness films discussed in the previous chapter. *Tasio*, however, advances an altogether different view of nature. While in *Habla, mudita* and *Feroz*, the landscape is enunciated through an urban point of view, *Tasio* captures the experience of rural life through the perspective of those who dwell there. As such, the representation of space does not so much centre on man's alienation from nature as his symbiotic closeness to the earth. As foregrounded in the film's promotional tagline, 'un canto a la libertad' ('a song to freedom'), the protagonist throughout the film remains free from the pervasive structures of modern capitalism, an aspect which particularly appealed to Elías Querejeta. In an interview at the time of the film's release, the producer said: 'me interesaba que fuera un canto a la libertad, y el hecho de que Tasio no abandone sus carboneras y no quiera ir a la ciudad a trabajar' (Gurruchaga, 1984, n.p.).[1] In focussing on both the cultural distinctiveness of the Navarrese peasantry and the natural environment in which they work, the film explores the question of roots as both a symbolic and physical concept. As Norton has pointed out, the word 'ecology' derives its original meaning from the Greek word oikos, which means a 'place to live' or a 'house' (2006, p. 105). The etymology of this word resonates particularly well with *Tasio*: the cultural identity of the peasantry in the film is inseparable from their sensory engagement with the land. Regional belonging in the film therefore gleans its meaning from a dichotomy between nature and culture. This tension, we will see, arguably responded to two key issues of importance to the recently elected PSOE government: the continuing awareness of environmental issues which had first emerged in the post-desarrollista years (see chapter 2), and the rise of Spanish regionalism.[2]

This chapter will consider *Tasio* as largely a response to this sociocultural context. Funded in part by the Basque autonomous government, the film will be discussed as an attempt to rediscover a regionally distinctive way of life at a time when it was increasingly under threat. I will show how the restructuring of agrarian life during the miracle years jeopardized the relationship between the peasantry and the natural environment, curtailing both the freedom and cultural distinctiveness of Spain's rural communities. In paying close attention to the poetic elements of the film, this relationship between man and land is explored through Heidegger's later writing on technology and in particular his conceptualization of 'dwelling'. In so doing, I will illuminate the multiple ways in which the theme of home, both symbolic and physical, provides an exploration of regional identity and a way of saving the environment.

The environment and regionalism under the PSOE

During the transition to democracy, Spanish policymakers began to respond to the environmental crisis left behind by the rampant overdevelopment of the miracle years, which was discussed in chapter 1. A greater sensitivity towards the issue of conservation was first officially demonstrated by the 1978 Constitution, which called for both a collective duty to protect the environment and a more controlled use of the country's natural resources. According to Ian Gibson, however, the government's sudden interest in ecological issues inevitably belied more politically self-serving concerns (1992, p. 114). With Spain's accession into the European Economic Community on the horizon, its politicians were especially keen to bolster its nation's green credentials: its environmental legislation would have to be in line with the rest of Europe's (Gibson, 1992, p. 114). In the months leading up to the 1982 election, the promise of a comprehensive environmental act was at the fore of Partido Socialista Obrero Español's (Spanish Socialist Workers' Party) electoral campaign. According to Gibson, however, this legislation failed to materialize, and the socialist government's position on conservation issues would soon turn out to be 'ambiguous' (1992, p. 114). Unlike its European counterparts, the Spanish socialist government would fail to create a ministry of the environment as, according to Gibson, it would have sat uncomfortably with Felipe González's plans for further modernization: 'González, hell-bent on material progress, believed that such a body, with power to meddle in the projects of other ministries (particularly Industry, Economy, Public Works and Agriculture), might be disastrous for his plans to turn Spain into a leading industrial power' (Gibson, 1992, p. 117).[3]

In spite of González's apparent neglect of green issues, the emergence of Spain's autonomous regions would eventually bring to bear a positive impact on the environment, albeit on a local scale. The long-awaited official acknowledgement of Spain's cultural heterogeneity began in 1978, when the government devolved a large degree of autonomy to the 'historic regions', Catalonia, Galicia and the Basque Country, which had enjoyed powers of self-government in the past. By 1983, the whole of Spain had finally become a decentralized *Estado de autonomías* [state of autonomous regions], in which all of its seventeen regions were afforded varying degrees of self-rule. One of the key responsibilities handed over to the individual autonomies was the control of the local environment. Although Gibson argues that, during the early years of socialist rule, the autonomies did not have the bodies to deal adequately with ecological matters (1991, p. 116), the shift in power would soon turn out to be beneficial for the environment. As Hopkins notes, the municipalities were soon able to protect their local surroundings by inhibiting building in certain places while encouraging it in others (1990, p. n.p.).

Several of the *autonomías* were also granted the power to create their own regional cinemas.[4] In the case of the Basque Country, the Consejería de Cultura del Gobierno Vasco established their own system of subsidies in 1981, whereby up to 25 per cent of the film's budget was conferred to films which were shot on location in the region, and which were made by predominantly Basque crews (Riambau, 1995, p. 417). Two years later, a number of regional films such as *Tasio* would be able to benefit from not only regional funding but national funding as well. The newly appointed directora general de cinematografía, Pilar Miró, passed a law – Real Decreto 3304, which soon became known as *La ley Miró* (The Miró Law) – which awarded up to 50 per cent of the expected budgets of films by new directors which were deemed 'de calidad' (high quality). As a producer with unstinting enthusiasm for auteurist films and new directorial talent, Elías Querejeta's productions were ideal candidates for Miró funding.[5] Moreover, the producer's reputation as the *enfant terrible* of the Francoist establishment arguably contributed towards the favourable treatment afforded him by the socialist film policy.[6] In receiving 20 million pesetas from the Basque government and a further 30 million from the PSOE, *Tasio* was one of the first films to be a beneficiary of both subsidies (Gurruchaga, 1984).

In embracing Spain's cultural diversity, the emerging regional cinemas arguably served as a corrective to some of the negative social repercussions of unfettered *desarrollismo*. As Riquer i Permanyer argues, chief among these consequences were 'the superficial and accelerated cultural integration of much of the population' and the 'profound ignorance of Spaniards regarding the nature and origins of the country's cultural and linguistic diversity'

(1995, p. 271). Paradoxically, owing to continued patterns of migration, the heterogeneity that these cinemas sought to champion was rapidly vanishing, for one of the overriding symptoms of the end of the peasantry, as Brandes demonstrates, is a loss of cultural distinctiveness (1975, p. 9). According to the geographer Keith Halfacree, however, this contradiction can be found in many contemporary representations of local rurality. As the author puts it: 'We may have to recognise that whilst the referent – the rural locality – may be withering away in respect to its causal significance and distinctiveness, its nominally associated social representation may well be flourishing and evolving' (1993, p. 34). This absence/presence is strikingly borne out in the case of *Tasio*, as two years after its release in 1986, just 11 per cent of the Navarrese population were found to be working on the land. Moreover, the Basque Country and Catalonia, the two regions with the most developed regional cinema infrastructures, correspondingly contained the smallest agrarian workforces in Spain excluding Madrid, with just 4 per cent and 5 per cent respectively (Pérez Yruela, 1990, p. 214).

Prior to the release of *Tasio*, his first feature-length film, Montxo Armendáriz had already documented the contemporary reality of Navarrese rural life in two short documentaries, *Ikuska 11* (1981) and *Carboneros de Navarra* ('The Charcoal Burners of Navarre') (1981). In the latter, the director closely followed the daily routines of the last remaining community of charcoal burners in Navarre's isolated Sierra de Urbasa. During the making of the documentary, an elderly charcoal burner called Tasio Ochoa fascinated the director to such an extent that his life story became the inspiration for *Tasio*. During the making of the film, Armendáriz sought to painstakingly recreate Ochoa's life and surroundings, paying meticulous attention to their cultural particularities. He based the script on the events of Ochoa's life, and then asked Javier Eder, a local writer, to adapt the dialogue to the local dialect (Angulo et al., 1998, p. 53). Furthermore, the main actors were made to spend time with the villagers for several weeks before the shoot (Angulo et al., 1998, p. 53). The furniture and props used in the film belonged to local villagers in the area, who also provided the crew with old photographs so that they could recreate the clothes they used to wear (Angulo et al., 1998, p. 221). Even the music evoked an overriding sense of place: the Navarrese composer Angel Illarramendi drew his inspiration from the local landscape (Angulo et al., 1998, p. 229).

Restructuring the rural: the onslaught of technology

The narrative of *Tasio* traces the life of its eponymous protagonist, from his early childhood to his old age, and is played by Isidro José Solano as a fifteen

year old and Patxi Isbert as an adult. Although there is no mention of
concrete historical events, we are given to understand that the early years of
the protagonist coincide with the period immediately after the Civil War,
and his later years with the present day (1984). The film opens within the
forest. A camera slowly pans a number of fir trees. Several of the trees are
too tall to be contained within the frame, and their great height casts dark
shadows onto the forest. The camera then slowly glides elegantly down to
the height of a shorter, blossoming tree, which stands closer to the fore-
ground. Tightly skirting around its circumference, the camera then moves
close up to a burning heap of charcoal. Made possible through the use of a
moving crane, this complex sequence shot brings to the fore an altogether
different vision of the landscape from the previous chapter. If the establish-
ing shots of Gutiérrez Aragón's films attempt to grasp the totality of nature
from without, here we see the rural landscape from within. Right from the
beginning of *Tasio*, rural space is hermetically sealed from the outside: the
towering trees not only block out the light, but their rugged barks serve as a
barrier, sheltering the forest from all that lies beyond it. Too tall to be
contained entirely within the frame, the towering evergreens do not form
part of a pictorial view which can be enjoyed and consumed by the outsider.
Whereas the concept of landscape, as we have seen, involves the separation
or alienation of man from his environment, the opening sequence suggests
a return to the earth. *Tasio*, as we will see, does not so much privilege
'landscape' as it does 'land'. In privileging the land, the film therefore
concerns itself with those who belong and dwell within the rural environ-
ment. The sinuous movement of the camera which, in slowly curving
around the blossom tree, almost caresses its branches and brings out their
volume, suggests a closeness to the natural surroundings, a tactile engage-
ment with the land. This proximity to nature is therefore in contrast with
the analysis of the previous chapter, where the pictorial compositions of the
distant landscape were represented as the property of the urban outsider.
Moving towards the burning heap, a dissolve to an extreme close-up shot
provides us with a closer view of the peat-covered charcoal, with billowing
smoke and flames erupting from holes in its surface. Placing sacks of coal
on a horse's back, the father of Tasio then picks up a dead rabbit that has
been killed in a snare. From the outset, then, charcoal burning and hunting
are established as a way of life. In introducing the place of dwelling as a
place of work, the beginning sequence renders explicit the links between
home, land and work: the work on the land is inextricable from the regional
identity of its dwellers.

The theme of working the land is central to the narrative of *Tasio*. The
ancient tradition of charcoal burning mirrors the progression of Tasio's life
from childhood to old age. Like the cycle of life and death, charcoal, which
is dug up from the earth, returns to the earth as ash. The tradition entails a

complex understanding of the way in which nature works. As an adolescent, Tasio must learn how to climb the heap and walk carefully across the top, feeling for any potential holes with his feet. Sure in the knowledge that the heap is safe, the charcoal burner makes a hole in the top of the mound, which emits a dense cloud of smoke from the burning wood. Inserting a large piece of wood into the hole, he pushes down deeper into the wood until it turns into charcoal. In this scene, the act takes on the meaning of a ritual in which man learns to confront the dangers of nature. Tasio's nervous and unsteady movements across the heap are accompanied by a melody played on a tuba, its low bass notes evoking the image of the earth's bowels. As he inches gingerly towards the hole, some jarring, discordant notes of a cello sound, as if to signal danger; tension is further created through the use of an emphatic close-up handheld camera. The music stops as the adolescent widens the hole with some circular motions of the stick, thereby signalling the end of potential danger. The cello refrain occurs again in a later scene, in which the child of Tasio's neighbour climbs the heap. This boy, however, is not so careful: in climbing the charcoal heap too hastily, he falls into its burning depths. Although Tasio rushes to pull the child out of the smouldering heap, he dies before arriving at the hospital. The menacing notes of the cello therefore serve as a leitmotif for the underlying threat nature poses. The burning charcoal heap marks man's intervention with its natural land. But its surface stands not only as the fragile boundary between man and nature, but also that between life and death. The natural resource of wood symbolizes livelihood for Tasio and his fellow villagers, without which they would be unable to survive. But, as attested by the fate of the young boy, the mishandling of the same natural resource can incur the cost of human life.

Hunting is not only a way of supplementing Tasio's income, but is presented in the film as his lifelong passion. In a very early scene, Tasio as a young boy climbs a village tree and carefully takes two tiny chicks from their nest. Returning home for dinner, he gives the chicks to his mother. Tasio's older brother tells him that it is wrong to take young animals, to which the former responds hastily 'para que te enteres, nunca cojo más de la mitad de las crías'.[7] The father adds approvingly: 'Como debe ser: que cógerlas todas no está ni medio bien. Que una cosa es cazar, y otra es espiazar los nidos. Y nunca cojáis más de lo que es bien, que así, siempre habrá caza.'[8] The father's words have a profound effect on his son, and this is borne out by the actions of the latter as an adult. Shortly after the birth of Elisa, Tasio is invited to take part in an organized hunt on an estate a short distance from his village. There, Tasio and two huntsmen with dogs chase deer through the woods. As they approach the deer and prepare to take aim, the animal is shot by another group of huntsmen who are located off screen. Crestfallen, the protagonist returns to Antonio's farmhouse, where he tells the latter

that he will not be joining the group on the following year's hunt, explaining that 'Pa cazar tienes que enfrentarte al animal'.[9] He tells them that he dislikes hunting on country estates, as 'los animales están más como sujetos. No pueden escaparse', and that 'me gusta cazar a mi aire, no así'.[10] By means of the charcoal burning and the hunting, Tasio and the other villagers show that their land is something that must be lived with and respected. Their actions throughout articulate an active engagement with their environment; as such, the landscape is not a place which is consumed, but a very real dwelling. The respect which he holds for animals reflects his close understanding of the land. In saving half of the chicks, Tasio ensures that the species will not become endangered. Similarly, in refusing to exploit the animals as 'objects' on the game reserve, he is speaking out against the modern form of hunting and the mass exploitation it entails, opting instead for a more symbiotic, understanding rapport with his surrounding habitat.

Tasio's relationship with the environment is illuminated by the later writing of Martin Heidegger. In the face of modern technology and environmental crisis, Heidegger calls for a reconciliation with nature. Only when we return to the earth and rediscover our roots, he believes, can we ever be truly free. In seeking to address the existential homelessness and social atomization encountered by modern man, Heidegger's thinking is spatial in its approach. For the philosopher, space is not read as an abstract and homogenous realm, imposed by the interrelated structures of capitalism and technology; rather, it should be viewed as a local place which articulates a distinctive sense of belonging, and which should be protected and nurtured by its inhabitants. In his flight from modern progress and his atavistic return to nature, Heidegger's writing may immediately strike contemporary readers as reactionary. Nevertheless, his philosophy provides a compelling insight into the sociohistorical context of *Tasio*, and its contemporary relevance to the question of both environmentalism and regionalism respectively is explained below. First, since their publication in the 1940s and 1950s, Heidegger's predictions have proved to be largely correct: like its Western counterparts, Spain's increasing reliance on technological advances has had irreparable consequences on its natural environment. The West has been held captive to these technological structures precisely because the success of capitalism depends on them. Moreover, in drawing on Heidegger's writing, several ecocritics have recently sought to challenge this contemporary technological world system, thus proving that he is more relevant today than ever.[11] Second, Heidegger's belief that spiritual strength comes from the soil, although problematic, in fact proves to be productive when applied to the film. Although this dimension of his work chimes alarmingly with Franco's own vision of agrarian fascism which, as chapter 2 explains, eulogized nature as a mythical

marker of centralized nationhood, it also emerges as a way of empowering the more marginalized, underrepresented discourses of Spanish regionalism. Far from reactionary, then, his 'return to roots' throws light on the symbolic conflation of land and region in the film which, in reclaiming the soil, seeks to render visible a cultural distinctiveness which is rapidly vanishing.

In his essay 'The Question Concerning Technology' (1993), the philosopher critiques what man perceives or defines technology to be. This is because we are incapable of really seeing the essence of technology. Without finding its essence, we will never truly understand technology and our subsequent relationship with it.

> Technology is not the equivalent of the essence of technology . . . Thus we shall never experience our relationship to the essence of technology so long as we merely represent and pursue the technological, put up with it, or evade it. Everywhere we remain unfree and chained to technology, whether we passionately affirm or deny it. (1993b, pp. 311–12)

For Heidegger, technology, in the original sense of the world, is 'a mode of revealing' (1993b, p. 319). This revealing allows people to understand themselves as *Da-sein,* or as beings in the world. An analysis of technology can therefore show us what it means to be human and what our true relationship with the world is; it can reveal *who we are. Da-sein* is therefore the *essence,* the primordial truth of someone or something. Heidegger underscores the difference between the 'revealing' of pre-modern technology and modern technology. In order to explain how pre-modern technology reveals itself, Heidegger draws on the etymology of the word technology. In its original Greek form, the word *technikon* derives from *techne,* which has two meanings. First, it refers to the activities and skills of the craftsman; second, to the arts of the mind and the fine arts (1993b, p. 318). A silver chalice, according to the philosopher, is an example of the *techne* of the craftsman. We stand in wonder at a chalice, appreciating the skill and artistry which were involved in its making. As such, its *Da-sein* is immediately apparent: we notice the 'chaliceness' of the chalice. When things disclose their 'thingness', we arrive at the essence or the truth of the object. Our attention is shifted onto what Heidegger calls the 'causality' of the object (1993b, p. 316), whereby the 'cause' of the chalice is its skilful making and its 'effect' is the chalice itself. In contrast, modern technology is allied to science rather than the arts and crafts. Although modern technology is also a 'mode of revealing', it does not reveal the essence of things. In a mass-produced plastic disposable cup, for instance, the *Da-sein* is lost. Moreover, the mode of production which modern technology embraces complicates the clear chains of cause and effect which were found in the more primitive model. Whereas the former reveals the poetic, primordial

truth and the tangible causality of things, the latter discloses what Heidegger terms a 'challenging' of the earth:

> And the revealing that holds sway throughout modern technology does not unfold into a bringing-forth in the sense of *poeisis*. The revealing that rules in modern technology is a challenging [*Herausforden*], which puts to nature the unreasonable demand that it supply energy which can be extracted and stored as such. (1993b, p. 320)

To illustrate his claim, the philosopher draws on the example of a hydroelectric plant on the River Rhine. The river no longer reveals itself as a river, but as something which is challenged by man. It becomes an energy reserve to be exploited at man's will. Unlike the ancient bridge which stands over the river, the plant affects the 'being' of the river (1993b, p. 321). The river, therefore, loses its 'riverness' – its *Da-sein* – at the expense of being transformed into an energy reserve. As a site for human consumption, the river reveals itself as a 'standing reserve' (1993b, p. 323) which exists only to be exploited or 'challenged' by technological man. Just as a river becomes a reservoir as a standing reserve, so animals become cattle or a flat piece of land becomes a building site.

That Heidegger focusses on energy for his discussion on technology bears particular relevance to *Tasio*. Although Tasio and his community unlock the energy which is concealed in nature, they do not challenge it in the way that modern technology does. Unlike modern mining, in which vast swathes of land are exploited as 'standing reserves' of coal, charcoal burners depend on the sustainability of the forest. Illustrative of this is the way in which the burning heap is framed within the film. Complex crane shots, such as that of the opening sequence discussed above, frequently pan across surrounding trees, before the charcoal hill is shown emerging from behind the dense vegetation. By repeatedly situating the source of energy within an unspoilt natural environment, the film foregrounds the eco-friendly sustainability which charcoal burning entails. Furthermore, the film visually brings to the fore the causality inherent in their work. In the opening scene, for instance, the slow pan of the burning heap is followed by a cut to Tasio's father who is putting sacks of coal onto a horse's back. In visually pairing first the heap and then the bags of coal, the editing throws into relief the tightly bound chain of cause and effect which inheres in charcoal burning. In the following scene, a short path leads the father on horseback out of the forest and towards the village which lies just ahead. There, the coal will be deposited for the use of his community. Unlike the spatial separation of the production of modern technology, where the fruits of man's labour are distributed far and wide and conserved for future use, the coal produced by the charcoal burners is for local inhabitants. This stands in sharp contrast to the films discussed in the previous chapter, *Habla, mudita* and *Feroz*, in which

the landscape is configured as an energy resource, due to the industrial plant and deforestation. In these two films, nature reveals itself as a 'standing-reserve', a source to be 'challenged' by man. Pertinently, when drawing on the example of the Rhine, Heidegger asks: 'Rhine is still a river in the landscape, is it not? Perhaps. But how? In no other way than as an object on call for inspection by a tour group ordered there by the vacation industry' (1993b, p. 321). Heidegger's conceptualization of the landscape as a 'standing-reserve' therefore suggests several points of contact with the writing of John Urry (2002) and Raymond Williams (1973), who as we have seen in the previous chapter, differentiate between landscapes of consumption and production. While the 'consumption' of landscape can be aligned to the 'challenging' of modern technology, its physical 'production' allows us to achieve a oneness with nature.

Heidegger terms the overall context in which modern technology has come to develop as 'enframing': 'Enframing means the gathering together of the setting-upon that sets upon man, i.e. challenges him forth, to reveal the actual, in the mode of ordering, as standing reserve' (1993a, p. 325). The 'setting-upon that sets upon man' and the challenging that 'challenges him forth' imply that even mankind has become a standing-reserve for the demands of modern technology. Enframing, then, refers to a totalizing, all-consuming system in which both nature and man are gathered together. Enframing is like an evolving mountain chain ('That which primordially unfolds the mountains into mountain ranges and courses through them in their folded togetherness is the gathering that we call *Gebirg*') (1993a, p. 324) in which both it and we are shaped by structures of technology. When considering technology in this wider context – or, to use Heidegger's terminology, when we begin to 'enframe' it – we see that it is far from being a passive object which we have developed to suit our needs. It could be said, indeed, that it embodies a powerful, active force. Our ever-growing dependence on the structures of technology means that we are forever caught in its grasp. Technology is something which contains and encompasses us, rather than the other way round: in short, we are technological beings. In order to illustrate this, Heidegger draws on the example of the modern forester:

> The forester who measures the felled timber in the woods and who to all appearances walks the forest path in the same way that his grandfather did is today ordered by the industry that produces commercial woods, whether he knows it or not. He is made subordinate to the orderability of cellulose, which for its part is challenged forth by the need for paper, which is then delivered to newspapers and illustrated magazines. (1993a, p. 323)

Both forester and forest are transformed into standing-reserve. Man is equally as subordinate to technology as nature is: they are both formed by – and complicit in – the system of enframing. Embedded within the system,

however, we deceive ourselves that we are in control. And it is this deception which gives rise to our inability to understand the true essence of both natural objects and ourselves. This is the danger of which Heidegger speaks:

> Thus the challenging-enframing not only conceals a former way of revealing, bringing-forth, but it conceals revealing itself and with it that wherein unconcealment, i.e. truth comes to pass ... Enframing blocks the shining-forth and holding sway of truth. (1993b, p. 325)

This illusion blinds us from the *Da-sein*: 'In truth, however, precisely nowhere does man today any longer encounter himself, i.e. his essence' (1993, p. 332). In Heidegger's view, our subservience to the standing-reserve prevents us from seeing who we are. Therefore, it is not modern technology per se that poses the danger. Rather, the threat arises from a system which reveals the world as a standing-reserve, where we have lost touch of our *Da-sein* and the truth of things. It threatens to alienate us from our surroundings and sever our ties with the land. Furthermore, as modern technology conveys a causality which is intangible and evanescent, we do not feel the immediate link between our actions and the consequences that they bear on the environment. Unable to encounter both the essence and causality of technology, we forever remain its prisoner.

Tasio, as we have seen, tenaciously pursues freedom throughout the film. It was precisely his sense of freedom, which Armendáriz refers to as 'espontáneo y primitivo' [spontaneous and primitive], which inspired the director to make the film (Angulo et al., 1998, p. 228). In seeking freedom, Tasio refuses to become a standing-reserve like Luis and his brother: having both secured building work in the city, they abandon the rural way of life that the protagonist represents. Even when his brother asks him to join a self-employed collective of builders, Tasio still refuses to work for anyone else, in spite of the offer of health insurance. Tasio's struggle to extricate himself from the pervasive structures of capitalism grows more acute during the latter stages of the film. The public space of the surrounding country-side falls into the hands of private landowners and, as a result, both hunting and fishing are made illegal. Subsequently, the forest soon becomes subject to the constant surveillance of a park ranger, who is in close contact with the civil guards. In order to avoid the forest guard, Tasio resorts to poaching at night. In one sequence, the camera emphatically pans a car driving over a bridge. A static extreme long shot follows, in which Tasio and Luis are secretly fishing under the same bridge, before a second vehicle drives in the opposite direction. The rare appearance of the cars, which throughout the film have been largely conspicuous by their absence, carries particular signification within the rural setting of Tasio. In rural life, a natural sense of time is privileged over an abstracted, cultural conceptualization of time. Whereas the latter may be indicated through historicized signifiers such as

fashion and architecture, the former revolves around the eternal rhythm and cycles of nature. The fleeting car, which passes through the village without stopping, serves as a reminder of the emerging consumerist Spain that lies beyond the self-contained forest. In showing the car at the beginning of the sequence, a causal correspondence is suggested between modernization and the erosion of public rural space. According to the historian Sevilla-Guzmán, Spanish rural life during the miracle years became subject to an 'incipient agrarian neo-capitalism based on a new anti-peasant ideology' (1976, p. 103). The adoption of a European capitalist model during this period meant that agriculture evolved as another branch of industry and, as such, became 'just an economic activity and nothing else' (Sevilla-Guzmán, 1976, p. 116). In Heideggerian terms, then, rural life during this period becomes restructured as a standing reserve, a site to be challenged. As a consequence, the conception of agriculture 'as something tied to a way of life due to a peasant culture with a character of its own . . . goes against historical progress' (Sevilla-Guzmán, 1976, p. 116). The *Da-sein* of rural life became increasingly more incompatible with neo-capitalist agrarianism.

Paradoxically, the proliferation of large-scale capitalist farmers and landlords during the agrarian capitalist years reinforced traditional forms of class domination. The neo-feudalism to which landless peasants were subjected therefore became the dark underside of capitalist progress. To make matters worse, the Francoist regime divested the peasantry of political agency. For instance, rural trade unions – Hermandades de Labradores y Ganaderos (Associations of Farmworkers and Cattle Farmers) – were subject to the vertical control of the Francoist government and local authorities were directly elected by the government. Moreover, every rural community fell under the 'despotic and arbitrary control [of] the para-military Civil Guard' (Sevilla-Guzmán 1976, p 118). In the film, this is borne out when the park ranger catches Tasio fishing and takes him to the Guardia Civil, who subjects him to disproportionately severe treatment. Refusing to confess his crime, Tasio is imprisoned for the night. If hunting affords the freedom to be at one with the earth, then poaching entails precisely its opposite. Forced to poach because he is divested of land, divested of freedom because he is forced to poach, Tasio is caught in a vicious cycle of exploitation. The emergence of agrarian capitalism gave rise to a new type of agricultural entrepreneur. As 'organisers of progress', these new businessmen would oversee the 'production of cheap goods for the rest of the country, in a context of universal competitivity' (Sevilla-Guzmán, 1976, p. 116). In the film, this kind of agricultural entrepreneur finds its embodiment in a corrupt employer, who refuses to pay the protagonist and his brother the money for the coal they have provided. As a consequence, Tasio cycles out of the village and finds the businessman transporting the sacks of coal by the lorry load. As the only part of the diegesis which lies outside the confines of

the village and forest, the road in this scene indicates the spatial separation between producer and product which inheres in the neo-capitalist mode of production. In seizing his coal, the protagonist reasserts his freedom from this system; as such, his fight to maintain his way of life enacts a resistance from the pervasive structures of enframing. By remaining steadfastly to the earth, the protagonist refuses to be made a standing-reserve; instead he chooses to embrace the *Da-sein* of things, to live among their primordial essence.

The land as poetry

Towards the end of 'The Question Concerning Technology', Heidegger concludes that in order to find the lost truth of things, we need to return to the poetic meaning of *techne*, where art and technology were inextricably linked. Just as the ancient *techne* was revelatory of truth, so too are the fine arts and poetry of today: 'The poetical thoroughly pervades every art, every revealing of essential unfolding into the beautiful'(Heidegger, 1993b, p. 340). For the philosopher, then, the poetic is a way of recovering the original 'mode of revealing' of which modern man has so desperately lost sight. In Heidegger's later writings, he becomes increasingly fascinated with poetry. As a source of truth, poetry becomes not so much an object of literary analysis for the author as one of philosophical enquiry. In 'The Origin of the Work of Art' (1971), he claims that this revelatory dimension need not be limited to just poetry: 'All art, as the letting happen of the advent of what is, is as such essentially poetry' (Heidegger, 1971, p. 72). *Tasio* similarly gives rise to a distinctly poetic vision.

In spite of its ethnographic faithfulness to the harsh realities of rural life, in many ways the film departs from a purely realistic vision. According to the director, 'no existe un cine real, existe la representación o reconstrucción más o menos fiel de la realidad' (Angulo et al., 1998, p. 115).[12] In reference to *Tasio*, he claims that 'yo no buscaba una fotografía realista, sino que quería crear un tono y un clima que parecieran realistas' (Angulo et al., 1998, p. 221).[13] Just as the photography had to be tailored to the film's vision of reality, so too had its *mise en scène*. As Querejeta notes, 'durante la filmación de *Tasio* necesitaron toneladas de tierra y arena que tuvimos que añadir en multitud de planos exteriores porque no podíamos rodar en los pueblos tal y como están ahora' (Angulo et al., 1996, p. 119).[14] Upon its release, the critic Eric Alberich took *Tasio* to task, claiming that in presenting a too perfect vision of rural life, the film's depiction of nature tended towards the hyperreal: '*Tasio* es una película que deja transparantarse el artificio ... Las imágenes son demasiado limpias, muy poco pueblarinas' (1984, p. n.p.).[15] Nevertheless, the majority of critics who hailed the film a

critical success claimed that its visual language is not so much artificial as poetic. Among these, Pedro Miguel Lamet is the most vocal.

> No es fácil que la imagen fílmica pueda llegar a ser poesía ... *Tasio*, opera prima de Montxo Armendáriz debe entrar con todos los honores en este tipo de cine donde la imagen, la realidad, habla por sí misma con esa frescura y autenticidad de la vida misma. (1984, p. 153)[16]

But what is meant exactly by a poetic visual style? Moreover, how can we locate the poetic elements within a film? In the paragraphs that follow, a brief discussion of the theories of Pasolini's 'cinema of poetry' and Schrader's 'transcendental style', will serve as useful apparatus for identifying the poetic in *Tasio*. Their writing, as we shall see, suggests some convincing parallels between the poetic in film and the revealing of Heidegger's *Da-sein*.

For most of the film, the camera tightly follows the actions of the protagonist. The majority of scenes are therefore marked by his presence, and begin or end with his entering and exiting the frame. As continuity editing is conspicuous by its absence, for the most part, the viewer witnesses events unfolding at the same time that Tasio does. Thus, the narrative structure of the film is attached both spatially and temporally to his movement. The three slow landscape pans, however, prove an exception to this rule. Disconnected from the narrative, the landscape shots at first glance suggest a parallel with the films of Gutiérrez Aragón. However, the landscape shots in *Tasio* are quite different, in so far as they are not relayed through the gaze of a certain character. Divorced from a fixed subjective viewpoint, it is during these sequences that an authorial hand is most conspicuously felt. Accompanying the images of the trees and undulating valleys is the sound of a solo viola. Its jarring, discordant notes seem to reverberate across the landscape, suffusing nature with a sense of melancholy and longing. These shots not only effect an emotional response, but given their notable frequency and length (fifty, forty-one and fifty seconds respectively), they also function as a stylized visual refrain. The material reality of nature, therefore, bleeds into a highly personalized vision of the film-maker.

While both the vast bulk of the narrative and the landscape pans are aligned to Tasio's and the director's viewpoints respectively, the shots of the burning mound pertain to neither. Inclusive of the opening and closing sequences, the burning heap figures in six scenes. Apart from the first one, Tasio appears in the shots at different stages of his life. Like the oak tree in *Feroz*, its constant unchanging presence throughout serves as a counterpoint to the finite lives of Tasio and his father. During the second scene in which it makes an appearance, a close-up shot first follows the movement of Tasio as a teenager tending to the hole. This is followed by a gradual dissolve

into a static medium full shot, which frames the same action from further away; in turn, this is followed by a dissolve into long shot, in which the mound is surrounded by trees, and the burning mound is cloaked in smoke. This series of axial cuts, which provide different shots of the same filmic space, endows the image with an almost hypnotic intensity. Again, the *mise en scène* in this scene is clearly stylized, yet here the image is more ambiguous: our spatio-temporal attachment to Tasio is interrupted by the conspicuous intervention of form, which is signalled by the dissolve. In his essay 'The Cinema of Poetry' (1976), the Italian writer and film director Pier Paulo Pasolini attempts to define the stylistics of poetic cinema. Central to his definition is 'the free indirect subjective', which he describes as the tension which arises between the viewpoint of a character and that of a director. In applying the term to film, a free indirect image cannot clearly be ascribed to character perspective (manifested through the subjective shot or focalization) or the aesthetic vision of the director; rather, it is positioned somewhere between the two (Pasolini, 1976, p. 552). According to the author, this kind of image finds its fullest expression in 'obsessive framing' (Pasolini, 1976, p. 553), which manifests itself in two ways: first, in the 'close follow-up of two viewpoints, scarcely different from each other, upon the same object'; secondly, in 'the technique which consists in having characters leave and enter the frame, so that, in a sometimes obsessive way, the montage is the succession of a series of pictures' (Pasolini, 1976, pp. 552–3). Perhaps most importantly, from these stylistic mechanisms arises 'an insistence which becomes obsessive, as myth of the *pure and anguishing autonomous beauty of things'* (Pasolini, 1976, p. 552, emphasis added). According to the author, this 'autonomous beauty of things' gives rise to a cinema of poetry. The obsessive framing of the burning heap is an example of this free indirect subjective, and as such, it gives rise to a poetic image. Unmoored from a fixed perspective, it suggests a oneness with the world that can be experienced directly. The 'pure, autonomous beauty' that the poetic language of the film reveals is the *Da-sein* of objects.

Vicente Molina Foix has also drawn attention to the importance of the film's *mise en scène*, arguing that its poetic visual language brings out a transcendental dimension in objects. According to him, the expressive use of framing and lighting converts daily objects, such as the burning mound discussed above, into 'efigies totémicas' [totemic effigies] (1984). In his book *Transcendental Style in Cinema* (1972), Paul Schrader examines the ways in which three film directors, Yasijuro Ozu, Robert Bresson and Carl Dreyer, work to create transcendental images in film. Although Schrader does not mention cinematic poetry, there are some pertinent zones of contact between his writing and that of Pasolini, for both of their analyses revolve around a certain type of revelatory, ambiguous image. One of the characteristics of the transcendental style is dedramatization: 'the transcendental

style stylises reality by eliminating those elements which are primarily expressive of human experience, thereby robbing the conventional inter-pretations of reality of their relevance and power' (1972, p. 11). Critics have been quick to note the understated acting of the cast of *Tasio*. For instance, Angulo et al. have commented on its 'sobrio, ascético' [sober, ascetic] tone of expression (1998, p. 135), while Molina Foix has observed its 'lirismo elidido, la expresividad de lo no expresado' [restrained lyricism, its rich expression of the unexpressed] (1984). Indeed, the acting style in *Tasio* is strikingly restrained; static, even. Conversation is usually spoken in mono-tone voices, with pauses occurring between exchanges of dialogue, and actors move slowly and somewhat rigidly. Characterized by a certain sense of languor, this style of acting contributes towards the consistently slow pace within each scene, which is often compounded by the use of camera. For instance, long after the action or dialogue of a scene has finished, the camera is sometimes left to linger on the protagonist. Illustrative of this is an early scene in which, while lovingly making her son a bowl of milk, the protagonist's mother tells him not to get up so early in the morning. After she leaves the frame, the fifteen-year-old Tasio takes a drink of his milk, then very slowly lowers his bowl. A medium shot remains steadfast on the protagonist, who looks towards the right of the frame to a point off-screen for a whole seven seconds, before a new sequence begins. This shot does not possess a narrative function; it simply works as a meticulous representation of everyday life.

For Schrader, the style of dedramatization is most notably located in the work of Ozu, who frequently registers the dull and the commonplace in a pared-down visual style. Although the Japanese director worked predomin-ately within a non-Western style, it is not fanciful to suggest that he and Armendáriz share similar aesthetic concerns: in an interview, Armendáriz names Ozu, one of the three case studies for Schrader's study, as one of his greatest influences.[17] He mentions that he became fascinated by the work of Ozu, and his compatriot Mizoguchi, while he was filming his first short films. He describes his fascination thus: 'su narrativa me aportó una forma distinta de ver cine, de entender el ritmo interno del plano en función de la puesta en escena y creo que, aunque de manera inconsciente, están pre-sentes en mi cine' (Angulo et al, 1998, p. 209).[18] Correspondingly, the slow 'ritmo interno del plano' [internal rhythm of the shot] of *Tasio* intensifies the feeling of the passing of time, thereby alerting us to the existence of things. Like Pasolini's cinema of poetry, the transcendental style is revela-tory, thereby bringing to the fore the *Da-sein* of things. The divinely beautiful dimension of nature is disclosed via the poetic. The visual lan-guage engenders a sense of wonder that has been largely lost with develop-ment of modern technology.

The expressive use of editing also contributes towards the film's reticent tone. Ellipses occur in the scenes that hold the most narrative importance, thereby withholding their dramatic potential. This is borne out during the two sequences in which the deaths of the neighbour's son and Paulina occur. Tasio hurries to the rescue of the son of his neighbour, Ángel, who has fallen into the burning heap. After prising him from the charcoal, the protagonist runs to call an ambulance, while the unconscious boy lies on the ground next to the heap, convulsing violently. The following sequence shows a long shot of Tasio and his friend, Luis, fishing under the bridge. As night falls, the sound of death knells can be heard from a nearby church off-screen, whereupon Tasio says to his friend quietly: 'Será el hijo de Ángel, ni habrá llegado el hospital.'[19] A sound bridge carries over to a new sequence in which villagers are congregating outside a church and bells signalling Sunday mass can be heard. Foreclosing any possibility of melo-drama, the ellipsis serves to block any emotional response that the child's death might evoke. When we first ascertain news of the death, the use of static long shot and Tasio's barely audible and casually delivered dialogue work together to distance us further from the tragedy. The staggering of the sound of the bells not only adds to the general sense of ambiguity, but symbolically elides death with the weekly ritual of Sunday mass. As such, death among the impoverished villagers is represented as just another routine occurrence in the fabric of rural life: an event as commonplace as the weekly church service. The presence of the church bells is equally pivotal to a later scene in which Paulina dies. An exterior shot shows the protagonist entering his house. After a few seconds the camera, which is still positioned outside, shows Tasio running outside shouting for help. An ellipsis takes us to Tasio dressed for the funeral, with his side to the camera, taking down Paulina's shirt which had been hanging out to dry; this is followed by a static close-up shot of the church bells overlooking the village. In narrating the discovery of Paulina by means of off-screen space, the scene is carefully divested of its dramatic potential. Emotional distantiation is further accentuated by the ambiguous structure of the ellipsis: exactly how and when Paulina dies is foreclosed from the viewer. Significantly, these gaps in the narrative further contribute towards the film's poetic structure. If in a poem the pauses and spaces between words help to structure its rhythm and meaning, then the internal rhythm of the shot and elliptical editing in film arguably enjoy a similar function.

The land as dwelling

Tasio's refusal to leave his home persists right until the end of the film, where he is seen as an old man. The visual language of the final sequence of

the film first appears to reprise that of its opening sequence. In panning the trees from right to left, however, the crane shot of the forest travels in the opposite direction from the first scene. The symmetrical camera movement here introduces a trope of circularity: not only does it suggest that Tasio's life has come full circle, but it points symbolically to the theme of return. Now an independent young woman, Elisa has come back to the village to visit her father. Informing her father that she is to be married, she beseeches him to come and live with her in Vitoria. In responding 'Yo, no me muevo de aquí' [I'm not moving from here], the cyclical imagery here also alludes to his resistance to change. The presence of Elisa, a migrant to the city who has returned to her ancestral home, underscores the poignancy of Tasio's situation: without an heir to carry on the family tradition of charcoal burning, Tasio's distinctive way of life will soon end. As the sociologist Manuel Pérez Yruela has pointed out, the fallout of Spanish migration 'ha creado una generación de ancianos solitarios que continúan cansinamente aferrados a un modo tradicional de vida que sabe concluirá con ellos' (1990, p. 238), and the life of Tasio is no exception.[20] Indeed, the real-life Tasio Ochoa, the last surviving wood burner, died just a few years after the eponymous film was released.

In his monograph on Montxo Armendáriz, Chema Pérez Manrique has also drawn attention to the theme of home in the film. In drawing on the work of ethnographer José María de Barandiarán, the author suggests that this corresponds to the spiritual and mythological importance that Basque people have traditionally ascribed to the *etxe* (home). Barandiarán's account is worth citing at length.

> según la concepción tradicional que aún perdura en el pueblo, el vasco se halla ligado un *etxe*, 'casa' ... El *etxe* es tierra y albergue, templo y cementerio, soporte material, símbolo y centro común de los miembros vivos y difuntos de una familia. Es también la comunidad formada por sus actuales moradores y por sus antepasados. Tales son los atributos de la casa tradicional que ahora, con los nuevos modos de vida, van desfigurándose o desapareciendo. El mundo conceptual del vasco histórico gira, pues, alrededor del *etxe*, que a su vez persigue un ideal: hacer que cada uno de sus habitantes vivan sin dolor y sin pena en armonía con los suyos, en comunión con sus antepasados en esta vida y en la otra. (cited in Pérez Manrique, 1999, p. 81)[21]

There are some striking similarities between Barandiarán's account of the *etxe* and Heidegger's conceptualization of the dwelling. In the latter's essay, 'Building Dwelling Thinking' (1993), building and dwelling posit a meditation on the essence of being. The author notes that the German word for building, *bauen*, originally derives its meaning from 'dwell'. For Heidegger, 'to dwell' not only signifies 'to remain, to stay in a place' (1993a, p. 348) but reveals how 'we human beings are on the earth'. It also proffers a way of

finding freedom: 'To dwell, to be set at peace, means to remain at peace within the free, the preserve, the free sphere that safeguards each thing in its essence' (1993a, p. 351). In bringing together the notions of remaining, being and freedom, Heidegger's notion of dwelling eloquently encapsulates Tasio's situation. But, most fittingly is that the essence of dwelling can be found in what Heidegger terms 'the fourfold'. In the fourfold, '"on the earth" already means "under the sky". Both of these also mean "remaining before the divinities" and include a "belonging to men's being with one another"' (1993a, p. 351). Hinging on the organic unity between earth, sky, the divine and the mortal, the fourfold bears a striking resemblance to Barandiarán's description of the *etxe* as a 'tierra y albergue, templo y cementerio', where both the living and the memory of their ancestors live together in harmony (cited in Pérez Manrique, 1999, p. 81). In the face of the existential homelessness that enframing brings, to dwell in the world is to understand one's being in the world. But since dwelling is allied to *etxe,* it also discloses the essence of Tasio's cultural roots.

If the notion of dwelling sheds light on questions of regionalism, it also strikes at the heart of Spain's environmental concerns. While *bauen* means to dwell and to be, at the same time it also means 'to cherish and protect, to preserve and care for, specifically to till the soil, to cultivate the vine' (Heidegger, 1993a, p. 349). Tasio's nurturing of the earth enacts what Heidegger goes on to describe as 'sparing'.

> Real sparing is something positive and takes place when we leave something beforehand in its own essence, when we return it specifically to its essential being, when we 'free' it in the proper sense of the word into a preserve of peace. (Heidegger, 1993a, p. 351)

In revealing the sensuous presence of nature, therefore, Tasio also contributes towards its preservation. Working the land, dwelling and poetry are all symbolically woven together within the photograph of the film's promotional poster.[22] Standing in the foreground are the three actors who play Tasio at the different stages of his life: centre left, the youngest stands nearest the front; in the centre, the fifteen-year-old Tasio stands behind him and centre right stands the eldest Tasio, holding his charcoal-burning staff, behind them both. The overlapping bodies of the three actors points to the rites of passage which the protagonist goes through from child to adult. The Navarrese landscape serves as a backdrop to the three figures. Sloping down from the highest point, which is situated at the left, to the lowest at the right, the shape of the landscape figures as an inverse reflection of the three ascending bodies of the actors. Furthermore, just as the obliquely positioned actors gives rise to a notable sense of volume in the picture, so does the land: the three bodies of the actors are mirrored in three, overlaying planes – agricultural fields, trees and mountains – that form the landscape

behind them. The compositional symmetry suggests a close symbiotic relationship between man and land; but as indicated by the presence of Tasio's stick, it is a relationship that is also allied with *techne*, the care and causality that inheres in non-technological work. Land, man and work are intersected with a further crucial dimension on which the film rests. The looming presence of a great, concrete wall, against which Tasio and his friends play the regional game of *pelota vasca*, alerts us to the importance of the cultural dimension of dwelling. Positioned as an integral part of the landscape, the great wall signals the symbolic conflation of culture and nature, region and land. The *Da-sein* of these separate elements is disclosed through a carefully considered, poetic composition which, as we have seen, is characteristic of the film's visual style. The photograph, therefore, serves as a *mise en abîme* of the film's underlying themes: in intertwining land, *techne*, dwelling and poetry, it conveys Tasio's freedom to maintain his cultural roots in the face of a deteriorating rural Spain.

Conclusion

By way of conclusion, *Tasio* has been discussed as a response to both the growing environmental awareness and the rise of regionalism of the early PSOE years. In light of Heidegger's 'enframing', this chapter has explored the extent to which the miracle years curtailed both the freedom and cultural distinctiveness of the Spanish peasantry. As we have seen, the process of enframing has led to man's alienation from the earth, which has blinded him from the *Da-sein,* the truth of things. In defining himself against the enframing process, the protagonist is discussed as possessing a symbiotic relationship with the earth which, unlike modern man, enables him to perceive *Da-sein* of his surroundings. In analysing the poetic elements of the film, the chapter has investigated how the revelatory, transcendental dimension of its *mise en scène* gives rise to the *Da-sein* of nature, liberating man from the processes of enframing. Finally, in exploring Tasio's home as Heidegger's conceptualization of 'dwelling', the final section has revealed the extent to which the theme of the home posits both an exploration of regional identity and a way of surviving the environment. As an ethnographic portrait of a vanishing, culturally distinctive way of life, the film alerts Spanish audiences to their own lack of roots and freedom in the face of a post-*desarrollista* society. In bringing to the fore the symbiotic relationship between space and the individual, the analysis of *Tasio* also anticipates the focus for the two chapters which follow, which examine in depth the extent to which urban spaces shape and exclude social identities in Elías Querejeta's productions in the 1980s, 1990s and 2000s.

Chapter 5

No-Man's-Land: Transitional Space and Time

Filmed on the outskirts of Madrid, *Deprisa, deprisa* (Carlos Saura, 1980) signalled a new direction for Elías Querejeta PC. Not only did it indicate a predominant shift in emphasis from rural to urban space, but it would also be the first of several social realist films to be backed by the producer. Social realism tends to emphasize the relationship between space and identity. As Hallam and Marshment have observed, it usually revolves around marginal and oppressed characters who find themselves contained within 'tightly inscribed socio-economic and geographical boundaries' (Hallam and Marshment, 2000, p. 194). This is especially borne out in the case of *Deprisa, deprisa*, which centres on a gang of migrant delinquents who are both geographically and socially excluded from Madrid.

Elías Querejeta has stressed his social engagement with the issue of juvenile delinquency, and has claimed that politicians have adopted a draconian approach towards delinquency which deals with the effects and not with the causes. In response to this, the film, according to the producer, constitutes a 'sensibilización' (sensitization) towards teenage delinquents (Hernández Les, 1986, p. 88). Querejeta's interest in young people would also go on to yield several later productions which, like *Deprisa, deprisa*, explore the relationship between the social and the spatial. *27 Horas* (*27 Hours*) (Montxo Armendáriz, 1987) follows the lives of two teenage junkies in San Sebastián, a city which was particularly afflicted by mass unemployment at the time. The film's tight, hermetic framing, which works to dislocate the characters from their surroundings, emphasizes the solipsistic nature of their heroin abuse, while the washed-out, glacial hues of grey and blue reflect the emotional coldness they encounter in their family and personal lives. Teenage life would also provide the focal point for Armendáriz's next collaboration with Querejeta, *Historias del Kronen* (*Stories From the Kronen*) (1995), which explores the ennui of a group of privileged, upper-middle-class students one summer in Madrid. As Fouz-Hernández

has pointed out, the space of the city at night becomes a major ground for youth resistance in the film (2000). *Barrio* (Fernando León, 1998), which focusses on younger teenagers, is also set in Madrid. The city in this film is one of stagnant and exclusionary borders which participate in the marginalization of the young characters. As in *Deprisa, deprisa*, these films reveal the extent to which social identities are constituted and shaped by their surroundings.

In grounding the film in its historical context, this chapter considers Spanish delinquency to be a consequence of the uneven urban development brought about by Franco's miracle years. In so doing, I will explore the ways in which *Deprisa, deprisa's* critical *mise en scène* reflects the processes of social and geographical exclusion, paying particular attention to the representation of borders and waste. The film's triangular relationship between space, time and identity will be examined through Homi Bhabha's writing on the 'location of culture'. Bhabha's writing illuminates the ways in which the body of the delinquent both performs and contests national identity at a time of political, social and geographical change.

The transitional space and time of the Spanish delinquent

As we have seen in chapters 3 and 4, the redistribution of the Spanish population during *desarrollismo* profoundly altered the structures of rural life. As many agrarian workers left the country for the city, the depopulation of the Spanish countryside was accompanied by the thriving growth of the city. As Di Feba and Santos demonstrate, the shift in population impacted most heavily upon Madrid, Barcelona and Bilbao, the three cities that were already the most populous in Spain. Of the three, the capital was inevitably the most affected: between 1964 and 1973 a total of 686,544 rural migrants would relocate there (Di Feba and Santos, 2003, p. 103). The accelerated process of urbanization would bring with it great social change, manifesting itself in the restructuring of the Spanish class system. According to the authors, the period was marked by 'a movilidad social ascendente' [upward social mobility], which gave rise to a new aspirational urban working class (Di Feba and Santos, 2003, p. 104). For the first time, many migrants found the stability that they had so lacked in the country. Many of the new jobs in the industrial and service sectors offered possibilities for promotion from blue-collar to white-collar positions, and urban workers were encouraged to buy their own homes in the rows of new apartment blocks springing up in the suburbs. Di Feba and Santos show, however, that as a result of this change, cities 'sufrieron un proceso de segmentación al elevarse, en sus márgenes, barrios enteros habitados por esta nueva clase obrera' (2003,

p. 104).[1] Confined almost entirely to the sprawling suburbs, the emerging working class was an identity that was geographically circumscribed.

Although economically beneficial for many, the process of urbanization contributed towards the geographic exclusion of others: with the creation of a new urban working class came the creation and containment of an emerging underclass. According to the sociologist González Pozuelo, in several cases Spanish migrants were marginalized because of their illiteracy and inability to adapt to the different pace of urban life (1989, p. 50). Consequently, the unemployed found illegal housing in the communities of ramshackle *chabolas* (shanty towns) on the peripheries. As the cities gradually spread outwards, so the local authorities systematically replaced the shanty towns with the new housing for the working classes. The underclass were subsequently driven further afield and, in the majority of cases, alternative housing was not provided for them (González Pozuelo, 1989, p. 57). Via the demarcation of the 'periferia de la periferia' [periphery of the periphery] (1989, p. 52) the author argues that 'así se establece un proceso por el cual la propia estructura urbana actúa como multiplicador de las diferencias de clases, haciendo al pobre más pobre y al rico más rico' (1989, p. 51).[2] Following the evidence of Di Febo, Santos and González Pozuelo, it can be argued that the development of the capitalist city during the miracle years depended on this very exclusionary process. Moreover, as geographic exclusion engendered alienation, an analysis of the post-*desarrollista* Spanish city lays bare the ways in which the spatial and the social are inextricably realized one in the other.

Opportunities for the migrant underclass were set to deteriorate further after 1973. Spain's economic depression, which was triggered by the international oil crisis (see chapter 3), lingered long into the 1980s. Somewhat inevitably, the decline of the economy was met with soaring crime rates, and this was perhaps most noticeable in the rise of delinquency. For instance, between 1976 and 1978 the rate of delinquent crime rose twofold (Hernando Sanz, 2001, p. 265). A 1978 study by Huertas et al. makes explicit the link between delinquency, migration and geography. According to their findings, 83 per cent of Spanish children held in reformatories were rural migrants; moreover, the authors suggest that this figure would be greater if the number of second-generation migrants were included within the total (Huertas et al., 1978, p. 48). The authors suggest that inadequate housing – the major problem facing families of migrants – was a primary causal factor for the delinquents' turn to crime (Huertas et al., 1978, p. 44).

The increasing patterns of delinquency instilled a great deal of anxiety in the Spanish public. Huertas et al. demonstrate that insurance companies capitalized on this, running a number of advertising campaigns which urged the public to secure their property (Huertas et al., 1978, p. 88); furthermore, Hernándo Sanz shows that the sale of antitheft systems in

Spain soared considerably between 1975 and 1979 (Hernándo Sanz, 2001, p. 266). If during the miracle years public boundaries were erected to keep the migrant underclass out of the city, in the years that followed these exclusionary borders were extended to the private sphere of the home. This process of social control both arguably responded to and fuelled the histrionic coverage of delinquency in the right-wing press. As the vertiginous rise in juvenile crime coincided with the years immediately after the dictatorship, many detractors of democracy argued that delinquency signalled a descent into moral entropy. The emerging climate of post-dictatorship permissiveness, and the subsequent breakdown of authoritarian values that this entailed, were therefore blamed for this crime wave. However, a spatial analysis of urbanization under Franco reveals that delinquents – most of whom were migrants – were products of an environment that was in fact created by the dictatorship itself: that is, cities whose accelerated development hinged on a process of social control.

In its unflinching depiction of juvenile delinquency, *Deprisa, deprisa* reprises several of the concerns of Saura's first feature-length film, *Los golfos* ('The Hooligans') (1959). In the late 1970s, Saura started making a documentary series on delinquency called *Marginados* ('The Marginalized') with the producer's brother, Francisco Querejeta. Although the film failed to reach completion, Francisco Querejeta was able to inform Saura of the slang with which his delinquent subjects spoke, and helped him to gain access to some of the teenagers who had collaborated in the series (Sánchez Vidal, 1988, p. 147). This material would form the inspiration for the screenplay of *Deprisa, deprisa*. The film can also be seen as part of a greater trend within Spanish transitional cinema that revolved around the theme of teenage delinquency. The enormously popular *Perros callejeros* (José Antonio de la Loma, 1977) was the first film of this subgenre and would prove to be the blueprint for many of the delinquent films to come.[3] Set in the deprived outreaches of Barcelona, de la Loma's film centres on El Torete (Ángel Fernández Franco), a handsome teenage delinquent who smokes marijuana, steals cars and always gets the girl. The film's flamenco-pop soundtrack and Fernández Franco's gypsy features identify the delinquent as a migrant – or a second-generation migrant – to the city. Although Saura's social realism is largely at odds with the sensationalist style of de la Loma, *Deprisa, deprisa* and *Perros callejeros* have much in common: *Deprisa* is also set on the 'periferia de la periferia' of the city; it comprises a similar flamenco-pop soundtrack; and, like El Torete, its protagonist Pablo (José Antonio Valdelomar) was also a real-life migrant delinquent.

The spatial exclusion of delinquents such as Pablo and El Torete not only stems from their social status as migrants, but also from their identity as teenagers. For a teenager can both be denied places reserved for adults, such as nightclubs and offices, and places designated for children, such as

the playground. Via the production of these invisible boundaries that adolescents are forbidden to cross, space is therefore subjected to a process of demarcation and control. Our aims to territorialize space are, according to the geographer Doreen Massey, 'an active ingredient in the often contested social processes of youth culture's construction' (1998, p. 126). Furthermore, 'the control of spatiality', writes Massey, 'is part of the process of defining the social category of youth itself' (1998, p. 126). Like the identity formation of the Spanish migrant, then, space and the adolescent 'self' are interdependent, comprising two sides of the same coin. But during Spain's transition to democracy, the city in which the teenage identities of Pablo and El Torete were defined was also in the process of *defining itself.* The figure of the teenager, which marks the transition between childhood and adulthood, therefore serves also as a trope for a nation that is itself in the process of great social, political and spatial transformation.

Borders of exclusion

Deprisa, deprisa opens with two teenagers, Pablo (José Antonio Valdelomar) and Meca (Jesús Arias Aranzeque), stealing a car. They drive to their local bar in Villaverde, an outer suburb of Madrid. Here, Pablo meets Ángela (Berta Socuellamos Zarco) and asks her to go out to the disco with him; they soon fall in love and move in with each other. These early scenes introduce the M-30 ring road, which encircles the outer reaches of Madrid, and also reappears in other scenes later in the film. In the second sequence of the film, a series of oblique crane shots situate the road as the central part of the composition. On one side, the road is flanked by endless high-rise tower blocks; on the other, we see a stretch of neglected hinterland, with recalcitrant tufts of grass that have sprouted from the barren, dry earth. The M-30 straddles the peripheries of both the urban and the rural, without really belonging to either space. In several later sequences, long and extreme long shots frame the road from its side, so that it takes on the shape of a horizontal line. The camera, which is positioned from the *meseta* looking towards the edges of the city, presents Madrid as an impenetrable fortress; its rows of soulless buildings resembling a high-security wall. The rows of *desarrollista* housing blocks not only shield the inner city that lies beyond the teenagers' grasp, but they also serve to remind us of their own complicity within the process of social exclusion. As we have seen, erected so as to house the new working-class migrants, the construction of these buildings depended on the exclusion of the migrant underclass. These establishing shots therefore emphasize the dual process of uneven economic development and distribution of wealth. Like the tightly-bound layers of an onion,

the city is made up of circular boundaries of exclusion, which move centrifugally outwards onto the M-30 road and its surrounding hinterlands.

Between robberies, the characters spend much of their time in the wasteland adjacent to the roads. In the first of these scenes, which takes place in what appears to be an abandoned quarry, a long shot slowly pans pieces of defunct rusty agricultural machinery before moving onto the site of the actors. The following shot shows Pablo and Ángela firing a gun at some rusty tin cans which, like the equipment, are strewn across the rocky ground. The rusty farm equipment, stripped of its mechanical function and located on the fringes of the Castilian landscape, points to the demise of the region's agrarian economy, while the cans signal the increasing levels of waste brought about by the consumerism of the city. Expelled from the country and the city respectively, the farming equipment and the tin cans establish a correspondence with identity of the migrant delinquent. Like the detritus that surrounds them, they too are neglected and forgotten from both rural and urban spaces.

Pollution also figures in another sequence in which the group of friends goes horseback riding, again on the fringes of the city. Mounted, the five friends cross a busy suburban road to reach a lake. Now from the opposite side of the actors, an extreme long establishing shot situates the teenagers on the edge of the lake, next to a dead tree. In the forefront of the composition, the light of a beating sun emphasizes the brown, murky colour of a lake clogged with discarded barrels and sewage. The non-diegetic music fades as the sequence cuts to a full shot of the actors. A long shot from the POV of the actors tracks the other side of the lake, which is flanked by an abandoned mine. The camera dwells on the post-industrial landscape for a few seconds, while the sound of a bird calling and a passing express train are audible. Pointing towards the water, Meca tells his friends that when he was a child, the water was so clean that he could bathe and go fishing: 'En este lago yo me bañaba cuando yo era crío ... había patos y peces... pescábamos antes ... es muy hondo, muy hondo ... no veas.'[4] If his words evoke images of purity and innocence, the accompanying images serve as a striking contrast: his childhood play area has since become a cesspit in which Madrid dumps its sewage. Waste has arguably become an instrument of spatial control, circumscribing even more areas from which they are excluded and pushing them further away from the city. By connecting pure water with Meca's childhood, and contaminated water with his adolescence, the lake is arguably metaphorical: it posits an analogy for children who, through the geographic exclusion which the lake now symbolizes, have grown up to be neglected teenagers.

A parallel can also be further suggested between the infected water and the social infection that the teenagers embody. Like the sewage, the city purges itself of the social filth that the delinquents embody through

geographical expulsion. The rows of housing blocks discussed above subsequently take on the symbolism of a purifying filter, containing and excluding the marginal other. According to the geographer David Sibley, the association between the poor and the dirty has been a long-standing one and it ultimately finds its articulation in what he calls 'class-based geographies of defilement' (1995, p. 61). He identifies this as being crucial component of English Victorian urbanization.

> The poor as a source of pollution and moral danger were clearly identified in contemporary accounts of the nineteenth-century capitalist city. As socio-spatial segregation became more pronounced, the distance between the affluent and the poor ensured the persistence of stereotyped conceptions of the other. (Sibley, 1995, p. 55)

According to the author, once living conditions had improved and the poor were sanitized, the same notions of dirt and disease were used to construct images of immigrants, thereby conflating defilement with the language of racism (Sibley, 1995, p. 58). The author adds that this kind of discourse still exists today, with not only racial minorities being perceived as polluting, but other 'inner-city' social minorities, including Gypsies, ethnic minorities, gay and homeless people (Sibley, 1995, pp. 58–9). Although Sibley's account centres on the English model of urbanization, where the poor have been traditionally positioned within the city centre and the middle classes in the leafy suburbs, the socially constructed association between the poor and the defiled is clearly relevant to the film. This link is established in the opening sequence of *Deprisa*, when the victim of the car robbery calls Pablo and Meca 'canallas' (scum), and is reflected in the dishevelled appearance of the male actors who have greasy hair and spotty complexions, and wear sweaty and stained clothes.

Pollution, however, is not just encountered in the urban or semi-urban spaces, but also in the Castilian village of Maderuelo – the heart of rural Spain, and the birthplace of the protagonist. On their way to visiting Pablo's grandmother who still lives in the village, Pablo and Ángela stop to look at Maderuelo's surrounding landscape. Pointing towards an abandoned mattress and the several mounds of litter that lie on the track to the village, Pablo says: '¡Qué mierda! Hasta esto tienen que joderlo con la mierda de la basura . . . vamos a terminar todos enterrados en mierda. ¡Qué asco, coño!'[5] After a few moments, Pablo points to the small village lying immediately below them. Again, a once idyllic locus of childhood and nature has given way to desolate wasteland. Here, Pablo's fear that they will all be 'buried in shit' functions on two metaphorical levels. First, it makes explicit the link between abject filth and the delinquent that was first established in the lake scene. Second, it anticipates a process of social control in its most extreme expression, with exclusionary boundaries of waste so totalizing that they

even encroach upon the bodies of the delinquents themselves. Moreover, the imagery of being buried further invokes the claustrophobia and paralysis experienced by those who, like Pablo and his peers, have been divested of agency. Filmed in the heart of rural Spain, the scene draws attention to how Pablo has not only been rejected from the city but from the country as well. But if the village has rejected Pablo, then Pablo has also rejected the village. In responding to Ángela that the village is only beautiful for an hour, Pablo's comment reflects the changing perceptions towards a Spanish countryside that now only serves as a site for the fleeting consumption of tourists.

Liminal spaces, times and identities

In *Deprisa, deprisa*, boundaries are not only erected to contain and exclude; they also serve to both constitute and reflect the identities of the migrant underclass. In pertaining neither strictly to the city nor the country, the formation of their identities works to mix the social categories of urban and rural, thereby disrupting and transgressing their discursive boundaries. If the identity of Pablo and his friends rests precariously between the city-dweller and migrant, it also inhabits a blurred space between childhood and adulthood. Typical child and adult signifiers and codes of behaviour are counterposed in the film so as to illustrate this liminality. For example, in their local bar Pablo drinks a beer while Meca drinks some cold milk. Another set of contrasts is established within Pablo's small bedsit. In one scene, Pablo is seen reading the comic *Mortadelo y Filemón* while his girlfriend María waters the plants and undertakes housework chores. The *mise en scène* of the room, with walls adorned with posters of motorbikes and rag dolls as ornaments, belies the very adult behaviour of the couple. For in the same room, Pablo and María talk about buying a house together, practise holding a gun and plot bank robberies. The use of editing and sound further underscores this contradiction. Having parked the stolen vehicle in an abandoned quarry, the gang practises their shooting skills by firing at tin cans. On hearing the siren of a police car, they drive off into the surrounding thickets, with the police following shortly after. A sound bridge of the siren connects us to the following sequence, in which Pablo and Mecas are playing space invaders in a bar. Gradually, the police sirens fade into the similar wailing sound of the computer game. Like the children's arcade game, in which the player adopts the role of the aggressor, adult crime is just another game for Pablo and his friends. The liminal social identity of the teenager is described by David Sibley as follows:

> The boundary separating child and adult is a decidedly fuzzy one ... Adolescents are denied access to the adult world, but they attempt to distance themselves from the world of the child. At the same time, they

retain some links with childhood. *Adolescence is an ambiguous zone* within which the child/adult boundary can be located according to who is doing the categorizing. (1995, pp. 34–5, emphasis added)

That Sibley describes a time-limited identity such as youth in spatial language is particularly revealing. The liminal boundaries through which teenagers must move in fact participate in the production of their liminal identities.

The concept of liminality is absolutely central to the writing of Homi Bhabha, one of the most important thinkers in the contemporary field of post-colonial criticism. Although this chapter deals with the identities of internal migrants rather than those foreign immigrants and refugees, Bhabha's thinking nevertheless sheds light on the formation of marginal, in-between identities at moments of sociohistorical transformation. For the author, minority identities should not be read as pre-given identities which are pitched in opposition against traditionally dominant ones; rather, the two are locked in a constant state of negotiation. Instead of dwelling upon the usual binary oppositions between the First World and the Third World, between the colonizer and the colonized and between black and white, we should instead divert our attention to the boundaries between them. In so doing, we should think 'beyond narratives of originary and initial subjectivities' favoured by official culture, and instead focus upon 'those moments or processes that are produced in the articulation of cultural differences' (1994, p. 1). According to the author, the boundaries between official cultures and identities are where new cultural meaning is created. In the words of Homi Bhabha, they constitute 'the location of culture'.

These 'in-between' spaces provide the terrain for elaborating strategies of selfhood – singular and communal – that initiate new signs of identity, and innovative sites of collaboration, and contestation, in the act of defining the idea of society itself. (1994, pp. 1–2)

For Bhabha, these borders are where personal identities and shared national identities are performed and contested. In embracing liminality, the author therefore emphasizes the fluidity and hybridity of 'nationness', thereby undermining the more traditional conceptualization of the nation state as a monolithic and homogeneous entity.

The overlapping of the spatial and the temporal can be witnessed in the 'beyond', a term that Bhabha uses to describe the liminal 'location of culture'. Being in the 'beyond' not only refers to being in an in-between space; it also means to be part of 'a revisionary time, a return to the present' which 'reinscribe[s] our human historic commonality' (Bhabha, 1994, p. 7). In other words, the meaning of the 'beyond' privileges 'cultural contemporaneity' and the 'here and now' (Bhabha, 1994, p. 7). The 'beyond' therefore indicates cultural reinvention and newness; it is a space

of the present. Bhabha conveys his conceptualization of the 'beyond' by means of the trope of movement:

> For there is a sense of disorientation, a disturbance of direction, in the 'beyond': an exploratory restless movement caught so well in the French rendition of the words *au-delà* – here and there, on all sides, *fort/da*, hither and thither, back and forth. (1994, p. 1)

According to Bhabha, this ambulatory movement finds its fullest expression during moments of cultural transition, where the intersection of space and time gives rise to 'complex figures of difference and identity, past and present, inside and outside' as well as, most pertinently for our analysis, the figure of 'inclusion and exclusion' (Bhabha, 1994, p. 1).

Bhabha's writing illuminates the social and geographical positioning of the delinquents in *Deprisa, deprisa,* who are also arguably situated within 'the location of culture'. While their directionless movement back and forth across the hinterland underlines the spatial dimension of the 'beyond', their transitional age as teenagers underscores its temporal dimension. Moreover, as they are symbolically positioned as the emerging present, they represent the 'cultural contemporaneity' and newness of a nation in seismic cultural change. Their hand-to-mouth, day-by-day existence on the fringes of the modern city would therefore literally appear to bear out Bhabha's claim that the 'beyond' is characterized by 'a tenebrous sense of survival, living on the borderlines of the present' (1994, p. 1). This is perhaps most evoked in the film's title itself: the words *Deprisa, deprisa* foreground the frenetic pace to which its characters must adhere in order to survive. As its promotional blurb says: 'No quieren sino huir de lo que viven y para eso necesitan dinero, mucho dinero. Lo que pasa tiene que pasar en poco tiempo. El dinero, deprisa. El placer, deprisa. El amor, deprisa'.[6] In an interview, Saura has claimed that he was fascinated by the nomadic spontaneity of the teenage actors, who would suddenly decide to travel to other parts of the country (Sánchez Vidal, 1988, p. 150). According to the director, this provided the inspiration for the scene in which the group decides to drive to the sea one night – an event that happened during the time he was working with them (Sánchez Vidal, 1988, p. 150). Their itinerant, impulsive movement therefore recalls the 'exploratory, restless movement . . . hither and thither, back and forth' (Bhabha, 1994, p. 1) which characterizes the 'beyond'.

Pertinently, Bhabha himself has drawn attention to the metaphorical potential of youth culture, and has suggested that their status throws light on his own conceptualizations of nations and identities in process. In an interview for *Sight and Sound,* Bhabha discusses *Young Soul Rebels* (Isaac Julien, 1991), a film which tells the story of two teenage boys – one black and the other mixed-race – who are soul music DJs in London. The film's

emphasis on youth culture and cultural hybridity suggests some interesting parallels with *Deprisa, deprisa*. Set during the celebrations of the 1977 silver jubilee, the film proffers an alternative account of an important historical event that has contributed towards the shaping of an official national identity. In Bhabha's analysis of the film, the role of youth is privileged as a site on which questions of national and individual identities are staged. According to the author, *Young Soul Rebels* 'offers a creative re-definition of local space. The 1977 silver jubilee was so much about the celebration of local community, with all those "little Englands" decked out in red, white and blue bunting. The film turns this on its head and shows that there exists a range of cultural localities that conflict or coexist with each other' (1991, p. 18). Moreover, according to Bhabha, the celebration of hybridity that the film advances works particularly well with teenagers: 'That's what makes a transient, transitional youth culture such an excellent choice for a film about sexuality and ethnicity – it doesn't allow either of those identities to become fixed' (1991, p. 18). Indeterminate, fluid and hybrid, the identity of the teenager therefore appears to vividly convey Bhabha's notion of the 'beyond', a liminal site of culture that provides an alternative narrative of the nation. Through analysing two scenes of *Deprisa, deprisa* in depth, the section which follows will attempt to show how these alternative narratives are constructed in the film.

Narratives and counter-narratives of the nation

Blissfully unaware of their country's recent past, Pablo and his friends construct an altogether different narrative of the nation. As D'Lugo has observed, their ignorance is most thrown into relief when the group visits El Cerro de los Ángeles (1991, p. 100), a hill that marks the geographical centre of Spain. Raised above the surrounding flatlands of Getafe just south of Madrid, the site houses the Sagrado Corazón, a dramatically towering statue of Jesus which welcomes onlookers with open arms. Riddled with bullet marks, El Cerro de los Ángeles was the location of some of the bloodiest battles of the Civil War. During this period, the statue was destroyed by the republicans and Franco, in a typical gesture of defiance, oversaw the building of the replica which is seen in the film.

Despite its physical presence, the significance of the monument eludes Pablo and his friends. A low-angle, reverse travelling shot frames the replica of the Sagrado Corazón as the focal point of the scene, its grandiloquent height towering over the diminutive stature of the teenagers who are walking away from the statue. A late afternoon sun submerges the actors' bodies in deep-cast shadow, further reinforcing the prominence of the monument. While walking, the friends reminisce over the first times that

they committed a crime. As they approach the statue of the Sagrado Corazón, they stop to inspect it. Reading the inscription on the statue, Meca jokes: 'Cabeza de la imagen profanada del Sagrado Corazón de Jesús' – ¿Qué le habrá pasado a éste?'.[7] An elderly lady, who is inspecting the monument nearby, explains to the group that it commemorates the fallen nationalists during the war, and was destroyed by the republicans. Sebas responds by asking '¿Pero de qué guerra habla ésta tía?' [But which war is this woman talking about?].

The contrasting attitudes of the elderly women and the teenagers towards El Cerro de los Ángeles illustrate Homi Bhabha's ideas on how national identity is performed and contested. According to the author, the modern national subject is split between the pedagogical and the performative. The pedagogical refers to the way in which the people are constructed as an 'a priori historical presence' (1994, p. 147) and are subjects of a 'prefigurative self-generating nation' (1994, p. 148). The performative, on the other hand, refers to how people are 'constructed in the performance of narrative', whereby 'its enunciatory "present" [is] marked in the repetition and pulsation of the national sign' (1994, p. 147). The performative 'intervenes in the sovereignty of the nation's *self-generation* by casting a shadow between the people as "image" and its signification as a differentiating sign of Self, distinct from the Other of the Outside' (1994, pp. 147–8). In other words, while the pedagogical tells the nation and the people that they have *always* formed an organic, cohesive and homogeneous whole, the performative demonstrates that identities are *continually being performed* and are alienated from the official culture, thereby undermining the solid essence of the nation. Both concepts form an interdependent relationship, and are poised in an ongoing, antagonistic struggle. The division of the national subject should not be viewed as between one nation and an 'Other' foreign nation, but 'split within itself' (1994, p. 148); that is, within the same nation. This internal division therefore manifests itself in a nation's heterogeneity and hybridity.

Central to Bhabha's dual conceptualization of the pedagogical and the performative is the question of temporality. The splitting of the nation, according to the author, manifests itself in a kind of 'double time' (1994, p. 144) or a 'double narrative movement' (1994, p. 145). On one hand 'the people are the historical "objects" of a nationalist pedagogy, given the discourse an authority that is based on the pre-given or constituted historical origin *in the past*', but on the other the people are also '"subjects" of a process of signification that must erase any prior or originary presence of the nation-people to demonstrate the prodigious, living principles of the people as contemporaneity' (1994, p. 145). If the former foregrounds a sense of national time that is ahistorical and immemorial, the latter articulates the time of the here and now. But this sense of contemporaneity is

historically displaced from the linear continuum of time on which the nation founds itself, thereby introducing a 'temporality of the in-between' (1994, p. 148). According to Bhabha, then, this kind of interstitial time is fertile for the development of 'residual and emergent practices' that are located in the 'margins of the contemporary experience of society' (1994, p. 148).

In this scene, El Cerro de los Ángeles symbolizes a pedagogical strategy. Situated in the geographical centre of Spain, it transmits the national consciousness. The nation that the monument narrates, however, embodies two of the main tenets of Francoist ideology. In conflating national Catholicism with the victory of the Civil War, the memorial participates in the religiously ordained *cruzada* on which Franco based his conception of the Spanish nation. Located above the hills of Castile, it becomes as timeless as the organic rural setting that surrounds it, thereby naturalizing the ideology that the statue transmits. As such, the narrative of the Spanish nation becomes an 'a priori historical presence' (1994, p. 147), preordained and given. In rebuilding the holy monument in defiance of the iconoclastic republicans, the turbulent pre-Francoist nation is supplanted and transcended by one which is eternal and immemorial. The elderly women, who both respect and admire its sacredness ('es indignante en un sitio como éste ... ni siquiera aquí en un lugar sagrado', says one), also appear to be aligned with the pedagogical.[8] In didactically explaining its history to the youngsters, they bring to light the more literal meaning of Bhabha's term.

If the ladies demonstrate the pedagogical, then the delinquents show how the performative reveals itself. In mocking the ladies, the teenagers refuse to be part of Spain's national history. As the friends are more interested in exchanging personal anecdotes on their formative years of delinquency, the scene contrasts the narrative of public memory with that of private memory. However, the sequence does not merely serve to juxtapose the Francoist past with post-Francoist present. The contemporaneity that the teenagers embody is not part of the continuum of the past, present and the future. For they inhabit the disjunctive, in-between time of the performative, a temporality that falls outside the rational linearity of national histories. Culturally divorced from the national identity imposed by the monument, their perception of history privileges that of the private over the public, their marginal subculture over the nation. Moreover, their stories of delinquency are examples of subcultural, marginal practices, precisely the kind of practices that are illustrative of the performative (1994, p. 148). Bhabha writes that the performative gives rise to 'counter-narratives of the nation', and the stories of Pablo and his friends arguably bear this out. According to the author:

Counter-narratives of the nation that continually evoke and erase its totalizing boundaries – both actual and conceptual – disturb those ideological manoeuvres through which 'imagined communities' are given essentialist identities. (Bhabha, 1994, p. 149)

The teenagers therefore appropriate and contest the national narrative of El Cerro de los Ángeles – and, by extension, the nation – reconfiguring it as a liminal site of contestation.

That the role of Pablo was performed by José Antonio Valdelomar, a real-life delinquent from the area, sheds further light on Bhabha's notion of the performative. The naturalistic movement of the actors within their own real-life milieux enables them to tell their *own* stories, to re-enact elements of their own lives. Ironically, the fictional trajectory of Pablo would turn out to anticipate events in the actor's real life: three weeks before the premiere of *Deprisa, deprisa,* Valdelomar was arrested for robbing a bank in Ríos Rojos, a district close to the bank robbery that takes place in the film (Anon., 1981, p. 27). Valdelomar, as a result, was unable to attend the premiere of his own film as he was serving a prison sentence. Most prescient, perhaps, is the film's penultimate sequence, whose verisimilitude not only blurs the film's formal boundaries between fiction and reportage, but also serves to re-inforce the in-between temporality and identity of the migrant delinquent. After Pablo is shot during the bank robbery, Ángela comforts her dying boyfriend in their flat; in the background, a television newsflash appeals for information on the young fugitive. The shadowy *mise en scène* of the flat, in which the blinds are closed, emphasizes the television's bright flickering screen as a principal source of light. As such, the television set replaces the window as the view onto the outside world. After a few moments, the television news bulletin can be seen via an extreme close-up shot, so that the screen dominates the whole of the frame, creating the impression that we are watching the real thing. The knee-jerk histrionics of the news report serve to vilify the delinquents: grainy, sinister-looking mugshots of Sebas are followed by interviews with supposed witnesses condemning the teenagers, including that of a middle-aged man who compares the social problem of delinquency with that of terrorism. Again, life would turn out to imitate art: upon the release of *Deprisa, deprisa* similar levels of hysteria were also reached in the press, who maligned the film for glorifying delinquency. The right-wing newspaper *ABC* even accused the collaborative team of supplying the actors with drugs during the shoot, a story that Carlos Saura has strongly denied (Sánchez Vidal, 1988, p. 147). In both the film and in real life, the media would therefore appear to participate in the exclusion of difference. The media, which works to instil a shared sense of national self, appears here to take on a pedagogical role, enacting a 'continual displacement of the anxiety of its irredeemably plural modern nation' (Bhabha, 1994, p. 149).

But, as we have seen, the pedagogical can only exist in ambivalent conflict with the performative. If the media marginalized the delinquents, it also allowed the public to indulge vicariously in the Otherness of their subcultural lives. The story of the bank robbery, which aroused a great deal of public interest, received extended coverage in the media, and these extra-textual factors undoubtedly contributed to the film's commercial success: it made 155 million pesetas the year of its release, making it Querejeta's biggest hit to that date (Hernández Les, 1986, p. 331). The television can be seen as representing both a liminal space and time – a particularly apt medium for articulating the performative. While it marks a place that is neither public nor private, neither here nor there, it introduces a postmodern experience of time that is fragmented into a perpetual, simultaneous present; a temporality, in fact, that characterizes the contemporaneity of the performative. The media, therefore, arguably enacts a further narrative struggle of the nation.

Conclusion

This chapter has explored the production of space through its relationship with social identity. As I have shown, in *Deprisa, deprisa,* as in other Querejeta collaborations which focus on teenage identity, the delinquent is clearly positioned as a product of his environment. Neither urban nor rural, neither adults nor children, the in-between identity of the delinquents has been discussed as a trope for a nation that was itself in the process of great social and geographical transformation. This environment, which is one of exclusion and inequality, has been shown to be subject to the uneven processes of urban development which were brought about during Spain's miracle years. As well as denoting their marginalization and exclusion, the representation of borders has been discussed as pointing to the way in which their in-between identities are constituted. Bhabha's writing has illuminated how liminal identities, such as those of the teenagers, emerge at times of sociohistorical transformation. Their emergence, Bhabha has shown, is integral to new ways of constructing the nation through space.

Chapter 6

Global Spaces

In recent years, Elías Querejeta has focussed his attention beyond the national borders of Spain. For instance, *El último viaje de Robert Rylands* (*Robert Rylands' Last Journey*) (Gracia Querejeta, 1996) is a psychological drama set entirely in Oxford, while *Cuernos de espuma* (*Shampoo Horns*) (Manuel Toledano, 1998) is a fictionalized account of the drag queen nightclub scene in New York. With Jaime Corcuera's hard-hitting documentaries *La espalda del mundo* (*The Back of the World*) (2000) and the *Invierno en Bagdad* (*Winter in Baghdad*) (2004), the producer has continued to back projects which centre on the marginalized and the dispossessed. While *La espalda del mundo* examines child labour in Peru, the death penalty in the United States and political refugees in Sweden, *Invierno en Bagdad* provides an exposé on the atrocities committed in the recent Iraq War. In narrating other geographical spaces, these films seek to widen the horizons of Elías Querejeta PC.

If these productions seek to represent the global over the local, *Los lunes al sol* (Fernando León, 2002) and *Las cartas de Alou* (Montxo Armendáriz, 1990) demonstrate how the local is affected by the global. Addressing the growing Spanish social problems of male unemployment and illegal immigration respectively, the films point to globalization as their cause. While in the previous chapter marginal identities are discussed as a product of post-*apertura* capitalism, in this chapter it is the inexorable growth of global capitalism which shapes and challenges identity. The films show that in times of increasing globalization, existing Spanish identity formations and cultural belonging are repeatedly called into question. This chapter is divided into five sections. In the first part, the films are firmly situated within their sociohistorical context, centring on the radical economic changes which the PSOE government brought about. The restructuring of the Spanish economy, whereby national industries were opened up for foreign investment and immigration was controlled, signals the incipient stages of globalization in Spain. The second section, which lays out the critical framework for the chapter, introduces Foucault's notion of the heterotopia.

Foucault's writing is used to investigate the complex spatial dynamics of globalization, which are in turn illustrated by the ways in which they have subsequently taken root in Spain. It focusses on four key dimensions of heterotopia – the tension between utopian and real spaces, movement and control, the relationship between space, and spatial tension – which will subsequently serve as theoretical tools for the textual analysis of the films. The third section, which provides an analysis of *Los lunes al sol,* explores how globalization has led to the reconfiguration of public and private spheres, spaces which have traditionally been mediated by gender. In so doing, it will also discuss how the film's formal tension between social realism and melodrama results in spatial tension. The fourth part, which examines *Las cartas de Alou,* addresses the importance the film ascribes to movement and home. Both socially and spatially incompatible, the segregation that the African protagonist encounters is seen as a consequence of the enforced division of labour. The final section of this chapter explores the theme of utopia in both films. The tension which is created in the films between utopia and reality, fantasy and failure articulates the powerful vision of globalization, which advances a utopian vision of unfettered, mobile space, but which is simultaneously denied to the marginal.

Towards a globalized Spain

Shortly after the PSOE was elected in 1982, the first steps were made towards making Spain a globalized economy. The country's economic reform was symbolic of a greater trend which was sweeping through western Europe, where governments were beginning to withdraw from direct involvement in economic activity. Awakened by the radical reforms of Margaret Thatcher, public companies were suddenly being opened to the discipline of the international market (Harrison and Corkhill, 2004, p. 90). Despite the considerable opposition within the ranks of the socialist party, it was agreed that if Spain's economy were to be integrated into the EC (later the European Union), action would have to be taken to overhaul its structures (Harrison and Corkhill, 2004, p. 148). As McVeigh demonstrates, the social-ist party inherited a large public sector concentrated in traditional indus-tries such as textiles, steel and shipbuilding which were in considerable debt and largely in decline (2005, p. 94). A drain on government resources, these industries were to be gradually closed down and replaced by foreign investment instead (McVeigh, 2005, p. 103).

As well as attracting global capital, Spain's neoliberal economy would also lure an increasing number of economic migrants from the developing world: as Harrison and Corkhill note, 'from the mid 1980s Spain trans-formed from a net exporter of the population to a net importer' (1994,

p. 38). The influx of immigration filled the critical niches that were being vacated by Spanish workers: agriculture, construction and domestic service (Calavita, 2005, p. 68). However, while the nation readily promoted the unfettered mobility of capital, the free movement of immigrants was pointedly less encouraged. In June 1985, Spanish parliament passed the 'Ley Orgánica de Extranjería' (Constitutional Immigration Law), a law designed to control illegal immigration and guarantee foreigners' rights (Calavita, 2005, p. 27). There was, however, a catch involved: immigrants had to gain steady employment to maintain legal status, but given that they were usually forced to work in such precarious and unstable sectors, these conditions proved extremely difficult to meet (Calavita, 2005, p. 27).

Although globalization might well promote free and equal exchange, its detractors often claim that it in fact *conceals* the hegemonic features it depends upon (Dissanayake, 2006, p. 29). According to Doreen Massey, this is because the story of globalization has predominantly been told from the geographical speaking position of the powerful (1999, p. 43). In representing the social realities of immigration and post-industrial unemployment from the perspective of those who are oppressed, *Las cartas de Alou* and *Los lunes al sol* attempt to *reveal* precisely these hegemonic mechanisms.[1] Both films were the first to respectively dramatize these issues, and were conceived with the intention of exposing political realities which were largely unknown by the Spanish public.[2] Moreover, the films are intimately bound up with the medium of documentary, a fact that further shores up their commitment to realism.[3] Armendáriz says that he initially thought of making a documentary about immigration after meeting African street-sellers in Pamplona (Angulo et al., 1998, p. 246). After informing Querejeta of his idea, both director and producer travelled around Barcelona, Lérida, Almería, Huelva and León in order to meet communities of migrants (Angulo et al., 1998, p. 246). As many of the immigrants were illegal, they were unable to film as freely as they had hoped, and were therefore forced to abandon the documentary for a feature film instead (Angulo et al., 1998, p. 246). As in his earlier film *Tasio* (see chapter 4), the material that Armendáriz had researched formed the basis for his script (Angulo et al., 1998, p. 247). *Los lunes* similarly found its source in the medium of documentary. León visited a demonstration of shipbuilders in Gijón, Asturias, and he based the characters in the film on the experiences of the people he interviewed there (Ponga et al., 2002, p. 155).[4] The documentary footage of the demonstrations appear during the opening credits, so as to explain the recent histories of the characters (Ponga et al., 2002, p. 155).

Both victims of globalization, the shipbuilders and immigrants, are, in the films, shaped and determined by social and economic motivations. Their struggle against the system which contains them is most noticeably foregrounded in the films' opening sequences, where the demonstrators

and the illegal immigrants are framed in medium long shots as part of a larger collective. Often used in Italian neo-realist films such as *Bicycle Thieves* (Vittorio De Sica, 1948), this visual strategy serves to represent the characters as metonymic agents within a greater class struggle. This is clearly borne out by the promotional tagline of *Los lunes*, which reads: 'Este film no está basado en una historia real, sino en miles.'[5]

Globalized space as heterotopia

Michel Foucault's notion of heterotopia was developed in a lecture entitled 'Of Other Spaces', and although it was originally given in 1967 it was not published until 1986, almost twenty years later. Since its publication, the concept of heterotopia has captured the imagination of a considerable number of geographers who work with contemporary ideas of spatiality.[6] Foucault's lecture, however, is not without its limitations: it is just over a few pages long, and several of his passages are left obliquely undeveloped. Precisely because of its vague structure, I will place Foucault's writing in dialogue with three other authors: the sociologist Pierre Bourdieu, and the geographers Doreen Massey and Kevin Hetherington. In light of their writing, I will demonstrate that the concept of heterotopia can serve as an invaluable tool for examining the space of globalization. In so doing, I will discuss four interrelated aspects of the heterotopic in the following order: one, the tension between utopian and real spaces; two, the spatial play between control and freedom; three, the relationship between different global places; and four, the socially disruptive quality of being 'out of place'. In turn, I will show how these four dimensions find their expression in the changing sphere of globalized labour relations, focussing particularly on the questions of post-industrial employment and immigration in Spain.

According to Foucault, contemporary society is made up of two kinds of spaces: utopias and heterotopias. Utopias, for Foucault, are 'sites with no real place. They are sites that have a *general relation of direct or inverted analogy* with the real space of Society. They present society itself in a perfected form, or else society turned upside down, but in any case these *utopias are fundamentally unreal places*' (1986, p. 3). Foucault compares utopias with the spaces of heterotopias, which he describes as 'an effectively enacted utopia' (1986, p. 3), a space in which utopias find their material expression. A heterotopia is therefore both an imagined *and* a real place, a site of fantasy *and* a geographical entity.

Although written some fifteen years before the incipient stages of free trade, Foucault's notion of utopia prefigures the kind of discourse that would surround neoliberal economics, where Western political parties and other champions of globalization have often been quick to proclaim the

utopian freedom it brings to bear. According to Pierre Bourdieu: 'as the dominant discourse would have it, the economic world is a pure and perfect order, implacably unrolling the logic of its predictable consequences' (1999, p. 94). Neoliberalism, Bourdieu asserts, tends to 'sever the economy from social realities', removing any kind of structures that may serve as an obstacle to the pure market (1999, p. 95). Bourdieu argues that 'the ultimate foundation of this entire economic order placed under the sign of freedom is in effect the *structural violence* of unemployment, of the insecurity of job tenure and the menace of layoff that it implies' (1999, p. 97). In abolishing the worker solidarity of trade unions and reducing both the cost of labour and public expenditure, neoliberalism creates 'a *utopia of endless exploitation*' (1999, p. 95), whereby the implacable evolution of the market oversweeps the societal repercussions that follow in its wake, leaving the marginal and the dispossessed behind to fend for themselves.

In mapping the relationship between globalization and spatiality, the geographer Doreen Massey establishes some significant zones of contact with Foucault's heterotopia. For Massey, the economic process of globalization depends on a powerful imaginative geography of social inequality. Integral to its achievement is, according to the author, 'a geographical imagination which ignores the structural divides, necessary ruptures and the inequalities on which the successful projection of the vision itself depends' (1999, p. 37). While Bourdieu's critique of neoliberalism rests upon the question of unemployment, it is the issue of immigration that provides the main focus for Massey. While the dominant discourse presents neo-liberalism as a utopian 'powerful vision of an immense, unstructured, free unbounded space' of 'unfettered mobility' (Massey, 2005, p. 83), the reality for the poor and subaltern bears out a starkly different story:

> There are two apparently self-evident truths, two completely different geographical imaginations which are called upon in turn. No matter that they contradict each other, because it works. And so in this era of globalisation we have sniffer dogs to detect people hiding in the holds of boats, people die trying to cross the Rio Grande, and boatloads of people precisely trying to 'seek out the best opportunities' go down in the Mediterranean. *That double imaginary, in the very fact of its doubleness, of the freedom of space on the one hand and 'the right to one's own space' on the other,* works in favour of the already powerful. They can have it both ways. (Massey, 1999, p. 39, emphasis added)

This 'double imaginary', which posits an *imagined* unbounded space on the one hand but a *material* process of control and exclusion on the other, resonates with Foucault's description of a heterotopia as both a utopian and real space. As in the heterotopia, where the creation of space is largely a product of utopia, the 'double imaginary' seeks to legitimize neoliberalism through a utopian discourse. In this way, the spatial discrepancies of

difference and inequality are occluded, giving rise to what Massey terms 'a geographical imagination which ignores its own real spatiality' (1999, p. 37).

Significantly, in underscoring the tension between freedom and control, Massey's notion of the double imaginary also resembles the second key dimension of the heterotopia, where, according to Foucault, it:

> always presupposes a system of opening and closing that both isolates them and makes them penetrable . . . Either the entry is compulsory, as in the case of entering a barracks or a prison, or else the individual has to submit to rites and purifications. To get in one must have a certain permission and make certain gestures (1986, p. 5).

As we have seen, a dual process of opening (the free circulation of capital) and closing (the restriction of movement) is pivotal to the project of globalization – a system which, according to Massey, only works in favour of the powerful. This antagonistic dualism, which endlessly seeks to reproduce the disparity between rich and poor, has been described by Massey elsewhere as a 'geometry of power'. She writes that 'global space, as space more generally, is a product of material practices of power. What is at issue is not just openness and closure . . . but the constantly-being-produced new geometries of power; the shifting geographies of power relations' (2005, p. 85).

Massey's emphasis on the power relations *between* different geographic spaces leads us onto the third crucial point of Foucault's lecture: the interrelatedness of space. As a space in which 'all other real sites' are 'simultaneously represented, contested and inverted', a heterotopia is not just a characteristic of one specific place, but a particular *relation between* different places. Indeed, Foucault writes elsewhere in the lecture that 'our epoch is one in which space takes for us the *form of relations among* sites' (1986, p. 2, emphasis added). The interrelatedness of spaces, it would appear, is also integral to the transnational success of neo-liberal capitalism. Although Foucault does not specifically mention space on a global scale, Massey develops the same concept within the context of globalization. According to her, contemporary space should be understood *relationally*: it is 'the product of interrelations; as constituted through interactions, from the immensity of the global to the tiny' (2005, p. 9). She goes on to argue that 'precisely because space is a product of relations-between, relations which are embedded in material practices which have to be carried out, it is always in the process of being made' (Massey, 2005, p. 9). Heterotopic space can therefore be viewed as a nexus of global flows, a patchwork of economic interdependencies that forges connections from the international to the local.

Over the past two decades, the repercussions of this global economic network have been most profoundly felt in the workplace. As the geographers Noel Castree et al. argue, 'contemporary wage-workers are in a

complex landscape of geographical difference and geographical inter-dependence' (2004, p. 8). In other words, the conditions of workers in one locality are bound up with the fortunes of what is happening elsewhere in the world. As we have seen in the previous section, this is especially borne out in the cases of economic migrants and the traditional working classes who are employed in the heavy industries. Although these two groups comprise people from clearly different social backgrounds and races, the nature and fortunes of both are dependent on global factors. As in other wealthy western European nations, the steady rise of migrants to Spain has confirmed its status as a land of plenty (see Santaolalla, 2003, p. 62; Flesler, 2004, p. 103). At the same time, however, this increase also points to the dire socio-economic conditions of countries which lie beyond Spain's national borders. Indeed, the majority of those who have emigrated to Spain have hailed from the underdeveloped Third World (Calavita, 2005, p. 27). Furthermore, the conditions of these countries have in fact deteriorated since the onset of global capitalism: in the southern hemisphere, the gap between rich and poor doubled between 1980 and 1990 (Lipsitz, 1999, p. 194).

Although less immediately visible, the fate of the industrial classes of Spain have similarly been shaped by dynamics of change at a global scale, and the shipbuilding industry is clearly no exception. Drawing on the example of north-east England, Castree et al. show that over the last three decades, competitive international pressures have borne an impact on the manufacturing industry, leading to widespread job losses (2004, p. 145). According to the authors, the deregulation of foreign investment has precipitated a massive outflow of manufacturing to cheaper offshore loca-tions (Castree et al., 2004, p. 145). It is precisely this tide of international competition that led to the mass redundancies in the shipbuilding commu-nities of Gijón, whose union speeches provided the inspiration for Santa's (Javier Bardem) monologue in *Los lunes al sol* (Ponga et al., 2002, p. 158), where he protests against a free market economy which lays off local workers while purchasing ships from Korea. In belonging to heterotopic spaces of interrelatedness, both immigrants and the indigenous working classes can be seen as caught up in intersecting narratives of the global and the local.

As well as generating social inequality and labour control, the co-implication of the local and the global has also brought to bear consider-able societal change, which leads us onto the fourth and final dimension of heterotopic space. It is a commonplace that in a world of intensified movement and economic change, space becomes multivocal: different races and cultures are brought together to inhabit the same places, and traditional spatial structures are transgressed. Foucault describes this plural-ity of space as living inside 'a set of relations that delineates sites which are

irreducible to one another and absolutely not superimposable on one another (Foucault, 1986, p. 2). In other words, the coexistence of different spaces is far from harmonious; it engenders, rather, a process of spatial and social disruption. Foucault stresses this more explicitly in another passage, where he writes: 'a heterotopia is capable of juxtaposing in a single real space several spaces, several sites that are in themselves incompatible' (1986, p. 4). This sense of spatial incompatibility is the fourth crucial dimension of Foucault's heterotopias.

This aspect of heterotopic space is usefully developed by the geographer Kevin Hetherington who, in drawing on Foucault's writing, examines the social change which modernity brought about in eighteenth-century France. Hetherington explains that heterotopias 'unsettle because they have the effect of making things appear *out of place*' (1997, p. 50, emphasis added). Crucially, he adds that this juxtaposition of the unusual 'creates a challenge to all settled representations; it challenges order and its sense of fixity and certainty' (Hetherington, 1997, p. 50). In challenging the way we think, writes Hetherington, 'heterotopias are a major source of ambivalence and uncertainty, thresholds that symbolically mark not only the boundaries of a society, but its values and beliefs as well' (1997, p. 50). In so doing, heterotopias signal social change, whereby the 'out of place' forms the 'basis for alternative perspectives and orderings' (Hetherington, 1997, p. 50).

Although used in the historical context of eighteenth-century France, Hetherington's interpretation of heterotopias can equally be applied to the globalized space of *Los lunes* and *Las cartas*. In these films, we witness how changing economic structures have impacted greatly on social ordering, resulting most noticeably in the way the immigrants and the unemployed shipbuilders suddenly appear 'out of place'. For instance, José and Amador in *Los lunes* stay at home while their wives work, thereby reconfiguring the traditionally gendered realms of public and private spaces. The jarring presence of Alou, a Senegalese immigrant in Spain, is underscored by his constantly itinerant movement: unable to find either permanent work or shelter, he cannot integrate into any of the towns and cities he passes through. In both cases, their discordant positioning engenders what Hetherington describes as 'ambivalence and uncertainty' (1997, p. 50), whereby former ideas of the social are transgressed and overturned. In sum, Michel Foucault's writing brings to light the spatial tensions upon which globalization rests. Three of the dimensions of heterotopic space – the interplay between control and freedom, interrelatedness and being out of place, and the tension between real and imagined space – will provide a means of examining the relationship between the global and local in *Los lunes al sol* and *Las cartas de Alou* respectively.

The shifting spaces of masculine identity

In *Los lunes al sol*, unemployment presents itself as a threat to traditional masculine identity. Throughout the film, the gradual erosion of group solidarity and male dignity also manifests itself in the use of space. The opening documentary sequence, which, as we have seen, shows a large-scale protest of shipbuilders, serves to situate the characters' recent past within the arena of collective industrial action. What follows in the film, however, is a pointed contrast: the strong solidarity of the past has given way to the political impotence and unemployment of the present. As a result, the space of public protest has been replaced largely by a more domestic arena of personal relationships and failure.

This perception of failure is arguably most felt in the character of José (Luis Tosar), whose wife Ana (Nieve de Medina) is the breadwinner of the home. Working long hours in a tuna-packing factory, Ana's job is representative of the standard forms of female employment in deindustrialized regions. As Wheelock shows, in areas where deindustrialization leads to a decline of employment opportunities for male manual labour, new ones are provided for unskilled, poorly unionized female labour (1990, p. 56). Although Wheelock draws on the context of the north east of England, a similar industrial dynamic can be witnessed in the Galicia of *Los lunes*. Swiftly and silently, Ana carries out her work alongside dozens of other women, who make up the entirety of the factory floor. Standing on a high platform, a male supervisor presides over the rows of female workers, shouting orders at those who stop working.

Significantly, this restructuring of traditional social roles finds its expression through the reorganization of space in the film. While Ana moves within the public sphere of work, her husband can be found either in the pub or in the domestic realm of the home. Inextricably social and spatial, these shifts present a challenge to the automatic privileges of traditional masculinity. This is particularly evident in the scene in which Ana and José apply unsuccessfully for a personal loan. On attempting to sign the application form, José is told by the banker that they require only the signature of 'el sujeto activo' [the active subject]. José's embarrassment quickly materializes as anger: after he loses his temper with the banker, the couple leave the building and begin to argue outside. José starts to shout: 'Tú trabajas, tú pides los créditos. Y yo ¿qué? ¿Qué cojones pinto aquí?'[7] It is significant, here, that José expresses his emasculation through the means of spatial language. His dialogue foregrounds the importance of space in the construction of male identity: in feeling that he is unable to access the public sphere, his masculinity is plunged into crisis. The scene, therefore, brings to the fore the extent to which both public and private spaces are traditionally mediated by power relations. The transgression of these spheres, as we have

seen, makes relationships and people appear out of place, signalling the creation of heterotopic space. It is precisely this dimension of heterotopias which generates an unsettling and threatening sense of ambiguity which, as we can see, is borne out by José's inarticulate anger.

This heterotopic transgression most dangerously impacts on the subjectivity of Amador (Celso Bugallo). Although, like José, Amador has also been squeezed out of the public realm, it is within the domestic arena that his presence appears most incongruous. As the oldest member of the group and the former superior of Santa, his male identity is represented as simultaneously more hegemonic and troubled than the others. Correspondingly, it is his masculinity which is most profoundly enmeshed in spatial structures. Silent and lost in thought, he sits at the corner of the bar, drinking more and more heavily as the film progresses. Although he has told the others that his wife has gone away to visit her sick mother, it later emerges that this is a lie: in reality, she has left Amador for good, no longer able to take his drinking habit. In the absence of a wife to care for him, his flat has degenerated into a state of squalid disrepair. We first discover this through the POV of Santa, who one night has to carry his friend home as he has drunk too much. A probing hand-held shot moves around the bathroom and kitchen, alerting us to broken taps, rotten food and mounds of rubbish. As Santa opens his kitchen window, a sharp pull focus emphasizes the derelict shipbuilding yard which lies below, as if to suggest that it is the reason for Amador's decline. Quite literally unable to adapt to the domestic sphere, Amador's relationship to his home bears evidence of a heterotopia: he is, in the words of Foucault, defined by 'a set of relations that delineates sites which are irreducible to one another and absolutely not superimposable on one another' (1986, p. 2). In the cases of both José and Amador, it is precisely this inability of male and female social worlds to converge freely that creates heterotopic space.

José and Amador frequently escape from the domestic sphere of their apartments to join their friends at La Naval, the local bar. Described by Willott and Griffin as the 'quintessential realm of *pub*lic masculinity' (1996, p. 82), the pub appears in the film as the most frequent setting. As the authors argue, the pub is 'an important arena for the expression and reinforcement of traditional masculinities' (Willott and Griffin, 1996, p. 83). This certainly rings true with *Los lunes al sol*, where the clientele of the bar are exclusively male. Described in the script as 'un bar amplio y desangelado' (a spacious and gloomy bar) (Ponga et al., 2002, p. 233), the dimly lit bar serves as a refuge for the friends. Owned by former shipbuilder Rico (Joaquín Climent) and frequented solely by his former colleagues Santa, José, Amador, Lino (José Ángel Egido), Serguei (Serge Riaboukie) and Reina (Enrique Villén), the bar is also an enclave of political solidarity. Open well into the early hours of the morning, the bar's shutters are in one scene drawn as if to cocoon it from the rapidly changing world that lies

outside. With few windows to let in light, the outside world can mainly be seen through the noisy television set and a photo of a boat on a calendar hanging conspicuously on the wall. While the television allows them to escape temporarily from the emptiness of their present lives, the calendar photo of the ship points to their recent history and the common aim that has brought them together. The bar therefore represents a repository of traditional relationships, a site in which endangered male and political bonding are still permitted to coexist.

Despite its apparent seclusion, however, the bar is not altogether immune to the global flows of neo-liberalism. This is most clearly represented in the character of Reina who, unlike his fellow ex-employees, has found work as a security guard for the local football stadium. Unsentimentally pragmatic, Reina has adopted the logic of neo-liberalism (Ponga et al., 2002: 160), which he endeavours to pass on to Santa. Explaining the principles of the free market, he tells Santa that the modern world revolves around economic competition: just as the Spanish economy sources their ships from Korea at less cost than those from their own shores, so Reina would choose a cheaper bar over the Naval if one happened to open nearby. Reina's approach to life can also be seen even more clearly in Nata (Aida Folch), the fifteen-year-old daughter of Rico, who sits listening to their conversations in the bar. When, one evening, she is supposed to babysit for a neighbour's four-year-old, she instead arranges to go on a date, and asks Santa to take her place in secret. But instead of giving Santa the full 5,000 pesetas that she has just been paid, she gives him 3,000 and keeps the rest as a cut for herself. Walking away from Santa, she turns around and says: 'El mundo funciona así, Santa. Ponte al día' [That's how the world works, Santa. Get with it]. As an embodiment of the new economic order, the presence of Reina and Nata therefore threaten to fragment the homosocial solidarity on which the bar depends. Moreover, whereas masculine self-esteem might be expressed through the economic freedom to buy rounds of drinks, Santa and his penniless friends instead depend on the generosity of Rico, who begrudgingly provides them with free drinks. As well as compounding their perceived sense of disempowerment, this also potentially plunges the bar into further financial difficulty, thereby threatening the business with closure. The bar, therefore, expresses on a microlevel the struggles on which the entire narrative is based. The tensions between traditional masculinities and the market, the local and the global are all played out within a space which, like the solidarity of the shipbuilders, is under continuous threat.

That much of the film takes place in the bar also throws into relief the extent to which masculine identities are mediated by consumption. As a service economy which revolves around the provision of goods rather than the manufacturing of them, Spain has shifted from a country of production to one of consumption. Correspondingly, this pattern has brought about

commensurate changes in the traditional structures of male identity. José and Amador, for instance, spend much of their time consuming alcohol. This leads to the untimely death of the latter, whose addiction to drink leads to his suicide. The shift from production to consumption is also emphasized in both Bardem's physical appearance and performance. Often framed as the central point of a composition, the presence of Bardem acts as a gravitational force in the film, a pivot around whom all the other characters revolve. This is further emphasized, perhaps, by the sheer physical presence he brings to many of the scenes. With his burly frame and sizeable paunch, his body endows him with an almost bear-like appearance; stolid and slow, his movement throws into relief his great weight. Connell argues that a strong, muscular male body has traditionally been central to the construction of working-class male identity (1995, p. 55). According to the author, physical strength and endurance have served as both a means of survival in exploitative class relations and a means of asserting superiority over women (Connell, 1995, p. 55). If the working-class body has had a longstanding association with physical strength, Bardem's overweight and lumbering frame reveals precisely the opposite: his body is one of consumption rather than production. This is quite literally foregrounded in Santa's everyday habits of consumption, as many of his actions revolve around drinking or eating, providing the film with several moments of humour. For instance, he is seen leaving a half-eaten (and unpaid for) packet of crisps on the shelves of his local supermarket, only to make a quick beeline for a promotional display of Swiss cheese, which he cheerfully gobbles down. His 'consumptive' body in this film is made all the more striking when set against his earlier star image as the *machoibérico* stud in *Jamón, jamón* (Bigas Luna, 1992) and the Osborne wine publicity campaign, where he sported a tattoo of a bull. Deprived of the physical energy which was once required of shipbuilders, Bardem/Santa's appearance and performance point ironically to the redundancy of male strength within a post-industrial landscape.

Immigration and spatial transgression

If in *Los lunes al sol*, post-industrial unemployment contributed towards the heterotopic transgression of the traditionally gendered division of public and private spaces, in *Las cartas de Alou*, social and spatial disruption is created by immigration. In closely following the journey of Alou (Mulie Jarju) around Spain, the narrative of *Las cartas de Alou* is picaresque in structure. Unlike *Deprisa, deprisa*, where movement serves as an act of wilful rebellion, it is emphasized here instead as a precarious means of survival. This is quite literally dramatized in the opening sequence, in which an overcrowded dinghy transports the illegal migrants across the tempestuous

sea at night. When Moncef (Ahmed El-Maarouh), a Moroccan immigrant, falls into the sea, there is no turning back: the others must fight for their own lives and rapidly cross the stormy waters. The director explains that for immigrants like Alou, 'vivir en la ilegalidad y sin trabajo implica un movimiento continuo' (Angulo et al., 1998, p. 249).[8] In his indefatigable search for work, the protagonist moves from one city to the next. No sooner does Alou arrive in Barcelona than he leaves again in search of his friend, Mulai (Akonio Dolo), who is temporarily working in Lérida. Although Mulai's wife (Rosa Morata) warns him that it is much further than he might think, Alou responds cheerfully: 'Es igual. Si yo he ido 6,000 kilómetros para llegar hasta aquí, ¿qué más da unos cuantos más? Si hay trabajo, yo voy.'[9] Places of passage and travel, such as roads, railway stations, trains and plains, occur frequently throughout the film, conveying the transience of Alou's movement. When entering or leaving towns, establishing shots reveal a lack of distinct landmarks: Madrid and Barcelona are seen as bustling streets and sprawling suburbs respectively, creating the impression of a homogenised urban landscape.

Passages of transit not only signal movement, but connote surveillance and interrogation. The tragic overlapping of both of these dimensions is witnessed in the film's penultimate sequence, which is set in a train station in Barcelona. After spending the day together, Alou says goodbye to his Spanish girlfriend Carmen (Eulalia Ramón), who gets on a train to return to Lérida. As the train slowly moves away from the platform, two police officers ask for Alou's identity card. Unable to produce one, he is promptly escorted to a police van in which other undocumented immigrants are waiting to be deported. A succession of brief shots then occurs: we see the migrants herded from the police cell to an airport, followed by a shot of a plane taking off. This sequence vividly conveys the contradictory and multifaceted dimensions of heterotopic space. The train station is at once a space of freedom and a space of oppression: while it offers a point of transit for some, for others it is a site of exclusionary control. This dual process of facilitating and foreclosing is mediated by a further aspect of the heterotopia: interconnectedness. Providing a point of contact both with other national and international cities, the station is implicated as part of a wider network of multiple spaces. As Foucault reminds us, heterotopias find themselves in 'relation with all the other sites, but in such a way to suspect, neutralize, or invent the set of relations that they happen to designate, mirror or reflect' (1986, p. 2). As a heterotopia, therefore, the station not only connects us with other spaces, but does so in a way that calls into question its very interconnectedness. Access to the global network of flows, we are reminded, is largely the preserve of the powerful.

In common with the shipbuilders in *Los lunes al sol*, therefore, Alou's exclusion from certain spaces signals the creation of heterotopic space. This

is especially borne out in the film's representation of home. Even during the film's points of fixity, when Alou resides in some kind of accommodation, the possibility of a stable home is repeatedly undercut through the use of *mise en scène*. According to Robertson, while the road 'provides an escape from and an alternative to the home, and home can be "anywhere and everywhere" on the road . . . the trope of the road still requires the concept of home as a structuring absence' (Robertson, 1997, p. 271). In the gloomy boarding house in Madrid, where he lives with fellow street vendor Ibraham (Ly Babal), the camera dwells emphatically on a moving train which is seen through their bedroom window. The shot alerts us to the contingent nature of his stay, reminding us that although he has found companionship with Ibraham, he must resume his travels soon. When in Lérida, Alou stays with his Moroccan friend Moncef under a network of dank, disused arches. Arriving there for the first time, Alou is told that 'aquí vivimos sucios como los animales' [here we live dirty like animals]. When, later, Alou takes Carmen to see his former home, a long shot reveals some disused train tracks which cross over the arches, which appear to end abruptly mid-air. While again transience and movement are indicated by the tracks, their state of disrepair is suggestive of a frustrated journey. During this scene, Alou tells of his frustration with a country that does not accept him, intimating for the first time to Carmen that he would like to return to his land in the near future. This tension between home and away, fixity and movement is perhaps most tragically felt in Mulai's high-rise flat in Barcelona, which provides Alou with his final lodgings before leaving Spain. When Mulai and his wife suddenly leave Barcelona, they leave the flat entirely in the care of Alou and his younger friend Lami (M'Barick Guisse). For the first time since his arrival in Spain, the apartment provides Alou with a room of his own, thereby resembling the closest thing to what he may call home. However, any solace this space might afford turns out to be short-lived. As Mulai has stripped the flat bare of all its furniture, the friends search for an electric fire to keep them warm through the bitter winter months. Finding an abandoned heater on a rubbish dump, they eagerly bring it back to the apartment, taping over its broken cable. Shortly after, Alou returns home to find Lami dead, intoxicated by the heater's fumes. Through Lami's tragedy, Alou is quite literally excluded from the home. Lami's death is cruelly ironic: traditionally both the spiritual and symbolic centre of the homestead, the fire is instead here ultimately responsible for their tragic exclusion from it.

As Alou is excluded from creating his own home in Spain, African customs are a vital comfort to him, reminding him of the home he has left behind in Senegal. According to Rapport and Dawson, for a world of travellers and journeymen 'home comes to be found far more usually in a routine set of practices, in a repetition of habitual social interactions, in the

ritual of a regularly used personal name' (1998, p. 27). In several extended scenes, indigenous customs of the immigrants are observed, often with the actors speaking in their native tongues: in Almería, for instance, we see them eating traditional African food with their hands; in Lérida, we witness a group of Moroccans praying to Allah, and in Barcelona, we observe Alou and Lami drinking African tea. It should be noted, however, that these rituals take place in private places, away from the Spanish gaze. If Alou's name provides a way of reinforcing his African identity, it is placed constantly under threat by certain Spanish people whom he encounters. At various points, words such as 'moreno' ('darky'), 'negro' and 'Baltasar' ('Balthazar') are used instead of his name, Alou. In one scene, a racist supervisor addresses him as 'negro', to which Alou responds indignantly: 'Yo tengo un nombre, igual que tú y esos' [I have a name, just like you and them]. To his surprise, the protagonist later discovers that his friend Mulai, who has already been living in Spain for a few years, has changed his name to Johnny. Tellingly, it transpires that Mulai has been exploiting his fellow immigrants, hiring them in a sweatshop run by a disreputable Spanish businessman and producing fake identity cards in exchange for money. Mulai therefore demonstrates that although immigrants may attain some kind of integration, this can only be achieved at the cost of forsaking both one's identity and principles.

The heterotopic incompatibility of space clearly reflects the confrontation between the Spanish and the ethnically Other depicted in the film. Although she does not mention the use of space, Flesler notes that the failure of interracial romance is a defining feature of several Spanish films which, like *Las cartas de Alou*, explore the immigration question (2004, p. 104).[10] Carmen's father poses the biggest threat to Alou's relationship. Unlike others in Lérida, Carmen's father is initially accepting of Alou; on discovering that he is having a relationship with his daughter, however, their relationship begins to cool. During a tense game of draughts, he warns Alou: 'Oye Baltasar, a mi hija déjala en paz – no quiero que tenga problemas.'[11] The racial confrontation which emerges in this scene is symbolized by the game itself: Alou's black counters are pitched in opposition to the white counters of the father, which the latter stamps down on the board authoritatively. Even when, against the father's knowledge, Alou and Carmen are together, their intimate moments are withheld from the viewer through the use of elliptical editing. For instance, when Alou secretly visits Carmen at night, the scene ends abruptly after he discreetly enters her bedroom door. Their relationship, therefore, creates both a spatial and social disruption, which in order to survive, must be hidden from public view.

The social division of labour in the film similarly contributes towards the heterotopic exclusion of Alou. According to Calavita, 'the best immigrant is one that doesn't integrate' (2005, p. 73). Indeed, Alou is only able to find

work in contingent and precarious sectors which are specifically tailored for undocumented immigrants. The sphere of official employment, which is reserved for the Spanish working classes, therefore participates indirectly in the segregation of immigrants. Moreover, it is arguably this social division of labour which is integral to the controversial 'Ley Orgánica': foreign worker programmes in Spain take advantage of this legislation by 'allocating slots only to those industries and jobs who don't attract local workers, ensuring that, by definition, immigrant workers are distinct from the local working class' (Calavita, 2005, p. 73). It is this division that Alou repeatedly endeavours to surpass, telling his friend in one scene: 'Oye Mulai – yo no puedo seguir así. Necesito papeles' [Listen Mulai – I can't go on like this. I need an official work permit]. Mulai explains that in order to obtain residency, he requires a proper contract – a situation which throughout the film is represented as increasingly unlikely.

In common with the shipbuilders in *Los lunes*, the spatial division of labour is bound up with what is happening on an international scale. For instance, in Almería, the first job that Alou finds is in a large hothouse which cultivates courgettes on a mass scale for the international market. Working long exhausting hours in stiflingly hot conditions, the agricultural hothouses are a prime source of employment for economic migrants in Almería, of which some 70 per cent in this region are undocumented (Calavita, 2005, p. 70). Calavita notes that this kind of Spanish agricultural employment has become hybrid and contradictory: while the work is largely of a traditional, productive nature, it is also embedded in a global service economy. The author explains that 'with its intense but temporary periods of productivity, its global markets, price structure and labour force, (agricultural employment) is a hybrid of pre- and post-Fordist labour relations and employment structures' (Calavita, 2005, p. 73). Increasingly more educated and skilled, Spain's native population works progressively more within the global service sector, leaving the primary sphere of productive work to poorly paid immigrants. Economic migrants therefore do not just provide a supplemental workforce, but a particular kind of workforce: that is, one that is willing to do the jobs and be subjected to the conditions that locals no longer accept, in spite of Spain's high level of unemployment (Calavita, 2005, p. 68).

Between fantasy and failure: utopias and heterotopias

In the previous two sections, three dimensions of Foucault's heterotopia (the struggle between freedom and control, the interrelatedness of different international spaces, and spatial disruption) have provided a critical framework through which to examine the effects of globalization in *Los lunes al sol* and *Las cartas de Alou*. There remains, however, one more crucial aspect of

heterotopic space through which to explore the films: the tension which is created between real and imagined places. In applying this fourth and final notion of heterotopia to the films, this section will bring together the previous types of heterotopic space examined.

As we will see, in both *Los lunes al sol* and *Las cartas de Alou*, the lives of shipbuilders and immigrants are precariously poised between fantasy and reality, utopia and failure. This tension is partly conveyed through the use of cinematography. Alfredo Mayo, who worked as cinematographer for both films, creates images which are suffused with warm tones of colour. This has been observed by critic Stephen Brown who, in reviewing *Los lunes* for *Sight and Sound*, comments on the bright, sunlit palette of Mayo's photography (2005, p. 69). For the critic, the warm photography evokes a sense of optimism, which provides a contrast to the dismal weather which is usually expected of the film's Galician setting (2005, p. 69). In the case of *Las cartas de Alou*, the cinematographer comments that this was achieved through the use of Agfa, a film stock which generally creates a warmer palette, over the more habitually used Kodak (Heredero, 1994, p. 456). The glowing colours of the two films are strikingly at odds with the bleak socio-economic milieux of the characters, giving rise to a tension between utopia and reality.

This tension similarly informs *Familia (Family)* (1996) and *Barrio* (1998), two earlier Fernando León films which were also produced by Elías Querejeta. In the former, Santiago (Juan Luis Galiardo), a lonely, wealthy businessman, longs for a family of his own. For his birthday, therefore, he hires a group of actors to play an imaginary 'family' for just one day. The appearance of his actors is tailored to his personal taste: for instance, he makes the 'son', Nico (Aníbal Carbonero), take off his glasses and attempts to convince his 'wife', Carmen (Amparo Muñoz), to have her hair cut shorter. The end of the day, however, signals a return to reality: the actors are paid their fees and Santiago is left alone, as he was before, in his spacious but empty home. The film's promotional poster, which also appears on the cover of its VHS and DVD, is a still of the protagonist and the actors standing together, posing for a 'una foto de familia'. In the foreground, the teenage son, Carlos (Juan Querol), holds a mirror up to show the reflection of Alicia, the actress who is taking the photograph (Béatrice Camurat). The mirror serves to draw attention to the artifice of their performance: the ideal family, which is represented in the photograph, is but an illusion generated by Santiago's imagination. The theme of fantasy is further conveyed in the game which the protagonist plays with Nico. Lying on the ground, they direct their gaze to the sky above; together they must imagine which object each cloud resembles. Like Santiago, Rai (Críspulo Cabezas), the teenage protagonist of *Barrio*, dreams of another life. Throughout the film, he fantasizes about leaving the confines of his high-rise housing estate. When he discovers that a brand of yoghurt is offering a chance to win a

holiday in exchange for a number of yoghurt tops, he steals as many containers as he can from his local supermarket. Rai is soon informed that he has won not the holiday, but the second prize: a top-of-the-range jet ski. Too large to keep inside his tiny flat, he is forced to fasten it to a lamp post in front of his housing estate. The image of the stationary jet ski is poignantly ironic: it points to a fantastical journey that Rai will never make, thereby foregrounding the confinement of his real immediate milieu.

In *Los lunes al sol,* these two worlds are brought together when, one evening after babysitting, Santa and his friends stumble around Vigo's historic centre. Santa's attention is drawn to the window of an electrical goods store, in which several televisions are on display. Looking towards the centre of the display, Santa finds a television in which his reflection is simultaneously recorded through a closed circuit surveillance camera. Amused, Santa calls Lino and José over to take a look, and pretends to be a presenter on a gameshow, where the prize is a permanent job in Alicante. In this scene, the world of fantasy is set in pointed contrast to the reality of failure. The television enables them to project their fantasies onto the screen, affording them the fleeting status of celebrity for just a few moments. Poignantly, instead of pinning their hopes on a car or a foreign holiday, their dream prize is precisely what they so desperately lack: secure employment. The television screen therefore functions as a mirror, reminding the characters where they are not. Foucault draws on the example of a mirror to illustrate the unreal dimension of the utopia: 'The mirror is, after all, a utopia, since it is a placeless place' (1986, p. 3). Santa, however, promptly forecloses any further potential for fantasy. In reminding Lino that he has lost the opportunity of employment, he reminds him of their material reality. The potential to work in Alicante presents itself as a utopia: known for its sunny Mediterranean climate, it stands in contrast to their unemployed existence on the soggy Atlantic coast of Galicia. In this respect, the utopian dimension of the mirror is inextricable from its heterotopic dimension, which as we have seen, represents sites that are both real *and* imagined:

> The mirror functions as a heterotopia in this respect: it makes a place that I occupy at the moment when I look at myself in the glass at once absolutely real, connected with all the space that surrounds it, and absolutely unreal, since in order to be perceived it has to pass through this virtual point which is over there. (Foucault, 1986, p. 3)

As a non-place which reminds them of their actual deprived geographical location, the television screen is a heterotopic space which articulates both their sense of fantasy and their failure. But, as we have seen, while the utopia points to the open horizon of employment, it also simultaneously presupposes a system of control. A Russian immigrant, Serguei is not allowed to

enter their world of fantasy, despite knowing the correct answer to the question. Santa's hostility towards him is illustrative of those who are unable to accept that the economy has changed, and who instead choose to scapegoat the Other for their own hardship.

The convergence of the real and the fantastical is also thrown into relief in an earlier sequence, where we see Santa lying on the bed of his shabby lodgings, gazing pensively at the ceiling. Much of its beige paint has peeled away, leaving behind a gap in the shape of Australia. The shot serves as a bridge to the following sequence, which begins with an extreme long shot of Vigo's bay: in the foreground, the tiny figures of Santa and Lino can be seen climbing down from the pier onto some rocks below; further in the background, the indented coastline of the surrounding *rías* looms on the horizon, illuminated by the bronze light of the dawn sun. In the medium shot that follows, the two friends sit on the rocks; Santa begins to talk enthusiastically about Australia, a country so vast and unpopulated that, according to him, each person is allocated his share of land when they retire. Australia is thus presented in the film as a utopia, an antithesis to the confines of Santa's cramped bedroom. A vast and distant land, the appeal of Australia is telling: it is precisely this free access to space which is foreclosed from Santa. But as Foucault reminds us, a utopia is not just a better place, but a 'placeless place'. Though Australia is evidently a real place, for Santa it is configured as a powerful site of the imagination, a flight of fantasy which he invokes every night before falling asleep.

As a perceived land of hope and opportunity, Spain initially presents itself as a utopia for Alou. The opening sequence, which is accompanied by Alou reading a letter to his friend describing his hopes of finding him, illustrates this particularly well. His words accompany the images of a high-angle view of the sea, whose gentle waves are obliquely lit by the moonlight. The sequence which follows, however, is of a dangerously volatile sea, which provides the treacherous crossing for Alou and other immigrants to Spain; the shimmering waves of the previous shot are more obscurely lit, and a strong sense of foreboding pervades the scene. While the first shot suggests the horizon of a promised land, the second serves to remind us that this does not exist; like Santa's Australia, Alou's Spain is but a powerful construct of the imagination.

That Santa and Alou are both lured by the promise of faraway places is a direct consequence of globalization, which advances a powerful vision of unfettered mobility. This utopian vision, however, is repeatedly undercut by their material exclusion and displacement, illustrating what Doreen Massey has termed the 'double imaginary' of globalization (1999, p. 37). We are therefore reminded, once again, that this double imaginary only works in favour of the already powerful. Thus, for the dispossessed, the utopian promise of a globalized world remains nothing more than 'placeless place',

a nowhere which exists only within the realms of fantasy. It is worth noting that the word utopia is derived from two different roots: 'eu'-topia (better place) and 'ou'-topia (nowhere). Alou's and Santa's experience of globalization thus clearly finds itself in the overlapping of these two meanings.

For Hetherington, the horizon of the sea encapsulates heterotopic space. Correspondingly, the sea appears in both the opening and the end sequences of *Los lunes al sol* and *Las cartas de Alou*, lending their narratives a somewhat circular structure. In the penultimate scene of *Los lunes al sol*, Santa and his friends decide to deposit Amador's ashes into the sea. At the dead of night, Santa and José surreptitiously break into a passenger boat and manage to start its engine; Lino and Serguei, meanwhile, preside over the harbour, keeping watch for the police. While out at sea, the friends realize that they have left the ashes behind in the bar; stopping the boat's engine, they decide to remain adrift until the following morning. The next day, dozens of passengers wait impatiently at the harbour, while the men sit relaxing on the boat in the sun. In the final sequence of *Las cartas*, Alou attempts to return to Spain. On alighting from a small boat with other Africans, he happens to meet Moncef by coincidence, with whom he first travelled to Spain at the beginning of the film. A final extreme long shot lingers on their boat in the distance, as it sails away gradually into the horizon.

For Hetherington, the meaning of heterotopia is evoked through the writing of Louis Marin, who explores the difference between utopias as a good place and utopias as a non-place. According to Marin, the intersection of these two dimensions can be found in the horizon of the ocean. Marin writes that 'the frontier is the infinity of the ocean, its border, a boundless place. Utopia is a limitless place because in the island of Utopia is the figure of the limit and the distance, the drifting of frontiers within the "gap" between opposite terms, neither this one nor that one' (cited in Hetherington, 1997, p. 140). According to Hetherington, this so-called gap, which is poised between 'eu'-topia and 'ou'-topia, is also where heterotopias find their expression. Cast adrift on the ocean, the lives of Santa and Alou similarly hang in the balance between a better place and a non-place, hope and reality. Hetherington goes on to write that:

> [the horizon] is a boundless space of connections, the unreachable point of possibilities that offers a glimpse of the 'other side of the sky'. It is a space into which social relations are extended, beyond their own limits, into a gap that is betwixt and between, unlocatable, unrepresentable. Yet that point is an obligatory point of passage for different sorts of social ordering. (1997, p. 140)

In light of Marin's and Hetherington's writing, the horizon of the sea also epitomizes the construction of globalized space in *Los lunes al sol* and *Las*

cartas de Alou, and eloquently brings together the four dimensions of heterotopias which have served as the interpretative framework for this chapter. Firstly, in pointing to Australia and Spain respectively, the horizon in the films proffers a similar promise of free global connections. Secondly, in reaching out to faraway places, it signals the geographical interrelatedness of globalization, where the global impacts upon the local. But thirdly, as we have seen, while it offers freedom, it also imposes a system of control: the sea demarcates a frontier between Spain and Africa, a treacherous crossing from which many immigrants fail to emerge alive. Finally, that Santa and Alou find themselves afloat in a space which is 'betwixt and between, unlocatable, unrepresentable' is particularly significant: unmoored from a fixed geographical point, their positioning on the horizon eloquently articulates their social displacement. In interweaving all the dimensions of heterotopic space which have been discussed in this chapter – utopian and real spaces, interrelatedness, freedom and control, and displacement – the horizon possesses a *mise en abíme* quality, simultaneously condensing the four spatial structures of globalization which we have examined in the films.

Conclusion

This chapter has examined the extent to which *Los lunes al sol* and *Las cartas de Alou* bear witness to Spain's globalized economy, in which the global impacts on the local. The uneven processes of globalization have been shown to be largely responsible for the recent phenomena of post-industrial unemployment and illegal immigration. In light of Foucault's heterotopia, these social repercussions of globalization are shown to call into question existing identity formations and cultural belonging in Spain. In *Los lunes al sol*, traditionally gendered spheres of public and private spaces are transgressed, leading to emasculation and a restructuring in the workplace. In *Las cartas de Alou*, the presence of the immigrant is discussed as both socially and spatially disruptive. This, in turn, reflects Spain's discriminatory 'Ley Orgánica de Extranjería' which seeks to segregate immigrants from other Spanish workers. Finally, the theme of utopia has been discussed in both films. It has demonstrated that while the characters are lured by the utopian rhetoric of globalization, which advances an unbounded world of free mobility, their real life situations reveal to us that this vision is largely reserved for the powerful.

Conclusion

Despite his age, Elías Querejeta tirelessly continues to make a significant impact on the Spanish film industry. This was borne out in April 2008, when Querejeta was awarded a lifetime achievement award – the latest of a very long and accomplished line – at the San Sebastián Festival of Cinema and Human Rights. There, he was commended for his courageous and socially committed method of film-making that has consistently spoken out against injustice. After this award, Querejeta went on to write and direct the documentary *Cerca de tus ojos* ('Close To Your Eyes') (2009), a film that exposes the many breaches of human rights which are committed through-out the world. In some respects, this film brings us full circle. His only other previous attempts as director, *A través de San Sebatián* and *A traves del fútbol*, which he co-directed with Antxón Eceiza, were made at the beginning of his career, some fifty years ago. According to Querejeta, his return to directing was inspired principally by the significance of an award which promotes the values that have been core to his conception of film-making. After half a century, he has literally put into practice the conception of film-making that he has unrelentingly supported, championed and defended in other direct-ors. As we have seen in this book, this practice of film-making positions cinema as a transformative force: a force for social justice, and a force for making the invisible visible.

This book has shown how, from the early 1960s until the present day, Elías Querejeta's productions have documented the dramatic social trans-formations of a country caught in the grip of modernization. Viewed in its entirety, therefore, the corpus of Elías Querejeta Producciones Cinematográficas has been seen as a narrative of the geographical changes of Spanish society. If his films provide a history of modern Spanish space, they can equally be seen as a *spatialization* of modern Spanish history. In his productions, therefore, landscape does not so much present itself as a physical background as a dynamic and fluid foreground. This recurrent emphasis on Spanish landscape has consistently provided a means of exploring the historical and social reality of Spain. Spain's fraught and

uneven road to modernization, therefore, has been shown in his films to be both a historical *and* a geographical project: the burgeoning development of post-*apertura* capitalism, as we have seen, has been dependent on spatial change.

If landscape occupies a central position in Querejeta's film-making, then so too does an underlying dynamic of political resistance. As we have seen, the intertwining of these two aspects, space and politics, reflects a greater trend in the humanities which, in the wake of Henri Lefebvre and Michel Foucault, has sought to define our social existence in spatial terms.

Space has been discussed as a site of political contestation, a terrain across which the struggle between resistance and hegemony is played out. From the stagnant Francoist ideology and the superficial modernization of the miracle years to the social and spatial tensions brought about by post-*desarrollista* and global capitalism, this book has investigated the several different systems against which, over the past fifty years or so, this struggle has directed itself. As Ross says, an awareness of social space always 'entails an encounter with history – or better, a choice of histories' (cited in Gregory 1994, p. 348), and this has been strikingly borne out throughout Querejeta's work. Whether they focus on dispossessed rural peasants, the sexually repressed, delinquents, immigrants or the unemployed, his productions have sought to enunciate the social reality of Spain from the geographical speaking position of the oppressed. This has been absolutely central to Querejeta's underlying ethical vision: throughout his career, he has been unswervingly committed to alerting both Spanish and international audiences alike to the underexposed social issues of his country. An exploration of social space in his productions has thrown light not only on the public history of Spain, but also on the private histories of those who are most often excluded from its history books.

As we have seen, Querejeta's spatialization of modernization has been one of flux and change, contradiction and unevenness. The production of space, as Massey has recently written, should be viewed as an open-ended process: 'space is never finished; never closed. Perhaps we could imagine space as a simultaneity of stories-so-far' (Massey, 2005, p. 9). Although the producer has always remained tight-lipped about future projects, they will surely have something in common. His future collaborations will continue to map the transformations of Spanish space from without, both revealing and resisting its inequalities, and exposing and contesting its power structures.

Notes

Introduction

[1] Including foreign co-productions, Querejeta has produced fifty-six feature-length films to date. As well as the aforementioned, he is credited as having co-written the scripts of the following films: *El próximo otoño* ('Next Autumn') (Antxón Eceiza, 1963), *De cuerpo presente* ('Present in Body') (Antxón Eceiza, 1965), *Último encuentro* ('The Last Meeting') (Antxón Eceiza, 1966), *Stress es tres, tres* (*Stress Is Three, Three*) (Carlos Saura, 1967), *La madriguera* (*Honeycomb*) (Carlos Saura, 1968), *Las secretas intenciones* (*Secret Intentions*) (Antxón Eceiza, 1969), *Carta de amor de un asesino* ('Love Letter from a Murderer') (Francisco Regueiro, 1972), *Pascual Duarte* (Ricardo Franco, 1976), *Elisa, vida mía* (*Elisa, My Life*) (Carlos Saura, 1977), *A un díos desconocido* (*To an Unknown God*) (Jaime Chávarri, 1977), *Las palabras de Max* (*Max's Words*) (Emilio Martínez-Lázaro, 1978), *Dedicatoria* (*Dedication*) (Jaime Chávarri, 1980), *Feroz* ('Fierce') (Manuel Gutiérrez Aragón, 1984), *Una estación de paso* (*Whistle Stop*) (Gracia Querejeta, 1992), *El último viaje de Robert Rylands* (*Robert Rylands' Last Journey*) (Gracia Querejeta, 1996), *Cuando vuelvas a mi lado* (*By My Side Again*) (Gracia Querejeta, 1999), *La espalda del mundo* (*The Back of the World*) (Javier Corcuera, 2000), *Asesinato en febrero* ('Murder in February') (Eterio Ortega Santillana, 2001), *Noticias de una guerra* (*News from a War*) (Eterio Ortega Santillana, 2006). He is credited as the only writer of *Perseguidos* ('Hunted') (Eterio Ortega Santillana, 2004). In addition to these feature-length films, he has also written and directed in creative tandem with Antxón Eceiza the short films *A través de San Sebastián* ('By Way of San Sebastián') (1960) and *A través del fútbol* ('By Way of Football') (1962).

[2] 'he gets involved in the films, in the work of the director and scriptwriter, and I think it's a good thing.'

[3] 'when working with him, it's very difficult as a director to not convey what Elías wants without being aware of it.' Fernando León has similarly commented that 'Elías Querejeta es un discutidor nato, intentará siempre convencerte de muchas cosas, unas se quedarán en la película y otras no, pero ese frontón con él siempre te ayuda a reflexionar' [Elías Querejeta is inherently argumentative. He'll always try to convince you of many things, some will stay in the film and others won't, but his interventions always help you to think]. P. Ponga, M. A. Martín and C. Torreiro, *Hipótesis de Realidad: El cine de Fernando León de Aranoa* (Melilla: Consejería de Cultura Ciudad Autónoma de Melilla, 2002), p. 77. Moreover, the director Emilio Martínez-Lázaro concurs that the producer

'interviene mucho, aunque sea de una manera indirecta' ('he intervenes a lot, although in an indirect way'). R. García, 'Cómplice en la sombra: 'El productor' retrata a Elías Querejeta, figura clave en la industria del cine español', *El País, Cultura,* 13 April (2007), p. 4.

4 'The producer must be informed of every medium that goes into making the film. And if he is rigorous in what he does, his approach should not only take into account the script, the proposed literary project, but many other aspects: the lighting, the settings, the costumes.'

5 'Elías seeks an enriching relationship with the director, and if he doesn't find one, he kills it off.'

6 This is something that Querejeta stresses in most of his interviews. For instance, 'Produzco películas por satisfaccíon personal, no por el dinero' [I produce films for personal satisfaction, not the money] A. García, 'TVE inicia un ciclo dedicado al productor Elías Querejeta', *El País,* 7 November (1998), n.p.. Also, 'estoy más cerca de la artesanía que de la industria' [I'm closer to craftsmanship than to industry] P. Leyra,'Elías Querejeta: "En el cine está casi todo por inventar"', *Cambio 16,* June (2008), p. 84.

7 After Teo Escamilla and he parted ways in 1984, the team was without a regular director of photography. During the shoot of *27 Horas* (*27 Hours*) (1987), the director Montxo Armendáriz suggested that Javier Aguirreaobe be enlisted as cinematographer. Aguirreaobe reflects on his experience as follows: 'Tuve muchas dificultades, fundamentalmente motivadas por la incomprensión y falta de confianza del productor . . . Elías cuestionaba todo lo que me proponía . . . Elías imponía a menudo sus criterios; a veces con razón, pero siempre con pésima actitud de colaboración' [I had many difficulties, essentially caused by the producer's lack of understanding and trust . . . Elías questioned every suggestion that I made . . . Elías often imposed his own set of criteria; often he was right, but always with a very poor willingness to collaborate] J. Angulo, C. Heredero and J. L. Rebordinos, *Elías Querejeta: La producción como discurso* (San Sebastián: Filmoteca Vasca, 1996), p. 178.

8 For most directors, Querejeta's in-house team is therefore a luxury: they have consistently helped to maintain the high production standards that have been associated with his productions over the years. However, Erice has commented that Querejeta's production method 'se trataba de un equipo forjado alrededor de una idea y una práctica del cine que no eran mías' [was about a crew forged around a conception and practice of film-making that were not mine] R. Baza, *La primera vez: Una producción de Elías Querejeta* (Málaga: Ayuntamiento de Málaga, 2000), p. 47.

9 'a restrained style of photography, lacking in anything out of the ordinary (. . .) grey, like society in those days.'

10 These technical details, along with others, can be found in the definitive interview with Cuadrado in J. Barroso, 'Entrevista con Luis Cuadrado' in F. Llinás (ed.), *Directores de fotografía del cine español* (Madrid: Filmoteca Española, Instituto de la Cinematografía y de las Artes Audiovisuales, Ministerio de Cultura, 1989), pp. 229–47.

11 According to Escamilla, 'Si he llegado a donde ahora me encuentro, se lo debo a Luis Cuadrado . . . Hay muchas cosas suyas, claro está, que se me han quedado grabadas' [If I've got where I have today, I owe it to Luis Cuadrado . . . Without doubt, many of his things have remained stuck in my mind]. C. Heredero, *El lenguaje de la luz: Entrevistas con directores de fotografía del cine español* (Alcalá de Henares: 24 Festival de Cine de Alcalá de Henares, 1994), p. 248.

12 Berlanga's earlier films, such as *Bienvenido Mr Marshall* (1952), and Ferreri's films, such as *El pisito* (*The Little Apartment*) (1959), are notable exceptions, as well as the neo-realist-inflected *Surcos* (Juan Antonio Nieves Conde, 1951) and *Los golfos* (Carlos Saura, 1959). These films adopt a more Bazinian rejection of montage in favour of the long take; jump cuts can also be found in Berlanga's films.

13 See also K. Vernon and C. Eisen, 'Contemporary Spanish film music: Carlos Saura and Pedro Almodóvar', in M. Mera and D. Burnand (eds) *European Film Music* (Aldershot: Ashgate, 2006), pp. 41–59, who discuss Luis de Pablo's involvement with the 'Generación del 51' and provide an excellent analysis of his film scores for Carlos Saura.

14 'I try to create an working style which encourages the members of the crew to collaborate, which, most of the time, is not only possible, but also positive. The creative vision which arises from the making of a film, but not from the conception of a film, is a plural vision.'

15 As the director Eterio Ortega has said recently on his production method: 'Su forma de trabajo no la he conseguido con ningún otro productor. Elías es lento, requiere de mucho tiempo, tiempo para cuajar y que las cosas maduren y descansen' [I've never experienced a similar working method from any other producer. Elías works slowly, he needs lots of time for a project to get off the ground, time for things to come to fruition at their own pace]. Anon.,'Festival de San Sebastián: Una narración novelada de tres años de horror, angustia y muerte', *El País,* 29 September (2006).

16 This has often been observed. Jaime Chávarri says that Querejeta's productions 'tienen un look, un estilo, muy determinado, muy acorde a su personalidad' [clearly have a definite look, a style, which is very in keeping with his personality], Baza, *La Primera Vez,* p. 56. Stone similarly argues that his films 'share a look and tone that resulted from his particular style of production', R. Stone, *Spanish Cinema* (Harlow: Longman, 2002), p. 7.

17 For instance, Querejeta has commented that 'uno tiene que tener en cuenta la realidad en la que se mueve . . . En el cine español no hay ninguna referencia a esa realidad. Ninguna' [we have to be aware of the reality which we move in . . . Spanish cinema makes absolutely no reference to that reality]. E. Querejeta, 'Estamos negando la realidad', *Academia,* 5, January (1994), 37–9.

18 See for instance M. Kinder, *Blood Cinema: The Reconstruction of National Identity in Spain* (Berkeley and Los Angeles: University of California Press, 1993), M. D'Lugo, *Guide to the Cinema of Spain* (Westport, CT: Greenwood Press, 1997) and J. Hopewell, *Out of the Past: Spanish Cinema after Franco* (London: BFI, 1986).

19 'I will not submit to any kind of intimidation which attempts to suppress what has been legally authorised.'

20 '*Cousin Angelica* is more a reflection on time and memory than a political reflection. But a profound exploration of time inevitably leads to an encounter with historical and political details.'

21 'For me politics is not something that is extraneous, or detached from people's lives, but intrinsic to everyday life . . . Politics belongs to everybody: it's not some kind of hidden science, but an activity which is absolutely vital for survival.'

22 In the early 1970s, Querejeta spent some time collaborating with the German production company *Produktion I im Filmverlag der Autoren* (PIFDA) where he produced the aforementioned *La letra escarlata* (Wim Wenders, 1973) and *La banda de Jaider* ('Jaider's Gang') (Volker Vogeler, 1973). He was also producer of another German co-production *Belleza Negra* (*Black Beauty*) (James Hill, 1971)

and the Italian *Diabólica malicia* (*Night Hair Child*) (Andrea Bianchi, 1971). These films were critical failures and his decision to offer himself as executive producer was, in his own words, 'una opción de supervivencia' ('a survival option'). Although they were all shot in Spain, the films were designed by foreign producers and Querejeta's role was to oversee their production and facilitate Spanish distribution channels. See Angulo (1996, p. 31). Querejeta also later co-produced the French film *La cité des enfants perdus* (*The City of Lost Children*) (Marc Caro and Jean-Pierre Jeunet, 1995). With the exception of his ever-faithful production assistant, Primitivo Álvaro, his regular collaborative crew did not collaborate on these films.

Chapter 1

1 Querejeta set up his first *cine-club* with Eceiza when he was just sixteen.
2 'More or less a den of revisionist Marxists.'
3 Querejeta further profited from the lecture notes that Eceiza recalls sharing with him. Angulo, *Elías Querejeta*, p. 69.
4 In an entertaining interview with John Hopewell, Querejeta begrudgingly admits that some of the music was recorded in a bathroom. J. Hopewell, 'Interview with Elías Querejeta', *Stills*, 12, June/July 1984, p. 27.
5 'Our idea of realism wasn't based on the banality of cold hard realism.'
6 'the rustic carnival, the coarse village merry-go-round, the gaudy tourist-shop window, the picturesque dish of *fiesta*'
7 Querejeta also co-produced Jorge Grau's *Noche de verano* ('Summer Night') for PROCUSA, the earliest Spanish film to receive *interés especial* (special interest) funding in February 1963, although his contribution does not appear to be creative in any way.
8 'the smartest of all of them was Elías Querejeta, who had the intelligence to set up a production company funded by Special Interest ... This provided Querejeta with the financial base to set up his business, and he had the intelligence to use the Special Interest subsidies as a financial base to make films that would be successful at the box office.'
9 'breaking with the established formulas imposed by American cinema.'
10 'I have yet to see a single film by a young director which has truly discovered the Spanish landscape ... The Spanish landscape, both rural and urban, continues to be a protagonist which is almost unknown to us.'
11 The coastal landscape of Andalusia is conveyed through full shots and elliptical editing in *Último encuentro*, while in *Si volvemos a vernos* the streets of Madrid are explored by means of gliding, elegant long takes in Cinemascope.
12 'with the expressiveness of humiliated young boy and with the utter comprehension of a situation which, at heart, has not been borne of his own mind.'
13 'the putting into practice of the theory of critical aesthetics which *Nuestro cine* has set forth since its creation two years ago', 'authentic sense of cinematic narrative.'
14 'Deep in thought, Nelson walks along the road leading to the factory. Empty fields stretch out on both sides, no doubt soon to be built over with new factories.'
15 'My life revolves around getting up at seven o'clock ... eating my lunch in the office ...and during that half an hour I'm always alone ... I had such expectations of this city.'

16 'What is shown is a vision of reality based on slogans.'
17 'Don't speak! Don't speak! It's your image which counts! Any image is valuable, and superior to words.'
18 'But if he possesses her, he will be petrified. The sacred terror of the female, the terror of the *vagina dentata*. He knows that woman is strongest. He believes in the myth of the mantis.'
19 'Lots of people died here and now there are only the holes that remain. A good place for killing.'

Chapter 2

1 'expression of a buried violence that could break out at any moment, it's something that's in the environment.'
2 See for example E. Fox, 'Spain as Castile: Nationalism and National Identity' in D. Gies (ed.), *The Cambridge Companion to Spanish Culture* (Cambridge: Cambridge University Press, 1999), pp. 21–36.
3 Suicide also occurs in other Querejeta productions not discussed within this chapter: *Dedicatoria* (Jaime Chávarri, 1980), *De cuerpo presente* (Antxón Eceiza, 1965) and *El sur* (Víctor Erice, 1983). The producer has stated his fascination for suicide thus: 'Siempre me ha chocado el carácter de los suicidas, pero al mismo tiempo siempre me ha chocado su dominio, el dominio sobre la propia muerte' [The character of suicide victims has always shocked me, but at the same time I find the absolute control they possess over their own death equally as shocking], J. Hernández Les, *El cine de Elías Querejeta, un productor singular* (Bilbao: Mensajero, 1986), p. 111.
 According to the director of *Las palabras de Max*, Emilio Martínez Lázaro, it was Querejeta's own idea to have Max's friend Julián (Héctor Alterio) commit suicide. (Hernández Les, *El cine de Elías Querejeta*, p. 111.)
4 'certain Zurbaranesque values: an almost complete sense of stasis and, most of all, eternal, dense and immune to the passing of time.'
5 Both the theme and aesthetic of stasis resurface in other Querejeta productions which are not discussed in this chapter, as they are not set in Castile or the *meseta*. In *El jardín de las delicias* (Carlos Saura, 1971), the protagonist Antonio Cano (José Luis López Vázquez) is a Francoist industrialist, who is paralysed and suffering from amnesia. Paralysis also appears in *Cría cuervos* (Carlos Saura, 1975), in which the elderly grandmother (Josefina Díaz) is also wheelchair-bound. Like Cano, she spends her days attempting to remember the past.
6 'any details which reflect the humiliation of these workers.'
7 'he's a stud: the most noble, brave and fertile of the whole ranch. When he's enclosed with forty cows, he doesn't leave until he's had sexual experiences with them all.'
8 'But for me, equally as important as this violence was the desolation of the surroundings in which it took place.'
9 'The certainty that all my steps necessarily had to follow down paths that had been chosen for me unnerved me at the time and made me resentful.' C. J. Cela, *The Family of Pascual Duarte,* translated by A. Kerrigan (Champaign, IL: Dalkey Archive Press, 2004), p. 7.
10 'You don't get anything from speculating with land. You have to build on it!'
11 'Come off it! It was a right spectacle, what with all the rheumatism, arthritis and kidney stones on display. All the women were fat. . . '

12 'And I thought to myself: "We won't be alone anymore". Everything that I had dreamt for had disappeared.'

13 'I find the landscape of Segovia, where I have worked on other films before, absolutely fascinating, and it holds an attraction for me which I just can't explain.'

14 'I like this landscape a lot. I once read that the girl who was the model was paralysed and her name was Cristina in real life. Look at her arms. There's something mysterious about it, don't you think?'

15 Regarding the relationship between the painting and the landscape in the film, Saura comments 'el cuadro de Waif [*sic*] siempre me ha magnetizado mucho. No sé de dónde surge la relación entre ambos. Este paisaje lo utilicé en *Elisa, vida mía*. Este cuadro de Waif lo conozco desde hace muchísimo tiempo, siempre me ha fascinado y lo tengo clavado en mi cuarto con los cuadros y las cosas que me gustan' [I've always been captivated by Waif's painting. I don't know where the relationship between the two comes from. I used the same landscape in *Elisa, vida mía*. I've known Waif's painting for a very long time; it has always fascinated me and I have it up in my room, along with other pictures and things that I like], Anon. 'Carlos Saura', *Cuadernos para el diálogo*, 27 May (1978), pp. 50–1.

16 'In a moment of reflexion, what I'd like to do is to return to what was before; that is to say, to forget everything that I have learnt.'

17 'Believe me that there is no wolf, there is no lion, there is no tiger, there is no basilisk that reaches man: in ferocity he surpasses them all.'

18 'like some kind of invisible threat out of science fiction, there is something strange happening; something that might be in the landscape, or the car accident, or an accumulation of little things that have been pulsating in the film.'

Chapter 3

1 'Yes they see it, of course they see it, but from an economic rather than an aesthetic perspective'

2 'The intellectual hasn't approached the country, he doesn't know it.'

3 The director reports that the bear costume has since been turned into a rug. (Torres, *Conversaciones con Manuel Gutiérrez Aragón*, p. 177.)

4 'Emerging from the mist like a ghost, the being which changed a man.'

5 'I have always been fascinated by the magical side of the rural world. It has a language that you have to decode ... Its mystery can't be decoded entirely: there always remains something hidden, enigmatic and inaccessible.'

Chapter 4

1 'I was interested in the fact that it was a song to freedom, and that Tasio doesn't abandon his charcoal burning and go to the city to work.'

2 *Tasio* won a prize for best male lead at the Tenerife Ecological Festival in 1984.

3 During the early 1980s, a number of Spanish films responded to the growing awareness of the country's ecological issues. See for instance *El gran mogollón* ('The Great Big Fuss') (Ramón Fernández, 1982), *La rebelión de los pájaros* ('The Rebellion of the Birds') (José Luis Comerón, 1981) and *Hablamos esta noche* ('Let's Talk Tonight') (Pilar Miró, 1982).

4 This is predominately the case for the Basque Country and Catalonia, although much smaller regional film industries were also created in Galicia, Valencia, the Canary Islands and Andalusia.

5 All three of Querejeta's productions during the Miró period received state subsidies: *Feroz* (Manuel Guitérrez Aragon, 1984), *Tasio*, and *27 Horas* (Montxo Armendáriz, 1987).

6 As Núria Triana-Toribio notes, those who were related to the NCE or the EOC, and/or were oppositional during Francoism fared particularly well under the new system. According to the author, these film-makers became 'no longer the opposition but the establishment'. (N. Triana-Toribio, *Spanish National Cinema* (London: Routledge, 2003), p. 113.)

7 'Just so that you know, I never take more than half of the chicks.'

8 'That's how it should be: taking all of them is no good at all. One thing is to hunt, it's quite another to destroy nests. And never take more than what's needed, and that way there will always be enough to hunt.'

9 'To hunt you have to confront the animal.'

10 'The animals are more like subjects, they can't escape. I like to hunt my own way, not like this.'

11 See, for instance, J. Baters, *Song of the Earth* (London: Picador, 2000).

12 'There's no such thing as a real cinema, rather there is a more or less faithful representation or reconstruction of reality.'

13 'I wasn't trying to create a realistic style photography, but rather a tone and an atmosphere that appeared realistic.'

14 'During the shooting of *Tasio* tonnes of earth and sand needed to be added to many location shots, because we couldn't shoot in the villages the way they are today.'

15 '*Tasio* is a film which too easily reveals its affectations . . . the images are too sanitized, and do not authentically portray rural life.'

16 'It is not easy for the film image to attain the level of poetry . . . Montxo Armendáriz's debut film has the honour of joining the ranks of a kind of cinema in which the image speaks for itself, with all the vigour and authenticity of real life.'

17 Robert Bresson and Carl Dreyer, the other two directors whom Shrader mentions above as typifying the transcendental style film, are two of Querejeta's favourite directors. See R. Stone, *Spanish Cinema* (Harlow: Longman, 2002), p. 4. Also see E. Urreta, 'Mi trabajo tiene algo que ver con la forma de jugar de Baker y la música de Shonberg [*sic*]', *Diario 16*, 27 November (1988), pp. 36–9.

18 'Their narrative provided me with a different way of seeing cinema, which allows one to understand the internal rhythm of the shot in relation to the *mise en scène*, and I think this can be seen in my cinema, although unconsciously.'

19 'That must be Ángel's son – he didn't even make it to the hospital.'

20 'has created a generation of lonely elderly people who remain tirelessly bound to a traditional way of life that will vanish with them.'

21 'According to the traditional conception that endures in villages still, the Basque people are bound to an *etxe*, a home . . . The *etxe* is earth and shelter, church and cemetery, a material foundation and communal centre for family members, both living and defunct. It is also a community composed of both present inhabitants and their ancestors. Now, in the face of new ways of life, these attributes of the traditional home are losing shape and vanishing. The conceptual world of the Basque people thus historically revolves around the *etxe*, which in turn pursues an ideal: to make each of its inhabitants live in harmony

with their own, without pain and sorrow, in communion with their ancestors in this life and the other.'

22 This photograph also appears on the cover of the VHS and DVD versions of the film.

Chapter 5

1 'suffered a process of segmentation as entire neighbourhoods of this new working class were lifted from the margins.'

2 'a process was therefore established where the structures of urbanization only worked to intensify class differences, making the poor poorer and the rich richer.'

3 Other films of this subgenre, known as *cine quinqui,* include Antonio de la Loma's *Perros callejeros II: busca y captura* (*Street Warriors 2*) (1979), *Los últimos golpes de 'El Torete'* ('El Torete's' Last Punches') (1980) and *Yo, 'El Vaquilla'* ('I, "The Vaquilla"') (1985); Eloy de la Iglesia's *Navajeros* (*Young Knives*) (1980), *Colegas* (*Pals*) (1982) and *El pico* (*The Shoot*) (1983), and Manuel Gutiérrez Aragón's *Maravillas* (1980), which was more experimental in tone. The general style combined gritty realism with sensationalist, scandal-mongering scenes of sex and violence, which were typical of the *cine del destape.* In its treatment of marginal identities as subcultural style, the *quinqui* film suggests parallels with the American 'Blaxploitation' films of the early 1970s, in which black urban poverty was recast as spectacle.

4 'I used to swim in this lake when I was a kid. There were ducks and fish. We used to go fishing. It's really deep – can't you see?'

5 'That's just shit! They even have to fuck up here, with their shitty rubbish . . . we're going to end up buried in shit. How disgusting!'

6 'All they want is to escape from where they live, and for that they need money, and lots of it. The problem is that it has to happen very fast. Money, fast. Pleasure, fast. Love, fast.'

7 'The head of the profaned image of the Sacred Heart of Jesus. What could have happened to this?'

8 'It's outrageous in a place like this. Especially not in a sacred place like here.'

Chapter 6

1 Upon the release of *Las cartas de Alou,* Armendáriz said in an interview with *El País* that the aim of his film was to 'plasmar una realidad que creo en un 99 por ciento es desconocido' [represent a reality which I think is unknown to 99 per cent of people], A. Rubio, 'Montxo Armendáriz filma el frustrante viaje por España de un inmigrante africano ilegal,' *El País,* 7 January (1990), n.p.

2 Isabel Santaolalla shows that Armendáriz's film was the first Spanish film to tackle the question of immigration, and has been followed by several others since, such as *Bwana* (Imanol Uribe, 1996) and *Flores de otro mundo* (*Flowers from Another World*) (Iciar Bollaín, 1999) (Santaolalla, 2005, pp. 120–1). Though the issue of unemployment has surfaced in other Spanish films such as *Se buscan*

fulmontis (*Full Montys Wanted*) (Alex Calvo Sotelo, 1999), to the best of my knowledge *Los lunes al sol* is the first to make explicit the relationship between Spanish unemployment and globalization.

3 Like Montxo Armendáriz (see chapter 4), Fernando León had previously been involved in the medium of documentary. He directed *Caminantes* (2001), a documentary which follows Mexican Zapatistas and co-wrote the script for the Querejeta production *La espalda del mundo* (Javier Corcuera, 2000).

4 In an interview, the director describes the finished script as 'la síntesis de un cúmulo de muchas noticias, de sueltos de periódico, de observaciones de la vida misma' [the synthesis of a cumulation of many news stories, newspaper articles, and real-life observations]. C. Carvajal, 'Mi compromiso es conservar lo que está pasando', *Kinetoscopio*, 64, 3 January (2003), 17.

5 'This film is not based not on one true story, but on thousands.'

6 See, for instance, E. Soja, *Thirdspace: Journeys to Los Angeles and Other Real-and-Imagined Places* (Oxford: Blackwell, 1996) and D. Harvey, *Justice, Nature and the Geography of Difference* (Oxford: Blackwell, 1996). In spite of the attention paid to Foucault's work in the field of human geography, there has been little attempt to apply his writing to film.

7 'You work, you apply for credit. And what about me? What the hell am I doing here?'

8 'To live illegally and without work involves constant movement.'

9 'It doesn't matter. If I've gone 6,000 kilometres to get to here, who cares about a few more? If there's work, I go.'

10 The other films that Fleser mentions are *Bwana* (Imanol Uribe, 1996), *Saïd* (Lorenç Soler, 1998), *Poniente* ('The Setting Sun') (Chus Gutiérrez, 2002) and *Tomándote* (*Tea For Two*) (Isabel Gardela, 2000).

11 'Listen Balthazar – just leave my daughter alone. I don't want her to have any problems.'

Filmography

1. Films produced by Elías Querejeta

A través del fútbol ('By Way of Football') (Elías Querejeta and Antxón Eceiza, 1960)

A través de San Sebastián ('By Way of San Sebastián') (Elías Querejeta and Antxón Eceiza, 1962)

A un díos desconocido (*To an Unknown God*) (Jaime Chávarri, 1977)

Ana y los lobos (*Ana and the Wolves*) (Carlos Saura, 1972)

Asesinato en febrero ('Murder in February') (Eterio Ortega Santillana, 2001)

Barrio (Fernando León, 1998)

Belleza Negra (*Black Beauty*) (James Hill, 1971)

Buscarse la vida ('On the Streets') (Juan Manuel Chumilla, 2008)

Carta de amor de un asesino ('Love Letter from a Murderer') (Francisco Regueiro, 1972)

Cerca de tus ojos ('Close to your Eyes') (Elías Querejeta, 2009)

Cría cuervos (*Raise Ravens*) (Carlos Saura, 1976)

Cuando vuelvas a mi lado (*By My Side Again*) (Gracia Querejeta, 1999)

Cuernos de espuma (*Shampoo Horns*) (Manuel Toledano, 1998)

De cuerpo presente ('Present in Body') (Antxón Eceiza, 1965)

Dedicatoria (*Dedication*) (Jaime Chávarri, 1980)

Deprisa, deprisa (*Hurry, Hurry!*) (Carlos Saura, 1980)

Diabólica malicia (*Night Hair Child*) (Andrea Bianchi, 1971)

Dulces Horas (*Sweet Hours*) (Carlos Saura, 1981)

El desencanto (*The Disenchantment*) (Jaime Chávarri, 1976)

El espíritu de la colmena (*The Spirit of the Beehive*) (Víctor Erice, 1973)

El increíble aumento del coste de la vida ('The Incredible Rise in the Cost of Living') (Ricardo Franco, 1975)

El jardín de las delicias (*The Garden of Delights*) (Carlos Saura, 1970)

El próximo otoño ('Next Autumn') (Antxón Eceiza, 1963)

El sur (*The South*) (Víctor Erice, 1982)

El último viaje de Robert Rylands (*Robert Rylands' Last Journey*) (Gracia Querejeta, 1996)

Elisa, vida mía (*Elisa, My Life*) (Carlos Saura, 1977)

Familia (*Family*) (Fernando León, 1996)

Feroz ('Fierce') (Manuel Gutiérrez Aragón, 1984)

Habla, mudita (*Speak Little Mute*) (Manuel Gutiérrez Aragón, 1973)

Historias del Kronen (*Stories from the Kronen*) (Montxo Armendáriz, 1995)

Invierno en Bagdad (*Winter in Baghdad*) (Javier Corcuera, 2004)

La banda de Jaider ('Jaider's Gang') (Volker Vogeler, 1973)

La caza (*The Hunt*) (Carlos Saura, 1965)

La cité des enfants perdus (*The City of Lost Children*) (Jean-Pierre Jeunet and Marc Caro, 1995)

La espalda del mundo (*The Back of the World*) (Javier Corcuera, 2000)

La letra escarlata (*The Scarlet Letter*) (Wim Wenders, 1973)
La madriguera (*Honeycomb*) (Carlos Saura, 1968)
La prima Angélica (*Cousin Angélica*) (Carlos Saura, 1973)
Las cartas de Alou (*Alou's Letters*) (Montxo Armendáriz, 1990)
Las palabras de Max (*Max's Words*) (Emilio Martínez-Lázaro, 1978)
Las secretas intenciones (*Secret Intentions*) (Antxón Eceiza, 1969)
Los desafíos (*The Challenges*) (Víctor Erice, José Luis Egea, Claudio Guerín, 1969)
Los lunes al sol (*Mondays in the Sun*) (Fernando León, 2002)
Los ojos vendados (*Blindfolded Eyes*) (Carlos Saura, 1978)
Los primeros metros ('The First Metres') (Carlos Saura Jr, Pablo Peréz de Guzmán,
 Javier Anastasio, 1980)
Mamá cumple cien años (*Mama turns 100*) (Carlos Saura, 1979)
Noche de verano ('Summer Night') (Jorge Grau, 1963)
Noticias de una guerra (News from a War) (Eterio Ortega Santillana, 2006)
Pascual Duarte (Ricardo Franco, 1976)
Peppermint Frappé (Carlos Saura, 1967)
Perseguidos ('Hunted') (Eterio Ortega Santillana, 2004)
Siete Huellas ('Seven Fingerprints') (Julio Medem et al., 1988)
Si volvemos a vernos ('If We Meet Again') (Francisco Regueiro, 1967)
Stress es tres, tres (*Stress Is Three, Three*) (Carlos Saura, 1967)
Tasio (Montxo Armendáriz, 1984)
Último encuentro ('The Last Meeting') (Antxón Eceiza, 1966)
Una estación de paso (*Whistle Stop*) (Gracia Querejeta, 1992)
27 Horas (*27 Hours*) (Montxo Armendáriz, 1987)

2. Other films

Alba de América (*Dawn of America*) (Juan de Orduña, 1951)
Bicycle Thieves (Vittorio de Sica, 1948)
Bienvenido Mr Marshall (*Welcome Mister Marshall!*) (Luis García Berlanga, 1953)
Bodas de sangre (*Blood Wedding*) (Carlos Saura, 1981)
Bwana (Imanol Uribe, 1996)
Calle Mayor (*Main Street*) (Juan Antonio Bardem, 1956).
Caminantes (Fernando León, 2001)
Carboneros de Navarra ('The Charcoal Burners of Navarre') (Montxo Armendáriz,
 1981)
Carmen (Carlos Saura, 1983)
Colegas (*Pals*) (Eloy de la Iglesia, 1982)
Condenados (*Condemned*) (Manuel Mur Oti, 1953)
Cuenca (Carlos Saura, 1958)
Deliverance (John Boorman, 1972)
Demonios en el jardín (*Demons in the Garden*) (Manuel Gutiérrez Aragón, 1982)
El amor brujo (*A Love Bewitched*) (Carlos Saura, 1986)
El cochecito ('The Little Car') (Marco Ferreri, 1960)
El corazón del bosque (*Heart of the Forest*) (Manuel Gutiérrez Aragón, 1979)
El diputado (*Confessions of a Congressman*) (Eloy de la Iglesia, 1979)
El extraño viaje (*The Strange Journey*) (Fernando Fernán Gómez, 1964)
El gran mogollón ('The Great Big Fuss') (Ramón Fernández, 1982)
El pico (*The Shoot*) (Eloy de la Iglesia, 1983)
El pisito (*The Little Apartment*) (Marco Ferreri, 1959)

El productor ('The Producer') (Fernando Méndez Leite, 2006)
El sueño de Andalucía ('An Andalusian Dream') (Luis Lucía, 1951)
Flores de otro mundo (*Flowers from Another World*) (Iciar Bollaín, 1999)
Hablamos esta noche ('Let's Talk Tonight') (Pilar Miró, 1982)
Ikuska 11 (Montxo Armendáriz, 1981)
Jamón, jamón (Bigas Luna, 1992)
Jane, mi pequeña salvaje ('Jane, My Little Savage One') (Elijio Herrero, 1982)
La aldea maldita (*The Cursed Village*) (Florián Rey, 1942)
La ciudad no es para mí ('City Life is Not for Me') (Pedro Lazaga, 1965)
La mitad del cielo (*Half of Heaven*) (Manuel Gutiérrez Aragón, 1986)
La rebelión de los pájaros ('The Rebellion of the Birds') (José Luis Comerón, 1981)
Las Hurdes (*Land Without Bread*) (Luis Buñuel, 1932)
Lola, la Piconera ('Lola, The Coal Girl') (Luis Lucia, 1951)
Los días del pasado (*The Days of the Past*) (Mario Camus, 1977)
Los golfos ('The Hooligans') (Carlos Saura, 1959)
Los inocentes ('The Innocents') (Juan Antonio Bardem, 1963)
Los últimos golpes de 'El Torete' ('El Torete's Last Punches') (Antonio de la Loma, 1980)
Mar brava ('Brave Sea') (Angelino Fons, 1982)
Maravillas (Manuel Gutiérrez Aragón, 1980)
Navajeros (*Young Knives*) (Eloy de la Iglesia, 1980)
O Lucky Man! (Lindsay Anderson, 1973)
Pablo G. del Amo, un montador de ilusiones (Pablo G. del Amo, An editor of Illusiones) (Diego Galán, 2005)
Perros callejeros (*Street Warriors*) (Antonio de la Loma, 1977)
Perros callejeros II: busca y captura (*Street Warriors 2*) (Antonio de la Loma, 1979)
Picnic at Hanging Rock (Peter Weir, 1975)
Poniente ('The Setting Sun') (Chus Gutiérrez, 2002)
Saïd (Llorenç Soler, 1998)
Se buscan fulmontis ('Full Monties Wanted') (Alex Calvo Sotelo, 1999)
Secretos del corazón (*Secrets of the Heart*) (Montxo Armendáriz, 1997)
Silencio roto (*Broken Silence*) (Montxo Armendáriz, 2001)
Sor Citroën ('Sister Citroën') (Pedro Lazaga, 1967)
Surcos (*Furrows*) (José Antonio Nieves Conde, 1951)
Susana (Antonio Chavarrías, 1997)
Tomándote (*Tea For Two*) (Isabel Gardela, 2000)
Un caballero andaluz ('An Andalusian Gentleman') (Luis Lucia, 1954)
Viridiana (Luis Buñuel, 1961)
Walkabout (Nicolas Roeg, 1972)
Yo, 'El Vaquilla' ('I, "The Vaquilla"') (Antonio de la Loma, 1985)
Young Soul Rebels (Isaac Julien, 1991)

Works Cited

Alameda, S. (1972). 'Inquieto Querejeta'. *Nuevos fotogramas*, 1232, 26 May: 22–3.
Alberich, E. (1984). 'Tasio'. *Dirigido por,* 119, November.
Angulo, J. (2003). 'Antxón Eceiza: el cine de la raigambre'. In C. Heredero and J. Monterde (eds), *Los 'nuevos cines' en España: Ilusiones y desencantos de los años sesenta.* Valencia: Festival Internacional de Cine de Gijón. pp. 271–85.
Angulo, J., C. Heredero and J. L. Rebordinos (1996). *Elías Querejeta: La producción como discurso.* San Sebastián: Filmoteca Vasca.
Angulo, J., C. Gómez, C. Heredero and J. L. Rebordinos (1998). *Secretos de la elocuencia: El cine de Montxo Armendáriz.* San Sebastián: Filmoteca Vasca.
Anon. (1974). 'Querejeta: un cine para unas ideas'. *El País,* 10 February.
Anon. (1976). 'Debería ser posible abordar la información a través del cine'. *El País,* 27 September.
Anon. (1978a). 'Elías Querejeta en el Festival de Berlín'. *Fotogramas,* 1541, 28 April: 17.
Anon. (1978b). 'Carlos Saura'. *Cuadernos para el diálogo.* 27 May: 50–1.
Anon. (1981).'"Deprisa, deprisa" se estrenará con su protagonista en prisión'. *Diario 16.* 13 March: 27.
Anon. (1984a). 'Interview with Luis de Pablo'. *Les Cahiers de la Cinémathèque.* 38–9: 139–40.
Anon. (1984b).'Feroz'. *Cahiers du cinéma.* 360–1: n.p.
Anon. (1987). 'La filmografía de Elías Querejeta, recogida en una serie de vídeo'. *El País: Cultura.* 24 December: n.p.
Anon. (1998). 'Medalla para Querejeta'. *El Progreso.* 25 June: 59.
Anon. (2006). 'Festival de San Sebastián: Una narración novelada de tres años de horror, angustia y muerte'. *El País.* 29 September: n.p.
Arocena, C. (2003). 'El próximo otoño: sentimientos realismo crítico'. In C. Heredero and J. Monterde (eds), *Los 'nuevos cines' en España: Ilusiones y desencantos de los años sesenta.* Valencia: Festival Internacional de Cine de Gijón, pp. 395–6.
Barbachano, C. (1989). *Francisco Regueiro.* Madrid: Filmoteca Española.
Barroso, J. (1989). 'Entrevista con Luis Cuadrado'. In F. Llinás (ed.), *Directores de fotografía del cine español.* Madrid: Filmoteca Española, pp. 229–47.
Baters, J. (2000). *Song of the Earth.* London: Picador.
Baza, R. (2000). *La primera vez: Una producción de Elías Querejeta.* Málaga: Ayuntamiento de Málaga.
Bhabha, H. (1991). 'Threatening Pleasures'. *Sight and Sound.* 4: 17–19.
— (1994). *The Location of Culture.* London and New York: Routledge.
Bilbatúo, M. (1966). 'Conversación con Saura: en busca de una realidad total'. *Nuestro cine.* 51: 18–28.
Blanco Rodríguez, J. A. (1998). 'Sociedad y régimen en Castilla y León bajo el primer Franquismo'. *Historia Contemporánea.* 17: 359–87.

Bordwell, D. and K. Thompson (1976) 'Space and Narrative in the Films of Ozu', *Screen*, 17, 2: 41–73.

Bordwell, D., J. Staiger and K. Thompson (1998). *The Classical Hollywood Cinema: Film Style and Mode of Production to 1960*. London: Routledge.

Bourdieu, P. (1999). *Acts of Resistance*. New York: New York Press.

Brandes, S. H. (1975). *Migration, Kinship and Community: Tradition and Transition in a Spanish Village*. New York, San Francisco and London: Academic Press

Brasó, E. (1974). *Carlos Saura*. Madrid: Taller de Ediciones Josefina Betancos.

Brown, S. (2005). 'Mondays in the Sun'. *Sight and Sound*. 15: 68–9.

Burch, N. (1973). *Theory of Film Practice*. London: Secker and Warburg.

Calavita, K. (2005). *Immigrants at the Margins: Law, Race, and Exclusion in Southern Europe*. Cambridge: Cambridge University Press.

Carr, R. (1980). *Modern Spain 1875–1980*. Oxford: Oxford University Press.

Casas, Q. (1984). 'Un Certain Regard: "Feroz" de Manuel Gutiérrez Aragón'. *Dirigido por*. 114: 90–3.

Castree, N., N. Coe, K. Ward and M. Samers (2004). *Spaces of Work*. London: Sage.

Cela, C. J. (1963). *La familia de Pascual Duarte*. Barcelona: Ediciones Destino.

Chamorro, E. (1985). 'Querejeta: Todo ángel es terrible'. *Cambio 16*. 727, 4: 116–21.

Connell, R. W. (1995). *Masculinities*. Cambridge: Polity.

Costa Morata, P. (1985). *Hacia la destrucción ecológica de España*. Barcelona: Ediciones Grijalbo.

Cristóbal, R. (1997). *Elías Querejeta: El hombre que hace posible la magia*. Huelva: XXIII Festival de Cine Iberoamericano.

Cueto, R. (2003). 'Elías Querejeta: Une dimension éthique'. *Positif*. 506: 96–9.

D'Lugo, M. (1991). *The Films of Carlos Saura: The Practice of Seeing*. Princeton: Princeton University Press.

— (1997). *Guide to the Cinema of Spain*. Westport, CT: Greenwood Press.

— (2010). 'Landscape in Spanish Cinema'. In G. Harper and J. Rayner (eds), *Cinema and Landscape: Film Nation and Cultural Geography*. Bristol: Intellect, pp. 117–30.

De Santis, G. (1978). 'Towards an Italian landscape'. In D. Overby (ed.), *Springtime in Italy: A Reader on Neorealism*. London: Tantivy Press, pp. 125–9.

Del Corral, R. (1973). 'Elías Querejeta: soy hombre de cine más que empresa', *Ya* (no date provided, found in the archives of Madrid Filmoteca).

Delclós, T. (1976). 'Entrevista con Luis Cuadrado'. *Dirigidor por*. April.

Deleuze, G. (1986). *Cinema 1: The Movement-Image*. London and New York: Continuum.

— (1989). *Cinema 2: The Time-Image*. London and New York: Continuum.

Di Feba, G. and J. Santos (2003). *El Franquismo*. Barcelona: Ediciones Paídos Ibérica.

Dissanayake, W. (2006). 'Globalisation and the Experience of Culture: The Resiliance of Nationhood'. In N. Gentz and S. Kramer (eds), *Globalisation, Cultural Identity and Media Representations*. New York: State University of New York Press, pp. 25–44.

Ettedgui, P. (1998). *Cinematography*. Woburn: Focal Press.

Everett, W. and A. Goodbody. (2005). *Revisiting Space: Space and Place in European Cinema*. Oxford and New York: Peter Lang.

Faulkner, S. (2004). *Literary Adaptations in Spanish Cinema*. London: Tamesis.

— (2005). 'New Spanish Cinema in the 1960s: Interviews with Antxón Eceiza and Julio Diamante'. *Studies in Hispanic Cinemas*. 2,3: 205–16.

— (2006). *A Cinema of Contradiction: Spanish Film in the 1960s*. Edinburgh: University of Edinburgh Press.

Ferguson, F. (1992). *Solitude and the Sublime: Romanticism and the Aesthetics of Individuation.* New York and London: Routledge.

Flesler. D. (2004). 'New Racism, Intercultural Romance, and the Immigration Question in Contemporary Spanish Cinema'. *Studies in Hispanic Cinemas.* 1,2: 103–18.

Fontenla, C. (1966). 'Tiempo de violencia: "La caza" de Carlos Saura'. *Nuestro cine.* 51: 12–17.

Foucault, M. (1980). 'Questions on Geography'. In C. Gordon (ed.), *Power/Knowledge: Selected Interviews and Other Writings 1972–1977.* Brighton: Harvester Press, pp. 63–77.

— (1986). 'Of Other Spaces' *http://foucault.info/documents/heteroTopia/foucault.heteroTo pia.en.html* [accessed 12 June 2006].

Fox, E. (1999). 'Spain as Castile: Nationalism and National Identity'. In D. Gies (ed.), *The Cambridge Companion to Spanish Culture.* Cambridge: Cambridge University Press, pp. 21–36.

Fowler, C and Helfield, G. (2006). *Representing the Rural in the Cinema.* Detroit: Wayne State University Press.

Fouz-Hernández, S. (2000). '¿Generación X? Spanish Urban Youth Culture At The End Of The Century In Mañas's/Armendáriz's *Historias Del Kronen*'. *Romance Studies*, 18,1: 83–9.

— (2005). 'Javier Bardem: Body and Space'. In W. Everett and A. Goodbody (eds), *Revisiting Space: Space and Place in European Cinema.* New York: Peter Lang, pp. 187–207.

Galán, D. (1974). *Venturas y desventuras de La prima Angélica.* Valencia: Fernando Torres.

García, A. (1988). 'TVE inicia un ciclo dedicado al productor Elías Querejeta'. *El País.* 7 November: n.p.

García, R. (2006).'Reportaje: 54 Festival of San Sebastián: El productor sin puro'. *El País.* 29 September: n.p.

— (2007). 'Cómplice en la sombra: "El productor" retrata a Elías Querejeta, figura clave en la industria del cine español'. *El País: Cultura.* 13 April: 46.

García de Dueñas, J. (1961).'Panorama del cine documental español'. *Nuestro cine.* 5: 10–15.

García de León, M. (1996). *El campo y la ciudad.* Madrid: Centro de Publicaciones; Ministerio de Agricultura, Pesca y Alimentación.

García Escudero, J. M. (1962). *Cine español.* Madrid: Ediciones Rialp.

Gennochio, B. (1995). 'Discourse, discontinuity, difference: the question of "other spaces"'. In S. Watson and K. Gibson (eds), *Postmodern Cities and Spaces.* Oxford: Blackwell.

Geselbracht, R. (1974). 'The Ghosts of Andrew Wyeth: The Meaning of Death in the Transcendental Myth of America'. *New England Quarterly: A Historical Review of New England Life and Letters.* 47,1: 13–29.

Gibson, I. (1992). *Fire in the Blood.* London: BBC Books.

González Pozuelo, F. (1989). 'Análisis sociológico de un barrio marginado'. *Cuadernos de Realidades Sociales.* 33–4: 45–62.

González Requena, J. (1989). 'La conciencia del color en la fotografía cinematográfica española'. In F Llinás (ed.), *Directores de fotografía del cine español.* Madrid: Filmoteca Española, pp. 118–65.

González Requena, J. (1998). *El campo en el cine español.* Madrid: Banco de Crédito Agrícola.

Gracia, F. (1988). 'Elías Querejeta: "Produzco películas por satisfaccíon personal, no por dinero"'. *Diario 16.* 7 November: n.p.

Gregory, D. (1994). *Geographical Imaginations.* Cambridge and Oxford: Blackwell.

Grey, T. (2008). 'Flashback: Cannes 1968'. *Variety.com.* 8 May. *http://www.variety.com/article/VR1117985372.html?categoryid=13&cs=1* [accessed 10 October 2009]

Grier, D. (1997). *La Castilla rural en la narrativa de posguerra.*Valladolid: Junta de Consejería de Educación y Cultura.

Grugel, J. and T. Rees (1997). *Franco's Spain.* London: Arnold.

Gurruchaga, C. (1984). 'Montxo Armendáriz: "Tasio es la historia de un personaje real"'. *Diario 16.* 22 September: n.p.

Gutiérrez Aragón, M. (1998). 'Un mundo mágico'. In J. González Requena (ed.), *El campo en el cine español.* Madrid: Banco de Crédito Agrícola, pp. 11–12.

Halfacree, K. H. (1993). 'Locality and Social Representation: Space, Discourse and Alternative Definitions of the Rural'. *Journal of Rural Studies.* 9,1: 23–37

Hallam, J. and M. Marshment (2000). *Realism and Popular Cinema.* Manchester: Manchester University Press.

Harrison, J. and D. Corkhill. (2004). *Spain: A Modern European Economy.* Aldershot: Ashgate.

Harrison, R. J. (1985). *The Spanish Economy in the Twentieth Century.* London: Croom Helm.

Harvey, D. (1989). *The Condition of Postmodernity.* Oxford: Blackwell.

— (1996). *Justice, Nature and the Geography of Difference.* Oxford: Blackwell.

Heidegger, M. (1971). *Poetry, Language, Thought.* New York: Harper and Row.

— (1993a). 'Building Dwelling Thinking'. In D. Krell (ed.), *Basic Writings: Martin Heidegger.* London and New York: Routledge, pp. 347–63.

— (1993b).'The Question Concerning Technology'. In D. Krell (ed.), *Basic Writings: Martin Heidegger.* London and New York: Routledge, pp. 311–41.

Heredero, C. (1987). 'Elías Querejeta: un estilo de producción'. *Dirigido por.* 144, 6–10.

— (1994). *El lenguaje de la luz: Entrevistas con directores de fotografía del cine español.* Alcalá de Henares: 24 Festival de Cine de Alcalá de Henares.

— (2003).'En la estela de la modernidad: entre el Neorealismo y la *Nouvelle Vague*'. In C. Heredero and J. Monterde (eds), *Los 'nuevos cines' en España: Ilusiones y desencantos de los años sesenta.* Valencia: Festival Internacional de Cine de Gijón. pp. 137–62.

Heredero, C. and J. Monterde (eds) (2003). *Los 'nuevos cines' en España: Ilusiones y desencantos de los años sesenta.* Valencia: Festival Internacional de Cine de Gijón.

Hernández Les, J. (1986). *El cine de Elías Querejeta, un productor singular.* Bilbao: Mensajero.

— (1988). *Primer plano,* October: 39–45.

Hernández Velasco, I. (1993).'No tengo talento para la comedia'. *El Siglo.* 19 April: 47–8.

Hernando Sanz, F. J. (2001). *Espacio y delincuencia.* Madrid: Consejo Económico y Social.

Hetherington, K. (1997). *The Badlands of Modernity: Heterotopia and Social Ordering.* London and New York: Routledge.

Hidalgo, M. (1984). *Carlos Saura.* Madrid: Ediciones JC.

— (1987). *Pablo G. del Amo, montador de sueños.* Alcalá de Henares: Festival de Alcalá de Henares

Highmore, B. (2002). *The Everyday Life Reader*. London: Routledge.

Hooper, J. (1995). *The New Spaniards*. London: Penguin.

Hopewell, J. (1984). 'Interview with Elías Querejeta'. *Stills*. 12: 27.

— (1985). 'Sol y sombra 1: Elías Querejeta'. *National Film Theatre Programme*. October–November: 20–1.

— (1986). *Out of the Past: Spanish Cinema after Franco*. London: BFI.

Hopkins, A. (1990). 'Fragile Spain'. *Sunday Times*. 24 June, n.p.

Huertas, J., J. Caballero and R. Pascual (1978). *Los hijos de la calle: La marginación y delincuencia infantil y juvenil en España*. Barcelona: Editorial Bruguera.

Kinder, M. (1993). *Blood Cinema: The Reconstruction of National Identity in Spain*. Berkeley and Los Angeles: University of California Press.

Kovács, K. (1991). 'The Plain in Spain: Geography and National Identity in Spanish Cinema'. *Quarterly Review of Film and Video*. 13,4: 17–46.

Labanyi, J. (1989). *Myth and History in the Contemporary Spanish Novel*. Cambridge: Cambridge University Press.

Labanyi, J. and H. Graham (1995). *Spanish Cultural Studies: An Introduction: The Struggle for Modernity*. Oxford: Oxford University Press.

Lamet, P. M. (1984). 'Tasio'. *Reseña*. November–December: 153–4.

Lawlor, T. and M. Rigby (1998). *Contemporary Spain: Essays and Texts on Politics, Economics, Education and Employment and Society*. London: Longman.

Lázaro, E. M., E. Querejeta and R. Franco (1976). *Pascual Duarte*. Madrid: Elías Querejeta.

Lefebvre, H. (1991). *The Production of Space*. Oxford: Blackwell.

Levinas, E. (1969). *Totality and Infinity: An Essay on Exteriority*. Duquesne: Duquesne University Press.

Leyra, P. (1998). 'Elías Querejeta: "En el cine está casi todo por inventar"'. *Cambio 16*. 1 June: 84.

Lipsitz, G. (1999). 'Home is where the hatred is: Work, music and the transnational economy'. In H. Naficy (ed.), *Home, Exile, Homeland*. New York and London: Routledge, pp. 193–212.

MacCabe, C. (2003). 'The Revenge of the Author'. In V. Wexman (ed.), *Film and Authorship*. London: Rutgers University Press, pp. 30–4.

Marcuse, H. (1964). *One-Dimensional Man*. Boston: Beacon Press.

Marsh, S. (2003). 'Tracks, Traces and Commonplaces: Fernando León de Aranoa's *Barrio* (1998) and the Layered Landscape of Everyday Life in Contemporary Madrid'. *New Cinemas*. 1,3: 165–78.

Martínez Reguera, E. (1982). *La calle es de todos, ¿De quién es la violencia?* Madrid: Editorial Popular.

Martín-Santos, L. (2004). *Condenada belleza del mundo*. Barcelona: Seix Barral.

Massey, D. (1998). 'The Spatial Construction of Youth Cultures'. In T. Skelton and G. Valentine (eds), *Cool Places: Geographies of Youth Cultures*. London: Routledge, pp. 121–9.

— (1999). 'Imagining Globalisation' in A. Brah, M. Hickman and M. Mac an Ghaill (eds), *Global Futures: Migration, Environment and Globalisation*. Basingstoke: Macmillan Press. pp. 27–44.

— (2005). *For Space*. London: Sage.

Massey, D. and K. Lury. (1999). 'Making Connections'. *Screen*. 40,3: 229–38.

McVeigh, P. (2005). 'Embedding Neoliberalism in Spain: From Franquismo to Neoliberalism'. In S. Soederberg, G. Menz and P. G. Cerny (eds), *Internalising Globalisation: The Rise of Neoliberalism and the Decline of National Types of Capitalism*. Basingstoke and New York: Palgrave Macmillan.

Méndez Leite, F. (1969). 'Los desafíos'. *Film ideal.* 214–15: 117–30.

Mínguez-Arranz, N. (2002). *Spanish Film and the Postwar Novel: Reading and Watching Narrative Texts.* Westport, CT: Praeger.

Mira, A. (2000). 'Transformations of the Urban Landscape in Spanish Film Noir'. In M. Konstantarakos (ed.), *Spaces in European Cinema.* Exeter: Intellect, pp. 124–37.

Molina Foix, V. (1984).'Tasio'. *Fotogramas.* 1702: n.p.

— (2003). *Manuel Gutiérrez Aragón.* Madrid: Cátedra.

Monleón, J. (1966a).'Eceiza: Problemas del nuevo realismo'. *Nuestro cine.* 51: 33–44.

— (1966b). 'Nuevo Cine Español'. *Nuestro cine.* 51: 4–11.

Mulvey, L. (1975). 'Visual Pleasure and Narrative Cinema'. *Screen.* 16,3: 6–18.

Muñoz, J. (1998).'Ser de izquierdas es tener educación'. *La Verdad de Murcia.* 17 June: 4.

Nichols, B. (1994). *Blurred Boundaries: Questions of Meaning in Contemporary Culture.* Bloomington: Indiana University Press.

Norton, W. (2006). *Cultural Geography: Environment, Landscape, Identities and Inequalities.* Oxford: Oxford University Press.

Pack, S. (2006). *Tourism and Dictatorship: Europe's Peaceful Invasion of Franco's Spain.* New York: Palgrave Macmillan.

Pardo Pardo, M. (2003). 'La economía durante el Franquismo'. In M. Requena (ed.), *Castilla-La Mancha en el Franquismo.* Biblioteca Añal: Ciudad Real, pp. 173–224.

Pasolini, P. (1976). 'The Cinema of Poetry'. In B. Nichols (ed.), *Movies and Methods: Vol. 1.* California: University of California, pp. 542–58.

Pavlovic, T. (2007).'Allegorising the body politic: Masculinity and history in Saura's *El jardín de las delicias* (1970) and Almodóvar's *Carne tremula* (1997)', *Studies in Hispanic Cinemas,* 3,3: 149–67

Pérez Manrique, C. (1999). *Le cinéma de Montxo Armendáriz: Arrêt sur image.* Toulouse: Presses Universitaires du Mirail.

Pérez Yruela, M. (1990).'La sociedad rural'. In S. Giner (ed.), *España: Sociedad y Política.* Madrid: Espasa-Calpe, pp. 199–242.

Pisters, P. (2003). *The Matrix of Visual Culture: Working With Deleuze in Film Theory.* Stanford, CA: Stanford University Press.

Ponga, P., M. A. Martín and C. Torreiro (2002). *Hipótesis de Realidad: El cine de Fernando León de Aranoa.* Melilla: Consejería de Cultura Ciudad Autónoma de Melilla.

Preston, P. (1993). *Franco: A Biography.* London: HarperCollins.

Querejeta, E. (1994). 'Estamos negando la realidad'. *Academia.* 5: 37–9.

Rapport, N. and A. Dawson (1998). *Migrants of Identity: Perception of Home in a World of Movement.* Oxford and New York: Berg.

Redondo, R. (1964). 'Cine joven español, parada y fonda'. *Film ideal.* 15 October: 684–5.

Riambau, E. (1995). 'El período socialista'. In R. Gubern, J. E. Monterde, J. P. Perucha and E. Riambau (eds), *Historia del cine español.* Madrid: Catédra, pp. 399–454.

— (2003). 'La legislación que hizo posible el NCE: Entrevista con José María García Escudero'. In C. Heredero and J. Monterde (eds), *Los 'nuevos cines' en España: Ilusiones y desencantos de los años sesenta.* Valencia: Festival Internacional de Cine de Gijón, pp. 53–68.

Richardson, N. (2002). *Postmodern 'Paletos': Immigration, Democracy and Globalisation in Spanish Narrative and Film, 1950–2000.* Lewisburg: Bucknell University Press.

Riquer i Permanyer, B. (1995). 'Social and Economic Change in a Climate of Political Immobilism'. In J. Labanyi and H. Graham (eds), *Spanish Cultural Studies: An Introduction: The Struggle for Modernity*. Oxford: Oxford University Press, pp. 259–71.

Robertson, P. (1997). 'Home and Away: Friends of Dorothy on the Road in Oz'. In S. Cohan and I. Hark (eds), *The Road Movie Book*. London: Routledge, pp. 271–86.

Rodríguez, M. (1990). 'Elías Querejeta, el arte de producir'. *Diario de Tarragona*. 24 October, n.p.

Rubio, A. (1990). 'Montxo Armendáriz filma el frustrante viaje por España de un inmigrante africano illegal.' *El País*. 7 January, n.p.

Sagastizabal, J. (1961). 'A partir de Cuenca'. *Nuestro cine*. 16–17.

Sánchez Vidal, A. (1988). *El cine de Carlos Saura*. Zaragoza: Caja de Ahorros de la Inmaculada.

Santaolalla, I. (1999) 'Julio Medam's Vacas: Historicizing the Forest'. In P. Evans (ed.), *Spanish Cinema: The Auteurist Tradition*. Oxford: Oxford University Press, pp. 93–114.

— (2003). 'The Representation of Ethnicity and 'Race' in Contemporary Spanish Cinema'. *Cineaste*. 29,1: 44–9.

— (2005). *Los 'otros': Etnicidad y raza en el cine español contemporáneo*. Madrid: Ocho y Medio.

Santos Fontenla, C. (1966).'Tiempo de violencia: "La caza" de Carlos Saura'. *Nuestro cine*. 51: 12–17.

Sarris, A. (1968). *The American Cinema*. Chicago: University of Chicago Press.

Saura, C. (1976). *La prima Angélica*. Madrid: Elías Querejeta.

Schama, S. (1995). *Landscape and Memory*. New York: Alfred A. Knopf.

Schrader, P. (1972). *Transcendental Style in Cinema*. Berkeley, London: University of California Press.

Sevilla-Guzmán, E. (1976). 'The Peasantry and the Franco Regime'. In P. Preston (ed.), *Spain in Crisis: The Evolution and Decline of the Franco Regime*. Hassocks, Sussex: The Harvester Press, pp. 101–24.

Shiel, M. and T. Fitzmaurice (2001). *Cinema and the City*. Oxford: Blackwell.

Short, J. R. (1991). *Imagined Country: Society, Culture and Environment*. London and New York: Routledge.

Shubert, A. (1990). *A Social History of Modern Spain*. London: Unwin Hyman.

Sibley, D. (1995). *Geographies of Exclusion: Society and Difference in the West*. London: Routledge.

Smith, P. J. (1999). 'Between Metaphysics and Scientism: Rehistoricizing Victor Erice's *El espíritu de la colmena* (1973)'. In P. Evans (ed.), *Spanish Cinema: The Auteurist Tradition*. Oxford: Oxford University Press, pp. 93–114.

— (2000). *The Moderns: Time, Space and Subjectivity in Contemporary Spanish Culture*. Oxford: Oxford University Press.

Soja, E. (1989). *Postmodern Geographies: The Reassertion of Space in Critical Theory*. London: Verso.

— (1996). *Thirdspace: Journeys to Los Angeles and Other Real-and-Imagined Places*. Oxford: Blackwell.

Stone, R. (2002). *Spanish Cinema*. Harlow: Longman.

Terry, A. (1973). *Campos de Castilla*. London: Grant and Cutler.

Torán, L .E. (1989).'Nuevo Cine Español: tiempo de renovación'. In F. Llinás (ed.), *Directores de fotografía del cine español*. Madrid: Filmoteca Española, con la colaboración del centro de Arte Reina Sofia, pp. 93–117.

Torres, A. M. (1969).'A propósito de los desafíos: Fragmentos de un coloquio sobre cine español con Víctor Erice, José Luis Egea y Claudio Guerín'. *Nuestro cine*. 82: 44–51.

— (1985). *Conversaciones con Manuel Gutiérrez Aragón*. Madrid: Editorial Fundamento.

Triana-Toribio, N. (2003). *Spanish National Cinema*. London: Routledge.

Urreta, E. (1988).'Mi trabajo tiene algo que ver con la forma de jugar de Baker y la música de Shonberg [*sic*]'. *Diario 16*. 27 November: 36–9.

Urry, J. (1991). *The Tourist Gaze*. London: Sage Publications.

Vernon, K. and C. Eisen (2006). 'Contemporary Spanish Film Music: Carlos Saura and Pedro Almodóvar'. In M. Mera and D. Burnam (eds), *European Film Music*. Aldershot: Ashgate, pp. 41–59.

Villate, J. (1974).'Habla, mudita'. *Reseña*. April: 33–4.

Wheelock, J. (1990). *Husbands at Home: The Domestic Economy in a Post-Industrial Society*. London: Routledge.

Willem, L. M. (2002). *Carlos Saura: Interviews*. Jackson: University Press of Mississippi.

Williams, R. (1973). *The Country and the City*. London: Chatto & Windus.

Willott, S. and C. Griffin (1996). 'Men, masculinity and the challenge of long-term unemployment'. In M. Mac an Ghaill (ed.), *Understanding Masculinities: Social Relations and Cultural Arenas*. Buckingham: Open University Press, pp. 77–94.

Wright, R. (1993). *Economics, Enlightenment and Canadian Nationalism*. Montreal: McGill-Queen's Press.

Zavattini, C. (1996). 'Some ideas on the cinema'. In R Dyer McCann (ed.), *Film: A Montage*. New York: Dutton, pp. 216–28.

Zunzunegui, S. (2003). '*La caza*: mirada distante, mirada lejana'. In C. Heredero and J. Monterde (eds), *Los 'nuevos cines' en España: Ilusiones y desencantos de los años sesenta*. Valencia: Festival Internacional de Cine de Gijón, pp. 415–18.

Index